AYUTTHAYA
Venice of the East

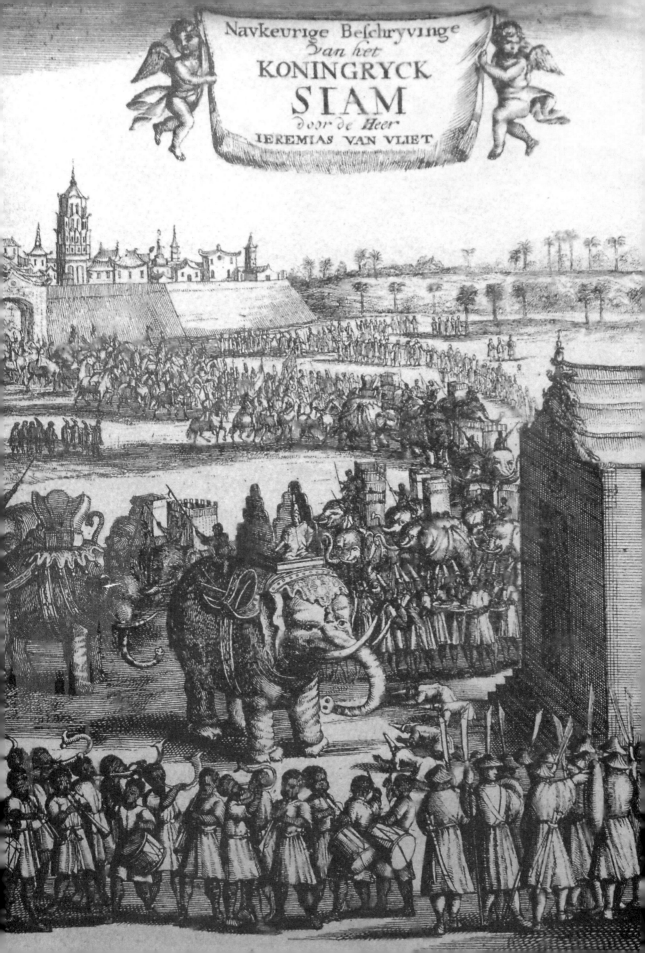

Navkeurige Beschryvinge
Van het
KONINGRYCK
SIAM
door de Heer
IEREMIAS VAN VLIET

AYUTTHAYA
Venice of the East

Derick Garnier

River Books

Dedicated to Thanpuying Arun Kitiyakara; with affection and respect.

First published and distributed in Thailand in 2004 by
River Books Co., Ltd
396 Maharaj Road, Tatien,
Bangkok 10200
Tel: (66) 2 225 4963, 225 0139, 6221900
Fax: (66) 2 225 3861
Email: riverps@ksc.th.com
Website: www.riverbooksbk.com

A River Books Production.
Copyright collective work © River Books 2004
Copyright text © Derick Garnier 2004
Copyright photographs © River Books 2004,
except where indicated otherwise.

Editor: Narisa Chakrabongse
Design: Suparat Sudcharoen
Production: Paisarn Piemmettawat

ISBN 974 8225 60 7

Printed and bound in Thailand by Amarin Printing and Publishing.

*Cover: Mural painting from Wat Khruawan, Bangkok
depicting a scene from the Mahajanoka Jataka.*

*Front flap: Mural painting from Wat Ku, showing two soberly-dressed Dutchmen.
(see page 92)*

Contents

Acknowledgements

This book would never have been written without the generous help of two friends.

Thanpuying Arun, who has lived beside the Chao Phraya for much of her life, suggested writing a book on the river and the towns which lie along its banks. She also gave me a great deal of information both from her own knowledge and from old funeral books and other rare sources.

Khunying Narisa, another friend, with typical generosity, agreed to edit and publish the book before even a word of it had been written.

Ajarn Chusiri Chamaraman very kindly read the whole book in manuscript and made many corrections and suggestions.

I must thank Dawn Rooney and The Old Maps & Prints at the River City for most kindly allowing us to use some rare maps in their collections; also the National Gallery of Thailand, the Underwater Archaeology Museum at Chantaburi, the Algemeen Rijksmuseum at The Hague and the Portuguese Embassy in Bangkok for allowing us to reproduce many of their pictures and maps.

Finally I must thank the librarians and their assistants at the Neilson Hays library in Bangkok and the library of the Siam Society for their help in searching out rare books; and in England the staff of the British Museum Reading Room (as it then was), the Bodleian Library and the staff at the Public Records Office.

This book would never have appeared in print without the patient and generous help of Khun Paisarn Piemmettawat and the staff at River Books.

Foreword

For some 400 years the commerce of the Eastern world passed through Ayutthaya. Goods from those great trading empires, China and Japan to the east, and India and Persia to the west went back and forth through Siam; up and down the Chao Phraya river and over the hills to the Andaman Sea.

To this trade Siam added her own 'native' products: metals such as copper, lead and tin, excellent hard wood for shipbuilding and products from her forests, dyes, perfumes and sealing wax, peacock's tails, ivory and elephants.

This exchange of goods was firmly, and very profitably, controlled by the kings of Ayutthaya. They built the greatest and most dazzling city that travellers encountered between Europe and Cathay.

With their armies of conscripts and their navy the kings of Ayutthaya enforced loyalty from city states as distant as Chiang Mai in the north and Nakorn Sri Thammarat in the south; from their borders with Cambodia and Vietnam to the very frontiers of Burma and China.

To western observers Ayutthaya seemed as prosperous as Venice herself. But her very eminence brought about her fall. In 1767, the Burmese hordes finally broke into the city, stole her images, burnt her temples and drove her people away before them like cattle to an exile from which few returned.

This book is an attempt to tell the story of the rise and fall of that great city, the 'Venice of the East'.

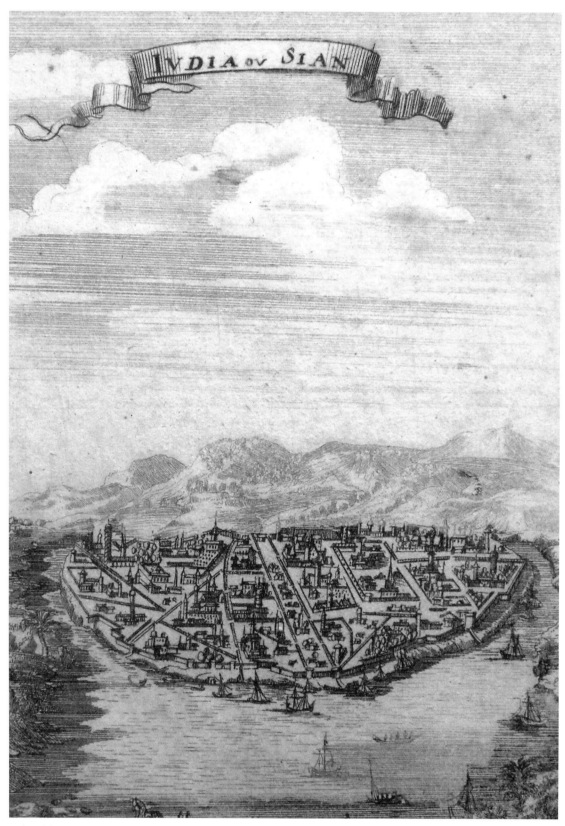

A fanciful picture of Ayutthaya drawn by Allain Manesson Mallet and published in 1683.
(Courtesy of the Dawn Rooney Collection)

The Rise of Ayutthaya

I t is necessary to be here in the months of April and May, when the vessels arrive from China and Japan … soon one cannot get anything at first hand; the merchants (i.e. the Moors) take everything to send to their own people." So wrote that enthusiastic observer of the Siamese scene, the Abbé de Choisy at the end of the seventeenth century. He was writing at a time when the exchange of goods between China, India and Persia which took place in Ayutthaya was at its height – or so it seemed to Westerners. In fact, those great trading nations had been despatching their fleets to the far corners of the known world for hundreds of years before the Westerners came upon the busy scene.

The Chinese have been active in international trade and shipping for at least the last two thousand years.[1] The development of Chinese maritime trading commenced during the Chin and Han periods (227 BC-220 AD). During the Tang and Sung dynasties, Chinese cargo carriers sailed on the Indian and Pacific oceans, from Canton in southern China to Martaban, the main sea port in Burma, and from Fukien to Japan and Korea. In the seventh century AD, Chinese trading vessels were seen on the river Euphrates.[2]

In Persia, King Darius the Great was sending fleets to India and Egypt six hundred years before the birth of Christ. The Sasanid dynasty of Persia had established a busy sea trade with China by the sixth century AD. In 748 AD, Persian ships were seen along the wharves of Canton.[3]

The Buddhist Jataka tales, which were composed in India about 2,000 years ago, contain many stories of Indian seafarers and their adventures. Many traders set off towards the East, looking for Suwannaphum, the Land of Gold. Three or four years later, long after their families had given them up for lost, they would return, some of them laden with gold.

The Europeans, like Johnny-come-lately, were last upon the scene. It was not until 1434 that Portuguese navigators dared put out into the seas beyond Cape Bojador, near Cape Verde, for there the waters boiled and sea serpents lurked. After 60 years of effort, a Portuguese expedition of four boats and a handful of men under Vasco da Gama reached Mombasa in 1498. In 1417, 80 years before, a Chinese fleet under Cheng Ho, the famous eunuch admiral, had reached the Kenyan town of Malindi. The fleet included no fewer than 62 galleons, each 450 feet long and with nine masts, and a total complement of 37,000 men.[4]

Of all these ancient maritime trading empires, China was perhaps the greatest, and certainly the one which had the most continuous effect upon

Thailand. While the Chinese could mount spectacular fleets, such as Cheng Ho's, which would sail halfway round the known world, it was much easier, cheaper and safer to send their junks out to some nearer shore and return the same year. They set out in spring on the north-east winds which would take them down to the Tropics. There, they would cruise the coasts of Indonesia, or move across the Gulf to the Thai shore and work their way up towards the northern reaches of the Gulf. Wherever they called they would sell their silks and porcelain, for which there was a ready market. They would buy Indian cloth, brought to South-east Asia by Muslim traders, pick up some local goods – perhaps hides or rhinoceros horn or fragrant-smelling wood – and return to China in the autumn on the south-west monsoon winds.

To feed this trade, a number of entrepôt ports grew up around the shores of South-east Asia: in Indonesia and the Spice Islands, Borneo where the Chinese later came for gold, Malaysia and southern Thailand, where goods could be carried across the peninsula to save the long and dangerous sea-voyage round the cape, and lastly in the ports scattered around the northern rim of the Gulf of Siam. The Malayan kingdom of Pattani flourished on Chinese commerce, and many Chinese junks called there every year bringing raw silk, silk cloth and porcelain. Songkla was long ranked as the second city of Siam, and one must assume that its eminence was due to trade. Nakorn Sri Thammarat and Chaiya still show signs of departed splendour. Then there is that elusive shade, Srivijaya; celebrated by scholars of old as the greatest trading empire of the region but frustratingly hard for them to find. It has been argued that Srivijaya could well have been Nakorn Pathom and later, Ayutthaya itself.[5]

These and many other ports round the shores of South-east Asia conducted a busy trade in each other's goods as well as in the rare and exotic articles produced in China and India:

"It would be impossible to enumerate all the active trade routes in this region... but one can say with confidence that virtually every South-east Asian commodity was available in any of dozens of trading centres."[6]

While any city state could survive on regional trade, a better profit was to be made by trading directly with India and China, best of all in one's own ships. Indian merchants had been active all over the area for hundreds of years and it was difficult to compete with them, but the China trade was, from time to time, open to foreign ships, and good profits could be made there. Only the larger and more sophisticated city-states could mount such an expedition.

The Chinese government liked to question the captains of junks on the places they had visited, and kept interpreters to examine the captains of foreign vessels trading in Chinese ports. These interviews were recorded and carefully preserved; some are nearly 1,000 years old. From them we gain tantalizing hints of ports and peoples around the Gulf. For instance, in the years 1200, 1202 and 1205 the state of Chen-Li-Fu sent three embassies

to China within the space of six years.[7] This was obviously a state experienced in foreign relations and overseas trade. Its ruler sent a gold-engraved memorial scroll to the Emperor of China. He also sent tame elephants – creatures which require stout vessels and careful handling if they are to survive a long voyage and rough seas – ivory, rhinoceros horn and cloth. All he asked was that he might be allowed to send annual missions of 'tribute', and perhaps receive a little Chinese porcelain. In fact, this was a clear attempt by a small and perhaps only semi-independent state to establish an export trade with China, couched in the diplomatic language of the time. Nevertheless, it was a reasonable request since the Chinese, according to their own reports on these missions, had long been sending junks to Chen-Li-Fu.

The first embassy landed at Ning-po, south of Hangchow. It was an impressive affair. The local *kang shou,* or go-between, summoned interpreters and a Malabar Indian to interrogate the emissaries and translate the scroll sent by the King of Chen-Li-Fu. They were able to report to the Chinese emperor that the country lay at the head of the Gulf of Siam (to judge from the sailing directions) and that it controlled over 60 settlements, each with its own administrator. Its ruler, who had been on the throne for 20 years, 'lived in a palace resembling a Buddhist temple', and his people 'tended to follow the law of the Buddha.'[8] The capital appears to have been inland, probably on the banks of a river; but the country had a port where ocean-going ships could berth, and it imported Chinese pottery which was popular with the local inhabitants. It was the only trading centre in the northern part of the Gulf which is known from records to have been visited by Chinese ships at that time. There must have been others, but it is reasonable to assume that Chen-Li-Fu was the busiest. Where was it?

This must have been one of the first questions the Indian interpreter posed. One can imagine the Chinese scribe screwing up his face as he listened to the rough, outlandish speech of these foreign emissaries, and as he tried to set down on his tablet in Chinese characters the sound of the names of the places from which they came. 'Chen-Li-Fu' – could this be his attempt at 'Chantaboon'? Hardly, if the geographical evidence is sound. Later arrivals said they came from 'Hsien' and 'Lohu'; it is tempting to see these names as transliterations of 'Siem' and 'Luvo'. They also talked of 'Ma-li-yu-rhe' and 'Pi-ch'a-pu-li'. Could these really be Malaysia and Petburi? Phonology alone is shaky evidence.

Wherever these places were located, we can say with some assurance that there were a number of small states at the head of the Gulf of Siam with the self-confidence and sophistication to send properly-equipped diplomatic missions to the Court of the Emperor of China to ask for trade between their two countries; and that they were sending out missions as early as the year 1200 AD.

However, they came at a bad time. There was war and unrest in China, and foreign trade was being curtailed. Envoys from Srivijaya were told as

early as 1178 AD that they need send no more envoys to the Court at Peking.[9] In 1170, the emperor ceased to confer honours on the ruler of Java. Both of these were states which China had used as entrepôts in its trade with India and Persia. So it was not surprising that in 1205, the envoys of Chen-Li-Fu were politely told that their country lay too far away for trade and that they need come no more. This gentle closing of the doors concealed a harsh reality within.

China was being attacked by the Mongol hordes, and darkness was to descend upon the celestial empire for a century. War and devastation made foreign policy and trade impossible. By 1277 the Mongol emperors had imposed their rule on China. Khublai Khan was free to set out and conquer South-east Asia. Here, as in Burma, his method was to send a haughty embassy which, using threats, demanded submission. (At this stage, the Chinese records speak of 'Hsien' and 'Lohu', rather than of Chen-Li-Fu.) Whether these states lay close to Chen-Li-Fu or were other names for the same area, it is impossible to determine; at any rate they were too far from the Mongol empire for a direct attack overland. The Mongols sent an envoy by sea in 1282, but his ship was intercepted by the Chams and he and his companions were killed before they could deliver Khublai Khan's demands.[10] In 1294 the emperor tried again and ordered 'Kan-mu-ting, king of Hsien kingdom' to come to court or else send hostages – an empty threat. A year later, the new emperor, Choeng-Tsung, bossily ordered Hsien: 'Do not injure Ma-li-yu-erh. Do not trample on your promise'. Whether the records are incomplete and there was an attack, or whether the Mongols simply ran out of steam, these arrogant demands seem to have gone unanswered.

Instead the rulers of Hsien and Lohu, and other city-states besides, responded by sending ships to China bearing 'tribute', part gifts and part offerings of trade: 'tigers, elephants, and boats made of *sha-lo* wood', and no doubt peacock's feathers, buffalo and rhinoceros horn, elephant's tusks and aromatic woods as well. All of these were goods which sold well on the Chinese market. China herself, however, long racked by wars, now suffered epidemics and floods, and was on the edge of starvation. Industrial production declined and foreign traders, who came to buy Chinese silks and porcelain, began to stay away. 'Hsien' and 'Lohu', which had begun to send tribute missions to the Court of the Great Khan continued intermittently until about 1320, and then looked elsewhere. It was not until a Chinese king of the Ming dynasty took over the empire from the Mongols in 1368 that China felt secure enough to proclaim herself once more suzerain of the East and demand homage from the smaller states of the region. By this time, Ayutthaya had emerged into the light of recorded history and we can identify the rulers who sent tribute to China and resumed trade.

The town is said to have been 'founded' in the year 1350 AD, and this has led people to think that the city, with all its temples and its palaces, was built then from scratch. There are several objections to this. Where did all the

artisans, craftsmen and labourers come from? Where did they live while they were building the city? Where did all their food come from, and how did they obtain their wealth? Towns do not develop like this, but grow up where trade routes meet. So long as conditions do not change, the citizens grow richer and temples are built, growing in size and magnificence as the town itself prospers. Eventually it may become the seat of a local king. It is only in modern times that capital cities such as Brasilia and Canberra have been created from nothing on empty land. Ayutthaya must have been built on or near an already prosperous town, just as the royal city of Bangkok was created from across the Chao Phraya in Thonburi, with King Rama using the workers and craftsmen of Thonburi, and its citizens to pay for the work.

That nearby town must have been one whose long-established wealth had been built up through trade, and whose craftsmen could build, carve, paint and gild, and cast images in bronze or gold. Where was that town? Could it have been on or near the present city? It is a site well suited for trade, given that three rivers meet there on their way to the sea. They are the Chao Phraya, the Pasak and the Lopburi. Between them they carried all the inland goods of the country down towards the coast, and were the only routes by which up-country people could send their goods to market. The Chao Phraya and its tributaries, which reach right up into the hills beyond Chiang Mai, served the north of Thailand; the Pasak river passes through Saraburi and reaches nearly to the Lao frontier. The third river is the Lopburi, which served that ancient trading town for more than a thousand years.

There is another reason why this site was so well-suited for a town. To the south and west of the town there is a strip of land which holds back the flood waters coming down the Chao Phraya during the rainy season, and turns the whole area into an enormous inland lake. This was no inconvenience to the people, who tended to build their houses up on stilts and go about in boats anyway. In fact, it was ideal for them because they could plant 'wet' rice, which grows quickly and is easy to harvest. Kaempfer, a German doctor who visited Ayutthaya on his way to Japan,[11] described the process in 1690:

"The Waters, by overflowing the Fields that are sown, make the rice grow so quickly, that the Stalks grow as fast as the water rises, and the Ears keep above the Surface, which when ripe, are cut off by the Reapers in Boats, and gather'd, but the straw which often is of an incredible length, is left in the water."

This all sounds much easier than the back-breaking sowing, transplanting and harvesting of 'dry' rice. And of course it meant that villagers had more time to grow other crops, or to roam the countryside for animals, plants and wood which could be sold to merchants at Ayutthaya, waiting for the arrival of the overseas fleets.

Thus it seems to make sense to suppose – in fact be almost certain – that people were living and trading in Ayutthaya long before it was 'founded' in 1350. There are also one or two wisps of evidence for the existence of such a

town. For instance, outside Ayutthaya, at the south-east corner where the junks from China used to moor, there is Wat Phanan Choeng, which the Chinese regard as 'their' temple. The huge Buddha image – one of the biggest in Ayutthaya – was fashioned 26 years before Ayutthaya itself was 'founded', and was built to commemorate and give thanks for the very prosperous trade that existed between Siam and China. It would have taken decades, if not centuries, to build up a commerce large enough to elicit such a thank-offering.

Another clue is that a number of visitors to Ayutthaya commented on buildings which they were told remained from a previous age. For instance, Ibn Muhammad Ibrahim, who was the scribe for a Persian embassy which came in 1686, wrote in *The Ship of Sulaiman*:

"The rule of (King Narai's) ancestors does not go back more than two hundred years and the city walls and fortresses were constructed about that time as well. There are some other temples and buildings which the natives reckon to be more than a thousand years old, but these constructions were the work of another age."[12]

Perhaps they were part of that same town or group of villages which had been trading with China since at least 1,200 AD and whose merchants built Wat Phanan Choeng.

It makes sense to suppose, then, that Ayutthaya was not 'founded' in 1351, but merely chosen as the site for a capital city. It was an easy site to defend, and was either a prosperous trading town itself, or lay across the river from such a town – a town with overseas contacts. Given that it also lay in the middle of a rich rice plain, then it would seem an ideal site for a local 'king' to adopt as his capital. Who he was it is difficult to say, since there are six different versions of the story of King Uthong founding the city.[13] Nevertheless, the very fact that the legend took so many forms suggests that there is substance behind it.

It is said of the western colonial empires that 'trade followed the flag'. In the case of Siam, however, it would seem that 'the flag followed trade'. Certainly King Taksin planted his standard firmly in Thonburi, the richest trading centre around, even if it was open to attack from the Burmese; and Bangkok, to which King Rama I moved his capital, was also an old trading centre. So it seems logical to assume that whoever 'founded' Ayutthaya was founding a capital and a dynasty, rather than building a new town in the middle of open countryside.

The reason Ayutthaya seems to 'appear' after 1350 is that kings keep records, but merchants do not. Or, at least, kings are interested in how posterity sees them and try to preserve their chronicles and those of their forebears, whereas merchants are more concerned to see that they are making a profit; and the more successful they are the less they want other people to read their accounts. There are royal chronicles going back to the beginning of the Ayutthaya period, but unsurprisingly, they say little or nothing about trade. This is a little lop-sided of them, given that all the kings

of Ayutthaya were involved in foreign trade; many Thai products were royal monopolies, the king's factors had first pick of imported goods and some kings, such as King Narai, took a personal interest in encouraging foreign trade. Despite this, little was written about it.

Fortunately, in 1368, just after Ayutthaya first came under the control of a king, the Chinese (who were compulsive chroniclers) once more gained control of their own empire under the Ming emperors. Within two years of coming to power, the first Ming emperor, Hung-Wo, sent out envoys to announce to the states surrounding China his accession to the Imperial Throne and to demand their submission to Chinese overlordship. One of these states was Ayutthaya. Their replies and subsequent relations with China are to be found in the official history of the Ming Dynasty.[14] Since the Chinese persisted in regarding all foreign delegations as missions sent to render tribute to the Emperor, the official records have a lofty tone:

"In the fourth year (of the Ming dynasty, 1371) their king (i.e. the Siamese king of Ayutthaya) sent envoys to present a letter of homage ... they came to submit tributes of tame elephants, (a) six-legged tortoise, and other home products. [The Emperor] decreed to present their king with brocade and fine silk and to give the envoys silk varying (as to their rank)."

The chronicles also record that in the fifth year a black bear, white monkeys and other local products were sent as tribute. In reality, though, relations were not quite so unequal, nor the Siamese quite such country bumpkins, as the Chinese chose to portray them.

The official Ming history itself corrects this distorted view, listing no fewer than 44 items as being 'among their tributary goods'. This is nearly twice as many items as the next largest tributary, Malacca, was able to send (26), three times as many as Johore (15) and Calicut (14); and, as for poor Cambodia, nothing special was mentioned at all. Ayutthaya, far from being a poor purveyor of six-legged tortoises and white monkeys, was actually re-exporting to China 22 items which had been brought from abroad into Thailand, as well as 14 varieties of cloth from India and the West. This, only a few years after Ayutthaya is said to have been founded, is vivid testimony to its success as an entrepôt port between China and the Muslim world. The fact that the history also listed Ayutthaya as 'the most familiar' of all countries foreign to China suggests a longer association between the two of them.

After this bright beginning, however, the Ming chronicles descend into a series of desultory references to missions from Ayutthaya bringing 'tribute', and so it is impossible to gauge the extent or nature of the trade between the two countries. The only point which is clear is that the Chinese court, as much as the Siamese, would not tolerate interlopers; when caught, their goods were seized and they themselves were liable to be executed in public. Ayutthaya, as China's principal trading partner, no doubt made much of her wealth from trade with China, but the details are not to be found in the state documents of either country. Only occasional missions between the rulers

were recorded. For instance, in 1553, envoys from King Maha Chakraphat were sent to present a white elephant. Unfortunately, it died on the way, but its tusks adorned with pearls and its tail for proof of its whiteness, were presented anyway. A strange dish to set before a king! The last entry is in 1643, only one year before the Ming dynasty itself collapsed and trade between China and the outside world once more declined.

However, Ayutthaya had long since found herself other trading partners in the East. Records have recently come to light[15] which show that she was in touch with Korea and Japan at the end of the fourteenth century when at least two trading missions were sent out by the Siamese, in 1391 and 1393. One, led by a certain 'Nai Gong' with eight companions, claimed to have stayed a year in Japan, before going on to the Korean Court. Two years later, an official Siamese trade mission to Korea was forced to put in at Japan to seek refuge from Japanese pirates. In 1419, and probably much earlier, the tiny island kingdom of Ryukyu, near Japan, was sending ships to Ayutthaya. But its king found that the Siamese could be as haughty as their overlords, the Chinese. In 1425 we find him complaining to King Boromaracha of Ayuddhaya:

"After our envoys returned to our country they were told by local (i.e. Siamese) officials that their gifts were insufficient. In view of this we have increased our gifts. Despite the fact that we proceed to your country taking presents, we are made increasingly subject to official supervision by your local officials. We are now forwarding a despatch to your country. We hope that you will offer sympathy to the men from afar who have to undergo the hardships of the voyage".

It is interesting that Ayutthaya felt confident enough to treat foreign traders as clients and supplicants, rather than as equals. It also shows that even in the early fifteenth century, the Siamese government strictly controlled overseas trade. Eventually, of course, trade was established on a regular basis, and from one to three ships a year were sent from Ryukyu to Ayutthaya. The exchange continued for 150 years and possibly as many as 168 ships were sent, but there is no record of exactly how many Siamese ships arrived in Ryukyu.

Another early trading partner of Siam was Japan. As we have seen, merchants from Ayutthaya were in Japan as early as the fourteenth century. Unfortunately we only have Japanese records for a short period of 30 years (1604-1635), but they are the most accurate records that we have of any country's trade with Ayutthaya. For this brief period, the Japanese government was able to compel all ships trading overseas to obtain a license for each voyage (from the Tokugawa Shogunate). Out of 355 ships which sailed to South East Asia in these years, by far the most popular destination was Ayutthaya, with 55 Japanese ships. Next came Luzon with 54, Tonkin with 37 and Taiwan with 36; but all these places are less than half as far away as Ayutthaya. In 1635, the Tokugawa government in Japan prohibited all Japanese from trading overseas, allowing only Chinese and Dutch East

India Company ships to bring goods to Japan, and then only through one port, Nagasaki. This must have been inconvenient for the merchants and no doubt limited trade; but it does mean that the Japanese records are more reliable.

From 1635 until 1723, when the records end, between one and nine 'Chinese' ships from Ayutthaya went to Nagasaki every year. The Dutch East India Company was also counting, being rivals for the trade between Ayutthaya and Japan. They thought that at least 45 Chinese junks went in the years from 1653 to 1661, while they themselves were only sending one or two ships a year. Then the Thai kings entered the race, using Thai-Chinese sailors. In the 30 years from 1664 to 1694 the Thais sent 77 junks, 54 of which belonged to the king, and thus the trade continued throughout the eighteenth and into the nineteenth century. There is a Japanese map of the port of Nagasaki in 1846 which shows a Siamese junk in the harbour.

If Ayutthaya was the favourite trading port for the Chinese, Japanese and Koreans, what made it so? The main reason must have been commercial: the variety, value and availability of products both from Thailand itself and from other countries such as India, which sent their goods to Ayutthaya to be sold. The only accurate records we have are those of the Dutch East India Company, which kept a large trading office in Ayutthaya during the seventeenth and eighteenth centuries.[16] These records show the astonishing variety and quantity of goods culled from the fields and forests around Ayutthaya. Yet these Dutch figures represent only a tiny part of Siamese exports. Much more was exported by the Chinese and the Indians who had been here for centuries and were adept in the tortuous ways of the East. They could outbid and undercut the Europeans at every turn. But, above them all there was the over-arching presence of the king. Armed with a monopoly warrant, his factors bought and sold at prices fixed by themselves; when they had done, other traders might scramble for what was left.

One of the most generally-desired Siamese products was ivory, which was a royal monopoly. Even so, the Dutch sold 53,000 pounds of ivory to Japan over a period of 60 years, and 26,000 pounds to Formosa within 30 years. Rhinoceros horn was another valued commodity, though a scarce one; the Dutch sent 320 rhino horns to Formosa in the same period. The Chinese used powdered rhinoceros horn in certain medicines (presumably aphrodisiacs) and probably bought far more than Formosa, but we have no figures for the China trade. (Rhinoceroses were to be found in the forests of central Thailand and could still be seen 150 years ago. There are a number of rhinoceros' horns on display in Vimarn Maek Palace, gifts to King Chulalongkorn, so presumably they were still being hunted as a 'sport' in the late nineteenth century.) Buffalo horns were also exported, and again were used by the Chinese in medicines.

However, perhaps the most successful of all animal products was hides: cow, buffalo and deer, particularly deer. The Japanese used deer hides for the straps on their armour and to make a kind of two-toed sock, called a *tabi*.

Deer were then very common in Siam and the slaughter was prodigous. Between 1633 and 1663 the Dutch sent to Japan nearly two million deer hides, and over the next 30 years, nearly a million and a half. It is only fair to add that as the Dutch then held the monopoly on deer skins, these horrific figures may represent something near to the total annual exports. For other animal products, such as elephant tusks, their share of the trade was small, and one is left to guess what the full annual death-rate may have been.

There were only two other common products of the animal kingdom and neither seem so morally repellent to us today; one was bird's nests, a Chinese delicacy, which was collected from along the southern coasts and probably did not pass through Ayutthaya at all; the other was bird plumes, especially peacock's feathers, which were used for fans. Peacocks are still to be found in the Thai forests in certain isolated areas.

The forests of Siam also provided a wide variety of exports. First, there were the trees themselves: ironwood which, as the name suggests, is a very hard and heavy wood, excellent for construction; teak; and a wood the Chinese called *sha-lo* which they used in boat-building. Soon the Chinese found that the Siamese were excellent boat-builders and sent orders to have some of their junks made here. It is impossible to say how many junks were built for the Chinese in Siamese boatyards, but of the 16 wrecks of junks which have been found along the Siamese coast and excavated, three were made of a wood which is unknown in China.[17]

Then there were the nostrums, dyes and perfumes which could be extracted from certain trees, often deep in the forest: hard to find and dangerous to reach. Such was the strangely-named 'eaglewood', an aromatic substance which was only to be found in small quantities in the rotten parts of a certain tree. It could be used as incense, as was the more common benzoin, or turned into perfume or added to certain medicines. It lay so deep in the jungle that people would form themselves into groups to brave the terrors of the forest and go in search of it – it must have resembled a truffle hunt. Despite these obstacles, the Dutch were able to acquire and export 24 tons of this rarity in a period of 30 years, and it is unlikely that they were the only or even the leading exporters of such a valuable commodity.

Another exotic product of the forest, which was exported from Ayutthaya by the ton was *gumlac*. It was used as sealing wax and was excreted by a particular type of ant found only on one kind of tree in the forests around Pitsanuloke and in parts of Laos. Not surprisingly the Dutch found it extremely hard to procure, especially as it was, like eaglewood, a royal monopoly and had to be purchased covertly. Even so, they were able to export about 185 tons of it in 30 years.

There were other curious products of the countryside: one was *gittagum*, which came from near the Cambodian border and was used both as a dye and as a cure for toothache; *black lac*, as its name suggests, was a source for lacquer and so was popular with Japanese and Chinese cabinet-makers.

Then there was *benzoin*, a resin collected from certain trees in northern Thailand and Laos, and used to make a type of incense. Sapanwood gave a red or violet dye and was popular in Japan for dyeing kimonos; saffron was grown both as a dye and as a medicine, and indigo for the beautiful violet-blue dye it produced. (As its name suggests, it was by origin an Indian plant, but it was sometimes grown in Thailand.) Benzoin and gittagum, eaglewood and indigo, peacocks' plumes and ivory…their names glitter and beckon today, just as their qualities drew the merchants of old, from India and Araby, from Korea, Japan and the Empire of the Great Khan.

However, there was a more prosaic article of export: base metal. Lead and tin were mined extensively, particularly in the south, and this may have been one reason why the kings of Ayutthaya were so keen to exercise political control over the peninsula. Both tin and lead were royal monopolies, which indicates that they were valuable export commodities, though exactly how valuable we shall never know. Tin and lead ingots have been found in the holds of junks sunk off the Pattaya shore. They were on their way to China, but such drab articles never appear in the official lists of tribute, and it may be that they slipped through as 'ballast'.[18] Once again, however, the records of the Dutch East India Office afford us a glimpse of one corner of the trade. For a brief 15 years (1672-1687) the Dutch were given a monopoly to export tin from Ligor (Nakorn Sri Thammarat); or. rather, they were given the monopoly right to export all the tin that was left after the king's factors had purchased what they needed. During this period and for a few years either side, they exported 18,270 'behar' of tin from Ligor, over 3,000 tons or, on average, nearly 200 tons a year. And this was only the left-overs from one of many ports on the Malay peninsula which were selling tin.

Exotic or mundane, commonplace or rare, these were the main raw materials which Siam was able to offer from her own, rich land. In addition, merchants at Ayutthaya would display in their warehouses or on board their ships all the artefacts of the East: silks and brocades from China, porcelain, carved ivory, quick-silver, bronze and copper vessels and the rarest of teas. From Japan came lacquered chests and cabinets, screens, fans and umbrellas, as well as quantities of silver bullion. Muslim traders from India brought opium, minerals, dyestuffs and cloth. India was pre-eminent in cloth, and it sold readily all over the Far East. The producers were sophisticated and varied their styles to suit the country they were exporting to, taking great care to secure correct designs. These were drawn in Siam and sent to the block makers in India (Gujarat was the principal centre), where they were modified so as to produce a good overall pattern on the fabric. These modifications were then returned to Ayutthaya for approval by the traders there, and the final design was then returned to India a second time and messengers were sent to the block-makers to allow them to proceed. When we recall that each of these four journeys could take three or four months, we may well feel the Indian merchants deserved their success.[19]

At the beginning of the sixteenth century, the Portuguese traveller Pires reported seeing Indian cloth 'in the fashion of Siam'.[20] So exactly suited was this cloth to the taste of the Siamese that it would hardly sell elsewhere, but every country was avid for Indian cloth in some colour or design. (The Spice Islanders were said to refuse to sell their spices for anything except Indian cloth, rejecting even silver bullion). Many different kinds were on sale along the wharves of Ayutthaya, and it was this variety of goods and the certainty that they would be there on sale every year which brought merchants from the farthest reaches of the known world and turned Ayutthaya into the greatest emporium of the East.

There were several reasons for its popularity. The Chinese government, when it was strong enough to form a commercial policy at all, preferred to deal with one main overseas trading centre. The Muslim merchants favoured a country where they could settle and practise their religion freely. Similarly, all sea captains, whatever their creed or colour, needed a safe harbour, good shipwrights and ships-chandlers for provisions and repairs, as well as favourable winds and a swift, safe voyage. Ayutthaya could supply all these needs. The royal government, when it was not weakened by internal feuds, kept a light but firm hand upon the processes of commerce and the peace of the interior. Goods from the interior, even from as far away as Laos and Chiang Mai, were brought by boat down the rivers which fed into the Chao Phraya. The Siamese seem to have been tolerant hosts. The 'Moors' brought their camels and their hunting dogs (which the Siamese hated), and they did 'exceedingly divert themselves in the flight of falcons'. As for the French soldiers, it was necessary to give them 'some *pagnes* to wash in, to remove the Complaints which these People made, at seeing them go all naked into the River'.[21] All visitors seem to have had a good time there, so long as they did not try to meddle in politics or question established monopolies in trade.

Another important factor, which has been mentioned before, was Ayutthaya's accessibility. It was easy for Muslim and Chinese merchantmen to get their goods to Ayutthaya and return the same year, and the Indians and the Arabs would make for Mergui or one of the other excellent ports along the Andaman shore.[22] There they would consign their goods to porters who would convey them by boat or by cart over the Tenasserim hills to the plains of the Chao Phraya, and thence to Ayutthaya itself. There was therefore no need for them to risk the treacherous Java Straits.

However, the journey home was not always straightforward, and could be both tedious and dangerous. There is approximately two months between monsoons, and in that time the trade winds could vary some weeks from the norm. Progress could then be slow. Here is Kaempfer trying to clear the Gulf of Siam:

"(The wind was south), contrary to our course, so that with tacking about, lying still, weighing and casting anchor, the weather being variable and sometimes very rough, we lost many days, advancing but little all the while".

It took them twelve days to get out of the Gulf. However, impediments such as this do not seem to have deterred the many different kinds of adventurers who journeyed to Ayutthaya. Some trades, such as precious goods between India and China, mixed in with local products picked up along the way, had been going on for hundreds if not thousands of years. The exchange point was Ayutthaya the Venice of the East. So to the Chao Phraya came Chinese merchants in their junks, Indian traders, Muslims in coastal vessels, having borne their goods safely overland from Mergui, and the occasional and troublesome Europeans.

It is time now for us to join them as they make their way up the Chao Phraya and first catch sight of those shimmering golden spires rising so unexpectedly from the dusty rice fields.

1. Dr. Pensak C. Howitz, 'Was the "Sattahip" a Siamese cargo ship?', *Bangkok Post*.

2. Quoted in *The Origin and Evolution of Thailand Boats*, Siam Society Library.

3. Ehsan Yar-Shater writing the general editor's preface to *The Ship of Sulaiman*, Routledge and Kegan Paul, 1972.

4. D. F. Lach (Editor), *Asia on the Eve of European Expansion*, 1965, p. 115.

5. Michael Wright, 'Ayudhaya and its Place in Pre-Modern Southeast Asia', *The Siam Society Journal*, Vol. 80, Part I, 1992. A scholarly and convincing explanation of how Ayutthya became the focal point of trade between East and West.

6. G.V. Smith, *The Dutch in Seventeenth Century Thailand*, Centre for South East Asian Studies, Northern Illinois University, 1977, p. 7.

7. O. W. Wolters, 'Chen-Li-Fu, a state on the Gulf of Siam at the beginning of the 13th century', *The Siam Society Journal*, Vol. 48, no. 2.

8. Wolters, *op. cit*, pp. 1-2.

9. Wolters, *op. cit*, p. 26 footnote 26.

10. G. H. Luce, 'The Early Syam in Burma's History', pp. 139-140, *Siam Society Journal*, Vol. 46, part 2.

11. E. Kaempfer, *A Description of the Kingdom of Siam,* (1690) Bangkok. White Lotus Press, 1987.

12. *The Ship of Sulaiman*, p. 89. (see note 3, above).

13. Michael Vickery, *The Siam Society Journal*, Vol. 67, part 2, p. 145.

14. T. Grimm, 'Thailand in the Light of Official Chinese Historiography – A Chapter in the History of the Ming Dyansty', reprinted in *The Siam Society Journal*, Vol. 49 (1961).

15. From a talk given by Professor Ishii at the Siam Society on 1st March 1988 and reprinted in the *Siam Society Newsletter*, Vol. 4, no. 2.

16. G. V. Smith, *op. cit*.

17. Dr. Pensak C. Howitz, *op. cit*.

18. Michael Wright, 'Where was Sri Vijaya?', *Siam Society Newsletter*, Vol. 1, no. 1.

19. Michèle Archambault, 'Blockprinted fabrics of Gujarat for export to Siam', *The Siam Society Journal*, Vol. 77, part 2.

20. *The Oriental of Tome Pires*. 2 vols., The Hakluyt Society, London, 1944.

21. La Loubère, *A New Historical Relation of the Kingdom of Siam*, London, 1673, pp. 38-39 and 26. Facsimile edition. Singapore, Oxford University Press, 1986.

22. See *From Japan to Arabia – Ayutthaya's Maritime Relations with Asia*, pages 2-4 for a detailed account of prevailing winds and sailing patterns in Southeast Asian waters. Edited by Kennon Breazeale, Foundation for the Promotion of Social Sciences and Humanities Textbooks Projects, Bangkok 1999.

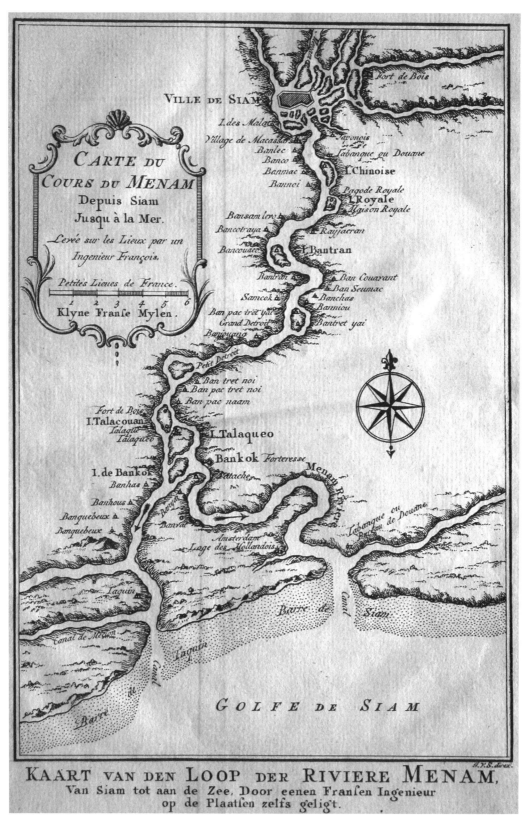

A decorative drawing of the Chao Phraya river from Ayutthaya to its mouth by Jacques Nicolas Bellin, 1762, and copied from a survey by a French engineer 100 years before. (Courtesy of the Dawn Rooney Collection)

The River Road to Ayutthaya

'The Kingdom of Siam is the most powerful, and its Court the most magnificent among all the black Nations of Asia.'[1] 'A strong great city, seated upon an island round which flowed a river three times the size of the Seine. There rode ships from France, England, Holland, China and Japan, while innumerable boats and gilded barges rowed by 60 men plied to and fro.'[2]

Visitors to Ayutthaya – whether seventeenth century Europeans like Kaempfer and the Abbé de Choisy, whose expectations were heightened by a voyage which sometimes lasted six months, or more prosaic Eastern merchants whose thoughts were fixed on profit – all were struck by the sight of the city which rose so dramatically before them from the surrounding fields. However, only very seasoned travellers were likely to have had a straightforward voyage.

The first problem was actually to find the river mouth. The captain of the ship on which Camoens, the Portuguese poet, sailed, entered the Maeklong river in mistake for the Chao Phraya, some 50 miles away. To make matters much worse, the ship then ran aground and the poet, clutching his manuscript of the Lusiad, only got ashore by hanging on to a piece of driftwood.[3] Asian navigators tended to sail along the coast, checking off the features on their coastal charts as they sailed by, but to the first-time voyager, the coastline of the northern reaches of the Gulf of Siam is featureless and flat. Such features as there are tended not to be marked on westerners' maps. Kaempfer noted 'many dangerous Shoals, Rocks and Islands ... which I was the more surprised to see as there is not the least hint of any such things on our maps.' For Thais, who often sailed along their own coast in the northern reaches of the Gulf, it was not so difficult to spot the local features. Kaempfer had as a fellow-passenger one 'Monproncena, the late King's Factor' and he pointed out Sam Roi Yod, Pranburi, Petburi, Maeklong and Ta Cheen as they coasted by. European sailors, however, relied more upon their rudimentary maps which were often wrong. 'It is an astonishing thing that there are modern Charts which put the longitude of Ayutthaya at 145 degrees, whereas the great Chart of the Observatory (at Paris) gives it at 122 degrees'. So said the Jesuit astronomers when they came to Lopburi in the seventeenth century to fix the longitude[4], for such uncertainties could be fatal.

Another cause of confusion was that the Chao Phraya then had three mouths; or rather, it was connected with the Ta Cheen river to the west, and

the Ban Hia river to the east by canals. These were adequate for small, coastal craft, but a larger, full-rigged merchantman would have to proceed cautiously indeed if it found itself entering a rural *klong* having chosen the wrong mouth of the river.

Having found the main river mouth, one next had to negotiate the notorious 'bar'. This lay across the mouth of the river at a depth of approximately 14 feet, and was no great hazard to sailing junks which drew very little water and, being flat-bottomed, tended to stay upright if run aground. However, western sailing vessels, with their deeper hulls, often had extreme difficulty crossing the Bar. There was a sort of channel marked with stakes, but it was better to off-load the cargo beyond the bar, leave a skeleton crew on board and hire a junk to transport the ship's goods up to Ayutthaya. It was a long and lonely wait for the sailors, anchored for days in the rough waters off the Bar, and thinking of those luckier members of the crew ashore, enjoying all the pleasures that Ayutthaya was said to offer visitors. It was small wonder that, on at least one recorded occasion, the sailors took to drink. When Kaempfer returned to his vessel after one such trip, he found the sailors had bought some of the local 'arrack'; they were as a result in a quarrelsome mood, and many had to be clapped in irons.

One can hardly blame them. When a storm blew up, all the local craft fled for a safe anchorage, leaving the lone foreign merchantman to ride out the tempest. An English sailor described it well.

"On further acquaintance, this same Bar turns out to be a really interesting character. What old sea-secrets he has to tell on a breezy afternoon when the gulls scream round, the fishing craft are plunging out to their stakes, or skating under sail across the mud flats; of the fleets of square-rigged ships beating out in the old days, twenty at a time, of the huge, many-masted junks warping out with their great wooden anchors and long grass ropes … until, of a sudden, a threatening squall begins to flash and growl in the north-west, coming up across the wind and cutting short our cogitations. The long, lug-rigged boats are running for home, and in a few minutes not a sail of the sixty that were bobbing in sight is left, and the lonely old Bar is in his passion, shrieking and howling at his maddest".[5]

It is hardly surprising, then, that some captains attempted to drive their ships by main force through the sludge. Here is Crawfurd trying to force a passage:

"March 25th. At 7 o'clock this morning we weighed anchor, and attempted to cross the Bar; but when about half-way over, the ship struck in the soft mud in which, as the tide fell, she sunk four feet. We had at the same time, not above four feet of water".

And there the ship, somewhat ignominiously, sat all day, the sailors sleeping in the shade on deck and the sails flapping gently in the breeze. Local sailors must have smiled as they scudded past, sliding easily over the mud flats. Eventually, as the sun was setting in the west, the evening tide lifted them clear, the ship floated and they crossed the Bar without sustaining any injury:

"A strong and favourable breeze soon carried us to the mouth of the Menam, … ploughing all the way through thin ooze; and at 7 o'clock at night we anchored off the village of Paknam about two and a half miles from the mouth of the river."

It had taken them 12 hours to cover some 10 or 12 miles, and it was a perilous manoeuvre; the ship could easily have keeled over in the mud, or broken her back. The captain realized this, and on the return journey he insisted on dismantling the masts and rigging, off-loading the cargo into boats and manhandling the ship over the mudflats. Even though the ship's draught had been reduced by three feet, she still sank at least five feet into the mud on every ebb tide, and had to be hauled laboriously out of her trench as the waters rose. It took the sailors a week to drag their ship across the 10 miles of mud flats, and then another week to reload the cargo and re-rig the masts and sails. They must have been thankful to get under way again for Koh Sri Chang.[6] Ordinary passengers understandably found it hard to amuse themselves during these tedious manoeuvrings. The ship might be canted over at such an angle that they 'could neither stand nor walk upon the deck but had to seek refuge on the outside of the outer bulwarks'.[7] Whilst the tide was out, however, they could clamber down from their perch and wander about the Bar, drinking the water which was fresh even a mile beyond the mouth of the Chao Phraya.

Once over the Bar, the first buildings to come into sight would probably have been the two guard houses, one on each bank. However, their purpose was not to stop ships, the river being far too wide at this point for cannon shot to be effective. (Even at the end of the nineteenth century, the forts at Samut Prakarn were unable to stop two small French gunboats from passing up the river, at a point where it is only half as wide. Moreover, guns then were twice as powerful and accurate as they would have been in the times of Ayutthaya). They were stationed there merely to keep a watch out for approaching ships and warn the authorities at Samut Prakarn, probably by firing a cannon.

At Samut Prakarn there lived an official who was responsible for the security of the lower reaches of the Chao Phraya, and so held in his hands, as it were, the keys of the kingdom. For such an important post only a noble of the highest rank was appropriate: someone of the rank of 'Chao Phraya'. His official residence was up a small river on the east bank, near the mouth; probably at Samut Prakarn, where the '*changwat*' harbour master has his office to this day. The area thus became known as 'Ban Chao Phraya'.

The river itself has long been known as the Menam ('river') Chao Phraya. King Mongkut, however, who was an authority on Siamese history, noted that since his time, and before, foreign visitors tended to call it, and go home and write about it as, simply the 'Menam'; the name 'Chao Phraya' was dropping out of usage. King Mongkut was particular about names, and wrote to the missionary press:

"It is wrong for the Americans and some other nations to call the Bangkok river simply 'Menam', for it has a specific name. It is the custom of the Siamese to call the stream nearest to them the Menam and add the names of one of the principal towns or villages on its bank to it, such as the Menam Bangkok, Menam Krung, Menam Ta Chin etc. The true name of the Bangkok river is the Chao Phraya but it has become obsolete".[8]

Although King Mongkut could not say how the name came about, a close look at an old map suggests an explanation. Rivers in Thailand, as elsewhere, have different names for different reaches; thus the mouth of the Ta Chin river is obviously named after the Chinese commerce which grew up there ('Ta Chin' can be translated as 'the harbour of the Chinese'). Further upstream, however, it becomes the Menam Noi, and near Suphanburi it is called the Suphanburi river. Similarly, the river to the west is called the Maeklong near its mouth – the name for the river being taken from the name for the area – but further upstream it turns into the Menam Kwae. So it seems reasonable to suppose that the Menam Yai, as it was called up around Ang Thong where it ran parallel with the Menam Noi, took the name Menam Chao Phraya for its southern reaches from the 'Ban Chao Phraya' which lay near its mouth, and which must have been well known to all sailors. Eventually, the name 'Chao Phraya' was applied to the whole river, as King Mongkut said, but by then the origin of the name had been forgotten.

All foreign ships which entered or left the river were supposed to anchor off Ban Chao Phraya and ask permission to proceed. They might also be required to leave their guns at this point. If they had on board a foreign delegation to the Court of Ayutthaya, word would be sent to the capital and a squadron of royal barges would row down the river to meet the emissary and accompany him with proper style up the Chao Phraya to Ayutthaya. Meanwhile, the ambassador and his staff would be entertained as lavishly as means permitted at Ban Chao Phraya, which was probably the main function of the Chao Phraya official. He would be a man of substance and dignity well-suited to his task: a diplomat, not a soldier, with neither the means nor the arms to stop aggressive foreign ships from sailing on up the river. Indeed, the history of the river Chao Phraya is littered with naval engagements and other disruptions which the Siamese would dearly have liked to snuff out at the mouth of the river if they had been able to do so.

Having paid a courtesy call at Ban Chao Phraya, foreign ships would begin the long haul upstream. The scenery at this point was featureless and drab. The ground was regularly inundated by the sea, and little could grow there except very coarse grass and nipa palms, which attract mosquitoes; there was probably little to be seen except occasional fishermen's huts. However, from 1634 onwards, visitors would have seen the squat outline of a Dutch storehouse standing alone on the west bank, a little above Samut Prakarn. It was a substantial brick building, and the envy of other trading nations. 'Amsterdam', as it was called, was used by the Dutch East India

Company to store sapanwood and other heavy goods which would not deteriorate if kept for some time in a damp climate. It was easier to load them on board ship here than at Ayutthaya, where the water was shallow. One can still see the solid brick foundations, half under the water and half ashore, amongst the houses of the small village of Ban Plakot.[9] Kaempfer stayed there and described his experiences, including a tug-of-war with a tiger:

"Before evening we reached the Dutch Habitation and Storehouse called Amsterdam, which is but two Leagues distant from the Sea. It is built according to the fashion of the Countrey on piles of Bambous. Stores of Deer and Buffle skins were kept in lofts, but the red wood for dying, call'd Faang, lies in an open place, till ships come to take it in, which happens every year. This wood, rubbed with some lime and water, yields the finest violet colour one could wish to see. The Governor of this place was a Corporal, a Swede by birth, and Core by name. I found him under some grief, for having lost a tame Suri Cat which he found again today, but in the belly of a snake he had killed...".

It must have been a lonely spot, and it is likely that Core was glad to have the company of the jovial Dutchmen. There were few Siamese villagers nearby and the Swede must have depended on his wild cat for company. The scenery outside the factory was featureless and bleak, Kaempfer declaring that 'there is nothing but Forests, Desarts and Morasses'.

Looking ahead from this point, our travellers would begin to see vast fields which stretched away to the horizon, sometimes with what appeared to be herds of buffalo grazing in them. However, they probably belonged to many different families in nearby villages; each farmer normally turned the family buffalo loose at about eleven, after a morning's work, to graze for the rest of the day. What the westerners saw were these privately-owned buffaloes, all grazing together, rather than one herd. The pastures south of Bangkok were well-known for their buffaloes. There are still a number of villages called 'Ban Krabeu' to the south of the Thonburi – Pak Tho road. Krabeu is an old Thai word for 'buffalo'.

Passing this scene, the ship would begin to bear off towards the east. The travellers were entering the first of the great bends or ox-bows which made progress up the Chao Phraya to Ayutthaya so frustrating and tedious. This particular bend was one of the worst; sailors would need to tack first east, then north, then west, then south, ending up after 17 kilometres only 700 metres from where they had started. A cut across the neck of the ox-bow was made in the late seventeenth century. (Valentyn's map of 1726 refers to it as 'en't Nieuw gemaekte Gat'; or 'newly-made cut'), but even though it was made at a right-angle and nearly three kilometres long, it still did not prevent salt water surging up with the tides. This entered the network of irrigation canals which took river water to the fruit orchards lying off the Chao Phraya, and the salt damaged the fruit trees. As a consequence, the owners complained and the cut had to be sealed off with water gates. It was still in use in the mid-nineteenth century, however. Royal 'barges' were sent to meet important foreign missions arriving by steamer and accompany

them to Bangkok. It was a tough journey, but when the Thai rowers got to the southern mouth of the 'cut' they nipped through it, rowed at high speed, and shot out into the main stream again with a great shout of glee, just ahead of the little *farang* steamer, chuffing round the main bend.

To the right, at this point, lay the town of Phra Pradaeng, a town with a chequered history but which, a hundred years ago, was one of the main defences of the river. It was well-situated to bombard enemy ships, for the river narrows at this point and ships had to veer away to the east, quickly changing course by 90 degrees: a difficult manoeuvre in a shallow, tidal river, and one which made it almost impossible for enemy ships to bring their own guns to bear on the Siamese forts.

Soon after entering this huge ox-bow, the sailors would see on the east bank the entrance to Klong Sam Rong, busy with small craft. This is the *klong* which used to lead out to the sea via the old Bang Hia river, and constituted the easternmost mouth of the Chao Phraya. It can never have been much used, except perhaps by small coastal craft wanting to slip down to Cholburi, and now the Bang Hia river itself has almost disappeared under the silt.

Apart from this, there was little of interest to look at during the long haul round the northern bend of the 'loop', though riverside houses and, more eye-catching to foreigners, Buddhist temples, were beginning to appear.

"We had gone no more than a league when we came across some pagodas, or temples housing idols. These are always accompanied by a small monastery with monks who are the priests of this country".[10]

Today, if you look to your right, you see the busy port of Klong Toey, but it is an ancient settlement. There is a *wat* there which was built in the days when Ayutthaya was the capital, and it was a prosperous area when Crawfurd anchored there 160 years ago. He described the many villages which then lined both banks of the river, and there was also 'a belt of orchards and gardens; the lower ground behind these again presented a wide extent of rice-lands'.

Finally, though, the river straightens out at the modern Rama IX bridge. It was at this point that the view began to change. For travellers in the days of Ayutthaya, the scenery from here on up to Bangkok, and beyond, became more truly tropical; this area was known as the 'Garden of Siam', and supplied Bangkok and Thonburi with fruit.

"This community is ... extremely fertile and beautiful. A wondrous river of fresh water flows through the town and continues down to the sea. On both sides of the river for several miles are orchards which are not partitioned by walls or fences ... every fruit native to Siam was available to us".[11]

There were coconut trees, sugar palms, and orchards with exotic fruits. Brightly coloured birds flashed their plumage amongst the leaves, and monkeys either swung from branch to branch or sat solemnly staring at the passing ship, nursing a baby in their arms. All too often they were rewarded for their trust with a stinging blast from a musket, and toppled out of the trees. The marksmen were interested to note that the mothers were able to

hold on to their young until their bodies hit the ground.

This verdant, tranquil scene must have been refreshing for mariners from China or Japan who had seen nothing but waves for weeks. For westerners, though, it was much more than this; it was their first view of the exotic East, and it left them entranced. One who found his dreams brought to life was the Abbé de Choisy. He had arrived in October, when the floods extended over the land:

"Both sides of the river are bordered by areca palms and coconut trees, which are green trees full of fruit, monkeys and birds.... From time to time, one glimpses vistas of green rice in flooded fields; or villages, with wooden houses on stilts. One can see all the animals on the first floor, where they will remain until December when the waters begin to retreat. We passed through villages which were half a mile long. From time to time, there appeared large canals, lined with trees containing monkeys and parrots. At all times the river is at least a quarter of a league wide, sometimes more, and there are wide expanses of rice fields".

Others were enchanted by the wild life which was then so abundant. Here is the exact, prosaic Kaempfer:

"Three sorts of animals afford much diversion to travellers sailing on this river. First are to be seen incredible numbers of monkeys of a blackish colour, some of which are very large and some less, of the common sort, and a grey colour which walk about tame, as it were for pleasure's sake, along the shore or climb up the trees. But towards evening perch themselves upon the highest trees on the shore in great numbers, like crows. The she-ones hold their young so fast on their breasts that they would not let them go even when they were shot down. They are fond of this part of the country on account of finding their food there on large 'milk-trees', called *tjaak*, growing there in plenty, with light-green leaves of an oval shape, their fruit not unlike our apples as to their bigness and form, except that they seem compressed and are of a very harsh taste. The glow-worms represent another show, which settle on some tree like a fiery cloud: with this surprising circumstance, that a whole swarm of these insects, having taken possession of one tree and spread themselves over its branches, sometimes hide their light all at once and, a moment after, make it appear again with the utmost regularity and exactness, as if they were in a perpetual Systole and Diastole. What is remarkable in the third place are the common gnats, or flies, which in the daytime appear but sparingly upon the water, but at night in such swarms like bees that it is difficult to guard against them... This vermin renders the journey by water, which would otherwise be pleasant enough, very troublesome and disagreeable."

These 'common gnats or flies' were more likely to have been the notorious mosquitoes of the Chao Phraya, which were commented on by almost every traveller:

"We travelled all night and arrived at Bangkok at three in the morning. We were devoured by mosquitoes or *maringoins* – this is indeed their domain".[12]

They were attracted by the forests of *tjaak* or nipa palm which grow in salt water and used to crowd down to the river banks along its lower reaches. Western navigators were so tormented by them that they included them in place names on their maps; the 'cut' at Pakkred and the much longer 'cut' at Pathum Thani appear on Valentyn's map as 't Kleyne Miskite gat' and 't Groot Miskite gat'. Crawfurd's ship was invaded by them:

"When it fell calm yesterday evening they came on board in such swarms that we were compelled to betake ourselves to the protection of boots, gloves, fans and, finally, our mosquito curtains. They appeared to be not only more numerous, but more venomous than the oldest of us had experienced in any other part of 'India'".

So there they all sat, gentlemen and sailors together, all swaddled up in their mosquito nets, until the attack abated at about 8 o'clock. Even in the mid-nineteenth century Prince Sai noted that his oarsman had to employ someone to keep the mosquitoes off his back, as he rowed the Prince about the river; the French explorer, Mouhot, said they were so numerous that one could catch them by the handful and their humming resembled that of a hive of bees.

However, if one could take one's mind off the swarms of mosquitoes, there was a great deal to see, particularly the orchards which began to appear regularly after rounding the great bend in the river above Phra Pradaeng. Choisy noticed the coconut palms and sugar palms which predominated, but there were a great many other varieties of fruit: *sala* palms which thrive in salty water and were to be seen near Bang Klo near the mouth of the river; pineapples at Bang Tamru and Bang Plat; guavas at Bang Sao Thong, and *lamyai* at Paklad. The best betel nut was grown near Rajaburana. It was known as *mak fad* because it had a peculiar sour, (*fad*) lingering taste in the mouth, which was apparently much appreciated in those days when everyone from the royal family downwards chewed betel. Near Rajaburana, a fruit called *lamut* was also grown. In English it is known as 'chicle' and its sap is used to flavour chewing gum, hence the brand name 'Chiclets'.

Now we are approaching Dao Khanong, where the soil is particularly fertile. Here there grew lichees and *mafai*, a small, yellow fruit with waxy skin, transparent flesh and a sweet and sour taste resembling a gooseberry. Dao Khanong was most famous for the Bang Mod orange groves which lay a little inland from the Chao Phraya but were fed by its waters. The Bang Mod orange is a small, sweet, green-skinned variety which is perhaps the most renowned in Thailand. However, these orchards have now almost disappeared, eaten up by property developers and transformed into ugly and pretentious rows of houses.

From Dao Khanong, the river continues to Bangkok and Thonburi, the latter a thriving commercial centre hundreds of years ago. When travelling along the canals of Thonburi by boat, it is impossible not to be struck by the mass of temples which crowd their banks, sometimes two or three side by side, the spires of others piercing the foliage inland. There are far more

temples here than were ever built on the eastern bank of the Chao Phraya, and it must have been an area of villages which grew rich from their orchards, their fields and the fish in their canals and river.

Thonburi also grew rich from foreign trade. Merchant vessels from the west could leave the sea at Ta Chin and proceed via what is today Klong Mahachai to the main course of the Chao Phraya at Thonburi, while larger ships, and boats coming from the east would have taken the main, or present, bed of the Chao Phraya. These two branches of the river then joined just below Wat Arun. It was obviously an important trading point. Ships from east and west, from China and Japan, as well as from India, the Middle East and South-east Asia would all have to pass this way. In addition there were the boats coming from upcountry Siam, a month or two's journey away, and the little paddled craft from the villages and orchards of Thonburi, bringing their goods to market or to sell to foreign seamen, just as the people of Damnoen Saduak do today. The little town which grew up here soon became noted for its wealth. Thanyaburi, or Thonburi it was called (*thanya* meaning 'full of wealth'), and the other villages on the western bank also benefited from their proximity to what became an important trading town.

The king had a tollhouse built, and the Dutch paid more to the Thonburi tollkeepers than they did to the tollkeepers in Ayutthaya itself, such was the importance of trade passing through Thonburi. The tollhouse was probably on the southern bank of Klong Bangkok Yai, perhaps near where Wat Galayanamit stands today. This is where it is shown on Valentyn's map and would have been a logical site.

Controlling the tollkeepers and seeing that things ran smoothly in this busy spot was that impressive figure, the Governor of Bangkok: 'un Mahometan de fort bonne mine', or 'fine Muslim', as Choisy called him. The Siamese often employed people of Persian or Indian origin to manage their trade, since it was felt that they had much more experience of foreign trade than the Siamese themselves; and indeed often had to deal with Muslim traders. The Bunnag family rose to pre-eminence at Ayutthaya in this way.

However, Bangkok-Thonburi was much more than just a trading centre. As foreign visitors noted:

"Banckok is a small walled city about seven miles from the sea and amidst fertile fields. The rivers Menam and Taatsyn meet at this point. Around the town there are many houses and rich farms. Banckok is strong by nature and can easily be fortified. In case the little town should be taken, fortified, and kept by a prince, the supply of salt and fruits to the town of Judia would be prevented. Also all navigation on sea and passage of the Moors from Tenasserim would be cut off".

This was the shrewd assessment of van Vliet, writing to his Dutch masters, the directors of the East India Company. The governor of Bangkok probably had some troops under his command; Choisy mentions at one point that a 'Portuguese is coming to command the troops in Bangkok and

will be under the control of the Governor'. There was probably also a fort, where the troops could have been housed, either where one sees the present fortified wall by Wat Arun, or on the opposite bank a little to the south of the Grand Palace. This is where it is shown on La Loubère's map. This information, though, can only have been of passing interest to the Dutch East India company, since like most sensible trading companies, they did not want to get involved in risky and unprofitable military adventures.

Until about 1521, all river traffic proceeding to Ayutthaya had at this point to enter a huge ox-bow about 15 kilometres long. It is difficult to be sure about this date, but certainly about this time it seems that the King of Ayutthaya ordered a cut to be made across the mouth of this enormous loop. Travelling up the Chao Phraya today one must visualise this cut as running from just below the Phra Pinklao bridge to just above the Memorial bridge. Going past the Grand Palace where the water is alive with boats and people, it is difficult to imagine that one is travelling along the line of an ancient *klong*. When the force of the water in the main river, which here is over 200 metres wide, was suddenly funnelled into a channel about six metres across, it is not really surprising that it quickly carved itself a wide new bed running through the old village of Bangkok. The villagers must have had to up sticks quickly and move their houses inland, away from the torrent: not once, perhaps, but several times. Today, people protect their banks with stone walls, but 400 years ago erosion went on unchecked.

The cutting of this canal explains why the name 'Bangkok' – which translates as 'The Village of the Wild Plum' – should have applied to both sides of the river in Thonburi times. The name is too provincial to span a mighty river. However, if there was originally no river there and later the king's canal simply bisected the village, it would be natural for the two banks of the canal to retain the same name, even as they got further apart. The old, abandoned, river bed, which we now call Klong Bangkok Yai and Klong Bangkok Noi, was denied the volume of water which once surged along it, and became sluggish and turbid. Its course altered and silt accumulated on its banks, with temples that had originally been built upon the water's edge now finding themselves stranded inland; the elegant temple *sala* where the monks once waited for a boat now perched foolishly on a mud bank. Buildings such as this remain as markers of where the Chao Phraya once flowed, looping its way round the back of Thonburi; a good example is Wat Sangkrachai which is now far from the edge of Klong Bangkok Yai.

Nevertheless, mariners of old must have been grateful to whichever king it was who had this short-cut made. It cut the village of Bangkok in two and eroded the villagers' land; but it saved nearly a day's sailing time for merchant ships. Today's superhighways, which carve their way regardless through old communities so that traders may thunder over Bangkok in 20 minutes, had their predecessor 500 years ago.

Traditionally it was regarded as one of the duties of a Siamese king to make canals and improve water navigation for his people. The Royal

Chronicles always mention the name of any canal dug on the orders of a king, saying who was in charge of the work, how much the labourers were paid and the length of the canal. Sometimes buffaloes and even the local people were required to trample up and down the bed of the canal to loosen the sediment which had accumulated and allow it to be washed away. The Chronicles also mention that it was the duty of conscripts or *lek* to clean out and deepen the *klongs* every summer.

Working their way through the new cut, travellers would have seen, on the east bank, the ancient and prosperous community of 'Samsen'. The name figures on Kaempfer's map of 1690 as 'Ban Samsen' and about 500 metres up the *klong*, as though to prove the antiquity of the area, one comes to Wat Bot, one of the few *wats* in Bangkok which date from the Ayutthaya period. In fact there are five or six *wats* on Klong Samsen within a couple of kilometres of the Chao Phraya. Perhaps this is the remains of 'Ban Samsen', a prosperous area even in the days of Ayutthaya. It therefore had its own *wat*, which can still be seen: one of the very few Ayutthaya period temples on the Bangkok side of the river.

At one time, there were two other rivers draining the eastern marshlands into the Chao Phraya. We can see them on Crawfurd's map, drawn when he was here in 1822, which was not so long after Bangkok became a royal city. Although rudely sketched by a local hand (unlike the careful charts Crawfurd had made of the Gulf of Siam), it has an air of truth about it. It shows three rivers coming in from the east: the Samsen, the Bang-Lam-Pu and the Sam Pheng. Thirty years later the Bang Lam-Pu and the Sam Pheng rivers had been captured by King Mongkut's canal, which was dug to encircle the city. In the days when Ayutthaya was the capital and the land on the eastern bank of the Chao Phraya had not been tampered with, one can imagine villages clustered along the banks of these two rural streams. However, they are not marked as settled communities on any seventeenth century maps, as Ban Samsen was, and the houses probably did not go very far inland. It seems that the soil on this side of the river was less fertile. The fact that there are so few old temples on this side of the river and so few man-made *klongs* suggests that farmers who wanted to farm inland, or could not get land on the river bank, found it easier to plant their fruit trees and their rice on the western side of the Chao Phraya. The Bangkok chronicles themselves suggest that the land on which Bangkok is built is infertile soil, for they speak of the king crossing the *takkard* of Bangkapi (a *takkard* being a wasteland where it is difficult to grow crops). Even 50 years ago it was impossible to grow well-developed mango trees in Bangkapi. So, the houses were built out over the water, or close to it, with an orchard behind and rice fields beyond that.

This raises the question of whether the people who lived up and down this lower part of the river bank were actually Siamese. Traditionally, Siamese farmers like to live on the banks of small rivers or *klongs*. Like the current itself, the pace of life there is slow. It is easy to bathe from the steps

of your house, to catch a fish for dinner, or to paddle across and talk to friends as the fancy takes you. Such a way of life eschews the grandiose; as the saying goes: '*nok noi tham rang tae phor tua*' – one should live in a small house like birds which build their nests just big enough for themselves. The main course of the river, with its grand temples, its guard houses and forts of brick, was something alien to the Siamese people.

Secondly, the lower part of the river was near the sea and this is something else Siamese farmers traditionally keep away from. The river water is too salty and the land is infertile; only poor-quality rice can be grown there. And as for fish, the staple diet of the Siamese, there are plenty to be found in the rice fields without the trouble and danger of putting to sea in a boat. It is the Chinese who like to live at the river mouth; '*pak mangkorn*', or the 'mouth of the dragon' as they call it. Cities built here will prosper and people buried near the sea will rest in peace. Cholburi and Petburi are essentially Chinese towns; witness the size of the Chinese graveyard at Cholburi. Moreover, the Chinese have always been merchants and traders so perhaps it was they who settled at Thonburi and in the area around and built it up into 'The City full of Wealth'.

Another significant landmark shortly before Nontaburi is the mouth of Klong Bang Kruai, which is the beginning of another huge detour, 21.5 kilometres long, well-named the 'Menam Om'. It goes far out into the countryside, passes Bang Om, then winds its way back towards the river Chao Phraya, which it eventually rejoins near Nontaburi, about a kilometre beyond Wat Chalerm Phrakiat. Boatmen must have blessed the king who had a short-cut dug; known as Klong Lat Muang Non, it is about five kilometres long and is said to have been constructed in 1636.

Pursuing our way north from Nontaburi, the next old town we come to is Pakkred. Here it is easy to see the short-cut canal and the old course of the river, plunging off to the west and encircling Pakkred 'island'. The old river is still noticeably wider at this point than the cut, which is said to have been dug in 1721.

North again, and we come to the last town of any size before Ayutthaya itself, Pathum Thani. This is also built on the bank of a cut, known as the *kret yai* in Thai, as distinct from the *kret noi*, or little cut, at Pakkred. Here, the old course of the river for once goes off to the east. Shorter than the other meanders, it may have been cut off in 1608, and today we can follow it along Klong Chiang Rak. It came into use again at the end of the nineteenth century when King Chulalongkorn ordered a fresh-water canal to be dug northwards, to bring clean water to Bangkok. That canal, Klong Pra Pa, was made to join the Chao Phraya via Klong Chiang Rak, because it was known that salt water never came this far up the river.

So the meandering course of the Chao Phraya was cut short in five places by the kings of Ayutthaya. It is interesting to notice that the five main towns on the Chao Phraya – Phra Pradaeng, Thonburi-Bangkok, Nontaburi, Pakkred and Pathum Thani, are all built on the banks of these short-cut canals. This

can hardly be a coincidence, but what is the explanation? Even after these five cuts had been made, the journey to and from Ayutthaya was still extremely tedious. Some unladen ships could get up as far as Bangkok with the help of the tide, but north of Bangkok, one had to rely on windpower or more probably manpower. Where the banks were uninhabited, the captain might put the crew ashore to haul the ship upstream with long ropes. They could be a great nuisance, trampling through vegetable plots set out along the river banks. Sometimes they would attach their ropes to a jetty or to a tree in someone's garden, and there were so many of them swarming over the land that few locals dared protest. Those who did might be beaten up, if the vessel's captain were rich.[13] More often they had to resort to long poles to quant the ship along. As we have seen, progress was extremely slow, and Kaempfer even details how he would frequently step ashore to buy herbal remedies which interested him, catch up his boat and step aboard again! Tedious this pace may have been, unless one was a compulsive shopper, but at least there was plenty to see.

Leaving Pathum Thani behind us, our travellers would soon have come to 'Lan Tay' where the river widens out. If their boat was under sail at this point, they would have to be careful as winds, gathering force across the open water, can still overturn double-decker boats if overladen. Shortly before this, on the west bank, appears the curiously-named Wat Gai Tia – the 'Bantam Wat' – which was built in the Ayutthaya period.

By now we are beginning to leave the riverside houses behind, rice fields are opening out on either side and we see the famous fork-billed storks from Wat Pai Lom wheeling overhead. Apart from the storks, the scene can have changed little since the times of Ayutthaya. It is a strange and timeless view: a moment of silence and tranquillity to prepare us for the excitement that is to come. As we follow the main river round to the right, the Menam Noi joins us quietly on our left, having quit the Chao Phraya or Menam Yai up at Chainat and run parallel to it for over 100 kilometres.

A further turn to our left to bring us north again, and all is changed. In the distance now the golden spires of Ayutthaya come into sight, glinting in the tropical sun. Before that, though, on the right, we pass the royal palace at Bang Pa In, and also its famous temple. Every year when the waters were at their highest, the king and his court bore new robes to the monks there. The *wat* at Bang Pa In is a very old foundation, and the royal residence there was built 350 years ago by King Prasart Thong. This is the last important landmark that travellers would pass as they turned into the final broad reach of the Chao Phraya and saw Ayutthaya glittering before them.

At this point, the sailors would make haste to lower the sails and prepare to land at the royal customs house at Hua Laem, on the eastern bank. Here, a chain could be stretched across the river attached to stout posts on either bank; relics of it were seen as recently as 1971. Just beyond is the village of 'Tamlé Thai', the 'Land of our Thai forefathers'. Perhaps it was given this name because the Thai could finally feel they were on home ground here,

having come far enough up the river to get away from the Chinese and the Mon lining the banks downstream.

This final stage was a potentially dangerous one for ships. The island of Koh Rien was visible, but many navigators did not know of the shoals that lie submerged off its southern tip. So many ships were wrecked at this point that divers still go down to look for cargo from those which capsized here. Having negotiated this successfully, however, the travellers would then be able to see the southern ramparts of the city, which, although much restored, still remain:

"At the lower end of the City appears a large bastion advancing into the water, besides several smaller ones. The first is furnish'd with Cannons against the Ships coming up".

The ship would swing to starboard under the muzzles of the guns, and glide past the Siamese war galleys on the left. A ship that was here to trade, however, would already have had its cargo cleared three times (at Ban Chao Phraya, at Bangkok and just now at Hua Laem) so could now cautiously manoeuvre itself in amongst the junks and tie up at a wharf on the eastern side of the city. The sailors and merchants would give thanks to God after their long sea voyage, and go ashore to view for themselves this Venice of the East: to marvel at its wonders, and to taste its delights.

1. Engelbert Kaempfer, *The History of Japan*, Vol. 1, p. 30. (see Chapter 1, footnote 11 above).

2. R. W. Giblin, The Abbé de Choisy. *The Journal of the Siam Society*, Vol. 8.

3. Mrs. Florence Caddy, *To Siam and Malaya*, Hurst and Brackett, London, 1889. (Some people think Mrs. Caddy misheard, and Camoens was actually shipwrecked off the Mekong).

4. R. W. Giblin, Early Astronomical and Magnetic Observations in Siam. *The Journal of the Siam Society*, Vol. 6, part 22, p. 7.

5. H. Warrington Smythe, *Five Years in Siam – 1891 to 1896*. 2 Vols. London, 1898. Vol 1. page 4. Reprinted White Lotus, Bangkok,1984.

6. Crawfurd, *Journal of an Embassy from the Governor-General of India to the Courts of Siam and Cochin-China*. London, 1828, Vol 1, p. 110 and 286.

7. F. A. Neale, *Narrative of a Residence at the Capital of the Kingdom of Siam*. Office of the National Illustrated Library, London, 1852. Reprinted White Lotus, Bangkok.

8. From The Bangkok Calendar for 1850, quoted by Sammy Smith in his *Siam Repository* for 1869, p. 343.

9. Mrs. Elisabeth Bleyerveld-van't Hooft, The Dutch Presence in Siam, *The Siam Society Newsletter*, Vol. 3, Number 2, June 1987, p. 8.

10. Guy Tachard, *Voyage de Siam....*, Paris, 1686.

11. *The Ship of Suleiman*, op. cit.

12. Choisy, *Journal du Voyage de Siam...*, Paris, 1687.

13. Sammy Smith, *The Siam Repository*, for 1871.

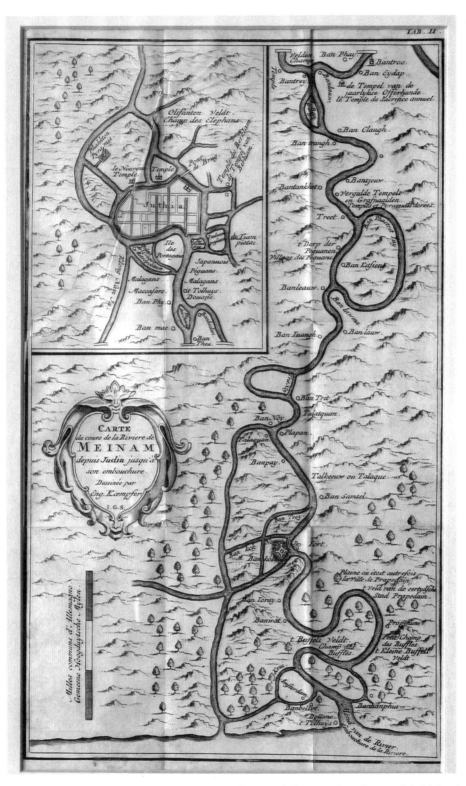

TAB. II.

Another drawing of the Chao Phraya, looking totally different to the last one, 'Carte du cours de la Rivière du Meinam depuis Judia jusqu' à son embouchure' drawn by Engelbert Kaempfer, 1729.
(Courtesy of the Dawn Rooney Collection)

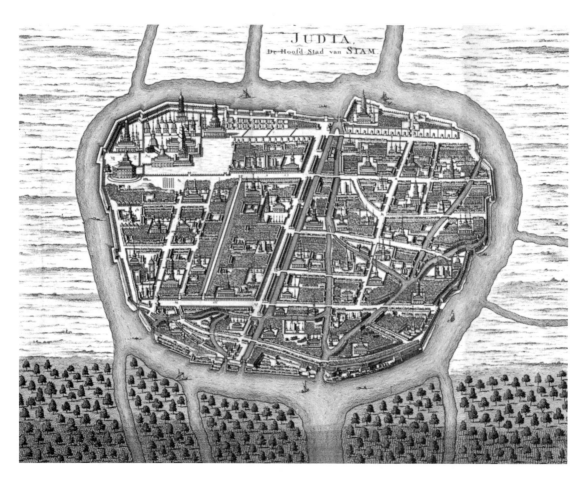

A view of Ayutthaya by Johannes Vingboons. At the top left-hand corner it shows a strange octagonal building, of unknown purpose. This also appears, carved, on an Ayutthya period scripture cabinet. (see colour illustration on page 169) (River Books Collection)

The City of Ayutthaya

T his Royal and admirable City is perfectly well-seated and populous to a wonder, being frequented by all Nations.' The first thing that should strike any visitor to Ayutthaya is the sheer size of the place. If you drive round the perimeter road which delineates the city's original boundaries, you will find the distance is about 11.5 kilometres. In comparison, the Rattanakosin Island, the original city of Bangkok, has a circumference of five kilometres: less than half that of Ayutthaya. Whoever laid claim to such a vast area as the site of his capital was a bold and ambitious man indeed.

However, nobody can say for sure who he was or where he came from. He is generally called 'Chao U Thong', but there are as many as six different theories as to his origins. This does not throw doubt on his existence: rather the opposite; the persistence of the legend lends it credence, though it reduces its substance.

One of the most interesting accounts of the foundation of Ayutthaya was written down by a Dutchman living in Ayutthaya called Van Vliet.[1] He claimed to have consulted Siamese histories as well as learned men, who said that Prince U Thong was the son of a Chinese ruler who had to leave the country for violating the wives of some of the most important mandarins. After many wanderings he arrived in Siam, where he founded a number of cities, including Bangkok. When Prince U Thong was told about the island of Ayutthaya, he expressed surprise that such a beautiful site was not inhabited. A hermit told him that the site had once been inhabited, but could not now be re-occupied because of a dragon which lived in a swamp in the middle of the city. When disturbed it blew poisonous saliva from its mouth, which brought about such an epidemic that everybody around there died of the stench. Prince U Thong promptly slew the dragon, filled in the swamp and founded the city of Ayutthaya.

This romantic tale seems to combine two quite separate legends. One tells of the foundation of Ayutthaya by 'Chao U Thong', but speaks of him as a Chinese prince. This seems strange, for he was clearly a man imbued with Indian culture, as the early buildings of Ayutthaya attest. The second legend speaks of a much older city built on the same site as Ayutthaya, or near it, and abandoned after a devastating plague.

This is very interesting because there are instances in Siamese history where cities were abandoned because of disease, and there is much to suggest that the site of Ayutthaya had been inhabited before. Archaeologists

have found traces of a pre-12th century Dvaravati town on and below the island at Wat Khun Muang Chai, Wat Maha That and Tambon Bang Kracha. Some historians believe that there was an old city to the east of the island, which they call 'Ayothaya', and that traces of some of these old buildings remain. For instance, the main *stupa* of Wat Ayothaya may originally have been built during the Sukothai period and later remodelled in the Ayuthaya style. Wat Phanan Choeng and Wat Yai Chai Mongkhon were certainly both founded before Ayutthaya, and the two Buddha images in front of Wat Yai Chai Mongkol are Dvaravati. On the island of Ayutthaya itself at Wat Dharmigharaj the stone lions round the *chedi* are Khmer, and the colossal Reclining Buddha, of which only the head remains, is in the style of U Thong (it can be seen in the museum).[2]

The inhabitants of Ayutthaya themselves believed there had been an earlier city there. In the seventeenth century, an Iranian delegation was told that there were many buildings and temples which the natives reckoned to be more than a thousand years old. However, like the nineteenth century Cambodian villagers who told Henri Mouhot that the temple ruins at Angkor had been created 'by the gods', the seventeenth century inhabitants of Ayutthaya felt that the ruins scattered about them were mysterious and alien: 'the work of another age', different from their own.

While Van Vliet's story of a runaway Chinese prince may be untrue, there is another well-known legend which connects not a Chinese prince, but a Chinese princess with Ayothaya. The story goes, and many scholars are inclined to believe it, that the Emperor of China gave his daughter, Princess Soi Dok Maag, in marriage to Chao Sai Nampueng, the Prince or King of Ayothaya. However, the union was not a success. It may have been that the princess pined for her native land, or perhaps she was bullied and teased beyond bearing; at any rate, in the end she committed suicide. The Chinese temple in front of Wat Phanan Choeng was built in her memory, and her relics, there enshrined, are still deeply venerated by both Thai and Chinese people to this day. Her father, the Emperor of China, must have regretted what he had done; he was simply trying to show the esteem in which he held this client state: an esteem based upon regular and profitable trade.

If this story has any truth in it, it gives weight to the theory that there was once a town near Ayutthaya which was able to trade with other countries in Asia, hundreds of years before Ayutthaya itself was founded. However, the reasons for its abandonment are unclear. Many old towns in Thailand have been forsaken or re-sited, usually because the water supply simply dried up, but sometimes because of devastating plague. However, water would never have been a problem at Ayutthaya, so perhaps Van Vliet's story of the dragon with its noxious breath took its inspiration from a very real pestilence which had wiped out Ayothaya so many years before. Possibly it was the Black Death which must have ravaged Southeast Asia in the 1330s and early 1340s.[3] After such a tragedy, few would wish to return and live in that city of the dead; boats going up and down the Chao Phraya would have passed the ruined buildings by.

The site remained an excellent position for trade and it is surprising that, until the slightly nebulous U Thong (as portrayed in Van Vliet's story), no one had re-claimed it. The island itself was an ideal site for a capital. It was easy to defend, the boundaries were clearly defined and there must have been a flourishing population in the villages beyond. King U Thong had the courage to claim it as his own, and not just as a trading centre; the names bestowed on both Ayutthaya and Krung Thep indicate what it was felt a capital should be. It was the home of the Gods: the seat of the King, and not a town for ordinary people to live in. It was a place which must be set apart.

In marshy land, the easiest way to do this is to dig a large ditch. This was particularly easy at Ayutthaya; nine-tenths of the boundary was already marked by the course of the three rivers. All the founder had to do was to dig a *klong* across the north-east corner of the site to join the Lopburi and Pa Sak rivers: a distance of about half a kilometre. Stakes were driven down into the bed of this *klong* to prevent the Lopburi river abandoning its old course running along the north side of the town. Then an earth rampart was thrown up round the city, though not, it seems, extending quite round the circumference of the island. Perhaps it traced a line between the royal city and the merchants already encamped along the eastern parts. Later, when danger threatened in 1549, a brick wall was erected to replace the wooden stakes which stood on the earth rampart: an enormous and costly undertaking. The wall had an inner and an outer skin of brick, and the space between was filled with mud, broken bricks and rubble. Forty years later, the line of the wall was pushed forward to take in the exposed north-east corner and to run right down the eastern side of the city, hugging the river line, until it came to the Pomphet fortress at the south-east corner. The old, shorter wall, which avoided the north-east corner, was then pulled down and turned into a road. One can still see the line it took; the road is called Pa Maphrao Road.

Inside this vast open space, and while it was being enclosed, the founder of Ayutthaya began to build himself a palace, a royal *wat* and, presumably, a city pillar, the home for the spirit of the nation. The main buildings are said to be laid out according to Hindu cosmology. Tradition maintains that King U Thong camped to the south of the island, where Wat Bhuddaisawan now stands, while his palace was being built.[4] The site he chose is where the ruins of Wat Phra Sri Sanphet stand today. When he died 19 years later, his ashes were interred nearby at Wat Phra Ram, which was put up by his son, or at least begun by him. A hundred years later, King Boromtrailokanat (1448-1488) moved the site of the royal palace north towards the river and there erected the Sanphet Prasat palace. We can still see the outline of it on the ground today: the most important building in the whole palace area.

It housed both the coronation throne and the throne from which the king bestowed titles and appointments. From here, the king received foreign ambassadors such as the well-known embassy from Louis XIV of France (La Loubère has left us a description of the event). The palace was extensively

remodelled by King Boromakot (1733-1758), but was completely destroyed a few years later when Ayutthaya was sacked by the Burmese. A three-quarter scale model of what it may have looked like is at 'Muang Boran', an historical park just outside Bangkok. Even scaled-down, it is a magnificent creation, with sweeping lines that seem to make it hover above the ground and architecture that is quite rightly regarded as the epitome of the Ayutthaya style. When Bangkok was founded, King Rama I had a copy of the Sanphet Prasat palace built to perpetuate the style and named it the Inthraphisek palace. Sadly, it was struck by lightning shortly after it was completed and the whole building, which was made of wood, was burnt to the ground. There is a painting of this event in the National Gallery. It is said that King Rama I braved the flames and crashing timbers to drag to safety the inlaid throne which can still be seen in the Dusit Maha Prasat palace. The original coronation throne, sheathed in gold and encrusted with gems, had been borne away by the Burmese. After this, no more attempts were made to recreate this loveliest of buildings.

Unfortunately, when we visit Ayutthaya today, we can find almost nothing to remind us of the splendours of the royal palaces. All that we can see is their ground plans, neatly picked out in layers of brick about two foot high, and it is impossible to visualize what they were originally like. The Burmese looted them just as the Siamese, it has to be said, had looted the Khmer palaces at Angkor Wat; however, they did not obliterate them. Sadly, this was done later. When King Rama I was desperately trying to reconstruct the Siamese capital, he ordered men in boats to go up to the ruined site of Ayutthaya and bring down as many bricks as could be found. Naturally, they could not take them from the temples, so they pulled down the city walls; then they took five of the city forts, leaving only Phom Phet, and finally they set upon the remains of the royal palaces, loaded them into barges and ferried them down to Bangkok, where they were incorporated into the Grand Palace, its temples and its walls.

There are no contemporary paintings to show us what the other buildings of the royal palace looked like. The early ones were made of wood, and it was only after 300 years that King Narai (1656-1688) rebuilt them in brick. Yet, miraculously, one of these early, wooden palaces survives, housed in the grounds of Wat Yai in Petburi. Again, there is a copy at Muang Boran, and the original probably dates from the seventeenth century. It was given by the 'Tiger King', Phra Chao Sua (1703-1709) to the Supreme Patriarch, who had it dismantled and taken by boat down to Petburi, where he had been brought up and educated. Thus it survived the sacking of Ayutthaya. There is a third building which shows us what the old Grand Palace compound at Ayutthaya may have looked like, and that is the Phra Thi Nang Dusit Maha Prasat in the Grand Palace. King Rama I had it built on the site of the palace which had just been burnt down. It is also a copy, at least in form, of a palace at Ayutthaya called the Suriyat Amarin Throne Hall, but it was completely refurbished by Rama II and the murals were painted in Rama VI's reign.

So, with these three palaces in our mind's eye, we can now turn to contemporary European accounts of the Grand Palace, which like the Grand Palace in Bangkok today, was more like a city in its own right. An observer at the time, Gervaise, recorded the following in 1688:

"The King's apartment is in the last courtyard. It has been newly built, and the gold glittering from it in a thousand places easily distinguishes it from the other residences [the palaces of earlier kings]. It is in the form of a cross from the centre of which rises a high pyramid of several stories. ...The covering is of tin and there is nothing so well-worked as the sculpture with which it is decorated on all its sides". [Is Gervaise here describing the Sanphet Prasat palace?]... The apartment of the Queen Princess, his daughter and his wives, which is nearest to his apartment appears from outside to be rather magnificent... Like that of the King, it looks out upon large, well laid-out gardens. The pathways are intersected by streamlets which give a certain freshness to the scene and, by the soft murmur they make in flowing, invite to sleep those who rest on the evergreen grass that borders them".

The same energy which drove U Thong to take possession of the empty island and set his palace there, spurred his successors on to military glory. For the next 80 years they were almost constantly at war, making a succession of forays to the North to try and subdue the northern kingdoms. They crushed Sukhothai and installed their own ruler, captured Angkor Wat, looted the town and stole the royal regalia.

At home they instituted a series of reforms to give themselves control over the people in the countryside. The population was divided into territorial groups under government officials, with everyone having to give six months' service a year to the state, either as soldiers or as labourers on public works. It was a hard yoke to bear. Equally alien to the common Siamese was the way in which the kings of Ayutthaya elevated themselves into God-Kings on the Cambodian model. The Chinese and Muslim traders also felt their heavy hand, for trade became a royal monopoly. Foreign traders had to sell to the king as much as he wanted to buy, and at the price he wanted to pay them. When they wanted to buy staple Siamese goods to take with them, they had to buy first from the king and, of course, at the price he asked. Only when his supplies were used up might they buy from other merchants.

All this sounds like a recipe for disaster, but arrogance was tempered with common sense. Ayutthaya, the capital city, flourished; trade increased and the town was embellished with more and more fine buildings. Visitors said that there were 450 temples in the city, and according to an official guide, there were 375 monasteries on the island, as well as 29 fortresses and 94 city gates:[5]

"This City, in particular, abounds in all parts with Temples, the Courts of which keep a regularly proportion with the streets and are full of Pyramids and Columns of divers shapes, and gilt over. They do not equal our churches in bigness, but far exceed them in outward beauty, by reason of the many bended roofs, gilt frontispieces, advanced steps, columns, pillars and other ornaments".[6]

Modern guide maps show the ruins of about 30 major temples, whereas even in 1860 the city walls of Bangkok enclosed a mere thirteen.[7] Moreover, the *wats* in Ayutthaya were often far bigger, even though many of them were founded in the first 150 years of Ayutthaya's existence, when the little state was almost constantly at war. The most important temple was Wat Phra Sri Sanphet. It was founded by King Boromtrailokanat on the site of King U Thong's original wooden palace, Sanphet Prasat; however, the grounds of the Grand Palace were so extensive that Wat Phra Sri Sanphet was still within its walls. Like the Temple of the Emerald Buddha, it was the royal *wat*, and there were no *kuti* or buildings for monks to live in.

The principal image of the city was kept there. Unlike the Emerald Buddha, which is tiny, Phra Sri Sanphet was huge. Cast in bronze in the year 1500, it was an image of a Standing Buddha 16 metres high: the largest standing metal image ever made. "This Prodigious Colossus" said Father Tachard who saw it in the 1680s. The Siamese craftsmen who fashioned it must have been extremely skilled and confident, and have had hundreds of years of practice behind them to undertake such a huge commission. It was then covered in no less than 173 kilograms of gold (one authority says 346 kilos).[8] To get some idea of its size, though not perhaps its grace, we must visit the huge seated image of Phra Mongkol Bophit; and then imagine it as encrusted in gold. In the end, of course, the Burmese built a fire around the statue to melt off the gold, and cracked the bronze core. Abandoned and derelict, the walls of the *viharn* fell on to the image and smashed it into pieces. King Rama I was so distressed that he had the bits brought down to Bangkok and tried to have them welded together, but the attempt failed, and all that remained of this most costly and beautiful Buddha image was tumbled into a *chedi* at Wat Chetuphon and bricked over. For visitors to the Temple of the Reclining Buddha, the *chedi* is called Chedi Sri Sanphet.

However, two of the images from the Royal *wat* of Ayutthaya were saved and can still be seen. Both are much venerated. One is the Phra Lokanart, which is at the Temple of the Reclining Buddha. The other is the Phra Buddha Sihing which is in Wat Phra Singh in Chiang Mai, with a copy in the Phutthaisawan Chapel in the National Museum.

Phra Sri Sanphet had been housed under a shelter, which was perhaps its undoing. Other huge images of the Buddha were left out in the open and must have presented an amazing spectacle, dotted about the landscape. Two of them we can still see, though they are much cribbed by their confining roofs. Phra Mongkol Bophit, just next to Wat Phra Sri Sanphet, is encased by a temple built by the 'strong-man' of the 1950s, Field-Marshal Sarit, and the very ancient Phra Chao Phanan Choeng which measures 19 metres to the top of his 'top-knot'. Phra Mongkol Bophit was the more impressive in that he was covered in plates of gold, but the Burmese melted off the gold and took it with them; some Thais maintain that this gold was used to coat the Shwedagon pagoda in Rangoon. Another large image which was once out in the open is Phra Pa-le-lai outside Suphanburi. It would be nice to see

these images outside again – where one can better appreciate their size and form – as they were designed to be seen, and as others can be seen at Anurajapura in Sri Lanka. One wonders why they were enclosed. Did the bronze or gold covering tarnish, or was it misplaced piety that housed them in?

Similarly, we can no longer see the large number of towering *chedis* at Ayutthaya, many burnished with gold or bronze, and *prangs* glistening white. There are only two now left – the great *chedi* of Wat Yai Chaimongkol which is the first pinnacle visitors see as they drive towards the ancient capital from Bangkok; the other, Wat Phu Khao Thong, stands glistening in the rice fields to the north of the city. Opposite to one another and exactly the same height, they were built by a father and his son, King Prasat Thong and King Narai.[9] In the middle of the city, at Wat Mahathat, we can see the colossal stump of what was the highest *prang* in all Ayutthaya; built in the seventeenth century, it scaled an incredible 50 metres and stood for 300 years.[10]

There is a very beautiful brick *chedi* at Wat Yana Sen, just to the east of the Grand Palace. It has not been restored, and exhibits the elegance and balance for which the architects of that time strove. Another *chedi*, in this style, is interesting because it marks the spot where the ashes of Queen Suriyothai were interred: one of the best-known heroines in Thai history. When the Burmese attacked Ayutthaya in 1548, the king, Maha Chakraphat, rode out at the head of his forces on an elephant. His queen, dressed as a man, followed on hers. When she saw her husband in single combat and at the point of defeat, she drove her elephant between the contestants and herself received the mortal blow.

Perhaps the best known (and most-photographed) *chedis* are the three which stand in an elegant line down the centre of the royal *wat*, Wat Phra Sri Sanphet. They all contain the ashes of kings, and the other, smaller ones contain the ashes of princes of the blood. Most have been pillaged for treasure, but one alone was left untouched; it has been properly excavated and the finds can now be seen in the National Museum in Bangkok. Treasures from other *wats*, such as Wat Rajaburana, can be seen in the museum at Ayutthaya. So little has survived, though, that one must regret the mass that has been lost. Many treasure hunters acted furtively and illegally but some, surprisingly, had royal sanction.

When King Taksin had temporarily driven out the Burmese and was trying to establish the royal capital at Thonburi, he was desperately short of money. It was known that many of the rich people in Ayutthaya had hurriedly buried their wealth when it was clear that the city was about to be overrun. Many of them were carried into captivity by the departing Burmese; others simply forgot where they had hidden their treasure. So King Taksin decreed that anybody who found buried treasure could keep half for themselves and give half to the Crown to help fill the Treasury. At first, prospectors had to be accompanied to Ayutthaya by a royal official, but so much corruption ensued that the King farmed out the right to control treasure-hunting to one man, who had to pay a stated amount to the

government. This only made matters worse. Bogus treasure maps were produced, and *chedis* and *stupas* were destroyed wholesale. It became, as King Chulalongkorn described it, like a disease of the people. Some would even go to the old Lopburi river which ran along the north wall of the Grand Palace, and pan for jewellery in the mud. They called their spoil *Phloi Muang*: Ayutthaya stones.[11]

Sometimes Buddha images, too large to inter, were cleverly concealed in plaster – and forgotten. At Wat Hong Rattanaram there is a gold and silver Buddha which was hidden from the enemy in this way. Much more famous, though, is the huge, solid gold Buddha at Wat Trimitr, which was also saved from the Burmese. No one knows where it came from, or when it was brought to Bangkok. Large and ugly and apparently made of stucco, it was eventually consigned to Wat Trimitr, a small Thai-Chinese temple, with the plebeian name of the 'Three Friends'. There was no room for it in the temple, so it sat out in the open under a temporary roof – for 20 years. Three metres high and weighing five and a half tons, the image was discovered in 1955, when the crane that was shifting it dropped it and the plaster cracked. It is said to be the largest gold object in the world (£28,000,000 was what the gold alone was worth in 1982, according to the *Guinness Book of Records*), and is ingeniously constructed. A key was found in the base; with it one can unlock and remove parts of the body, such as the neck, the arms and the Flame of Knowledge. The face, in Sukhothai style, is also extremely beautiful; some compare it to the Phra Buddha Chinarat image at Pitsanuloke. Whoever had the idea of camouflaging it in plaster deserves the thanks of the Thai nation, for it would have been a tragedy indeed if this had been borne off to Rangoon! (There is said to be another large solid gold Buddha image which was 'drowned'; perhaps it was being hurriedly moved downstream on a raft or boat which sank.) Amazingly, the *Thai Chronicles* speak of five such large gold Buddhas, but no one believed this tale until the Wat Trimitr 'Golden Buddha' was found. Perhaps there really are three more, waiting to be rediscovered.

Such profligacy testifies to great wealth; but then, everything was in gold. All the ornaments in the museum at Ayutthaya are made of gold, and letters to foreign powers were written on gold sheets. The name plates of royalty were all done in gold, and the envelopes in which royal letters were sent were made of gold 'nearly as thick as a man's thumbnail'. Even the children wore bangles of 24 carat gold. The puzzle is to know where all of it came from. Of course, it may have all been bought out of the profits of trade, but the Thai people are convinced that it was mined in Thailand. According to la Loubère, King Narai went to the trouble of finding a Spanish mining expert who came all the way from Mexico to search for the old Siamese gold mines. Like many later experts, he left, baffled.

This idea of Siam as an eastern El Dorado comes from the Buddhist *jataka* stories. In some of these tales, which are about 2,000 years old, Indian merchants return after long sea voyages in the eastern seas, speaking of a

fabled land, a land of gold: the land of 'Suwannaphum'. Since it is almost impossible to avoid touching upon the coast of Siam if one sails from India towards the rising sun, it became accepted that Suwannaphum was to be found somewhere in Siam. But where? There was the harbour with the tantalising name of 'Tha Thong', the Harbour of Gold, in the South; there was Bang Saphan, near Chumporn, where gold was found in 1749; there was a gold-rush at Kabinburi in the 1870s; there were seams of gold found near Narathiwat which the French mined in the 1890s. However, none of these places provided a constant source of gold. By 1886, the Siamese government had to buy and import Mexican gold dollars to mint Siamese gold coins.

All these temples, with their shimmering gold finials, their glittering roofs and their gilded *stupas* must have been an amazing sight. There was nothing to distract the eye in those days: no mean houses crowding up against the walls; no concrete classrooms or piles of sand disfiguring the grounds. The only other buildings of worth were the royal palaces. Of these there were three: the Grand Palace for the king, of course; a palace for the Wang Na, the King of the Front (the leader of the vanguard in war); and a palace for the Wang Lang, who brought up the forces of the rear. These military leaders were sometimes called the 'second' and 'third' kings, and some maintained that the second king was a likely contender for the throne. The Wang Na's palace was situated at the north-east corner of the island, and was first built there by Prince Naresuan in about 1577, after his father, the king, had extended the city wall to enclose this area. It must have been a pleasant spot, and a building of some consequence, because both Naresuan and later kings felt able to stay there, in preference to living in the Grand Palace. It is likely that they enjoyed getting away from the oppressive ceremonial and stuffy ways at court.

Unfortunately, this palace too was destroyed in the sack of Ayutthaya, and what was left was either shipped down to Bangkok, or incorporated into the palace which King Mongkut built for himself on the site. There is one echo of former times: the Phisai Sanlayalak observatory tower, which was put up by King Narai in the seventeenth century. He was a keen astronomer and was given some good instruments by the Jesuits, who watched the stars with him. King Mongkut carried on the tradition, and had King Narai's tower reconstructed on the same site. It seems, though, that King Mongkut reduced the extent of the original Chantarakasem Palace. Phraya Boran Rajathanindra, excavating in this area, found brick foundations to the south of the present boundary wall and under the present gaol. These are thought to be part of the old, much larger, Palace of the Front.

The Wang Lang, who was always considered a lesser figure than the Wang Na, lived on the other side of town, in a meaner dwelling, in the king's gardens beyond the walls of the Grand Palace. Around 1577, when the Chantarakasem Palace was built for the Wang Na, the Wang Lang's house was upgraded. No trace of it remains, but it was near the western landing stage, which one can still see, in a very dilapidated condition. It used to be a point

of some grandeur, where foreign emissaries came ashore and were led up a broad road to the gates of the Grand Palace for their Royal Audience.

We must now turn from the palaces of the kings to the dwellings of the common people and to an overview of the island. At first it remained largely deserted; the Siamese called it 'Pa-Than', or 'the wilderness'. Here is the late seventeenth-century observer, La Loubère:

"The City is Spacious, but scarce the sixth part thereof is inhabited, and that to the south-east only. The rest lies Desart where the Temples only stand". Other parts of the city were too far away or simply too flooded to live in at all comfortably. It was easier to live on dry land outside. Gervaise noted that 'there are abundance of empty spaces and large gardens behind the streets, wherein they let nature work, so that they are full of Grass, Herbs, Shrubs and Trees that grow wild.' In fact, the empty space was useful as a place of shelter during wartime; villagers, traders and craftsmen would all take refuge here, which also deprived the Burmese of forced labour and of supplies of meat and rice.

Slowly, however, tradesmen began to appear within the city, and streets were laid down and lined with primitive houses. La Loubère described the town:

"The first Street upon entering the City is that which runs Westward along the turning of the Wall: it hath the best Houses, amongst which are those that formerly belonged to the English, Dutch and French, as also that in which Faulcon resided. (It was most unusual to find westerners living inside the city walls. This was normally prohibited; even when Bangkok became the capital, no foreigners were allowed to live within the city for the first 70 years. It only occurred in the giddy days when Phaulcon was controlling foreign policy and courting the West.) The middle Street, which runs North towards the Court, is best inhabited, and full of shops of tradesmen, Artificers and Handicraftsmen. In both these streets are seen above one hundred Houses belonging to the Chinese, Hindoostanians and Moors, as they call them. They are all built alike of Stone, very small, being but eight paces in length, four in breadth and of two Stories, yet not above two Fathoms and a half high. They are covered with flat tiles, and have large doors without any proportion". It sounds very much like old Chinatown today; in fact it was probably the commercial quarter.

Then there were the houses of the poor, labourers and those who pursued the more humble trades:

"The rest of the streets are less inhabited, and the Houses of ordinary Inhabitants are but mean and poor cottages, built of Bambous ... and boards, and carelessly covered with Gabbé Gabbé, Branches and leaves of Palm Trees growing wild in Morassy places. (They sound like huts thrown up quickly to house workmen, like the corrugated-iron shacks of today.) The booths, or Shops of the town are low, and very ordinary, however they stand in good order, and in a straight line, as the Streets are".

Some of the streets were surprisingly large and straight, 'in some places planted with Trees and paved with bricks laid edgeways. Most of the streets

are watered with straight canals'.[12] These wide streets in Ayutthaya were intended for royal processions, when the king might pass before his people arrayed in all his glory. Perhaps the greatest of these state occasions was the Royal Kathin ceremony, when the king took new robes to the monks in the larger monasteries. There would be some 200 elephants in his train and 6,000-7,000 men accompanied him on foot. His Majesty would pass very close to his people lining the roadside, kneeling in front of him. They would fold their hands and bend their heads to the ground, too much in awe to gaze up at the spectacle passing before them. Foreigners were not so inhibited. The director of the Dutch East India Company, Van Vliet, watched the Kathin procession and must have taken notes as he watched, so detailed is his description:

"First come about 80 to 100 elephants, which are sumptuously decorated. On each of these elephants is seated, besides two armed men, a mandarin in his little gilded house having in front of him a golden basin, containing cloth and presents for the priests. Then follow 50 to 60 elephants, on each of which are sitting two to three men, each of whom is armed with bows and arrows. After this come, also seated on elephants, the five to six greatest men of the Kingdom, some of them wearing golden crowns, but each with his golden or silver betel box or any other mark of honour given to him by the king. They are accompanied by their suites of 30 to 60 men afoot. Following these come 800 to 1,000 men armed with pikes, knives, arrows, bows and muskets and also carrying many banners, streamers and flags … The musicians who follow the soldiers play on pipes, trombones, horns and drums and the sound of all these instruments together is very melodious. The horses and elephants of the king are adorned copiously with gold and precious stones and are followed by many servants of the court, carrying fruits and other things to offer. Many mandarins accompany these servants.

"Then follow on foot with folded hands and stooping bodies (like everyone who rides or walks in front of the king) many nobles, among them some who are crowned. Then comes the red elephant decorated very nicely with gold and precious stones. Behind this elephant follow two distinguished men, one of them carrying the royal sword and the other one the golden standard, to which a banner is attached. A gilded throne follows after them showing how former kings used to be carried on the shoulders of the people, and then follows His Majesty sitting on an elephant and wearing his royal garments and his golden crown of pyramidal shape. He is surrounded by many nobles and courtiers. Behind His Majesty comes a young prince, the legal son of the supreme king, who at present is eleven years old. The king's brother, being the nearest heir to the throne, follows then with great splendour, and seated on elephants in little closed houses come after this the king's mother, the Queen, and His Majesty's children and the concubines. Finally, many courtiers and great men on horseback, and 300 to 400 soldiers who close the procession.

"Altogether about 6,000 to 7,000 persons participate in this ceremony, but

only His Majesty, his wives, his children, his brother, the four highest bishops and other high priests enter the temple. Having stayed inside the temple for about two hours, the king and the whole splendid train return to the palace in the same order as here described. The streets are very crowded with people from the palace to the temple but everyone is lying with folded hands and the head bent to the earth." Bangkok has seen nothing like it. The early monarchs of the Chakri dynasty did not have the means to put on such a display and there was then no street in the capital where 200 elephants and several thousand people could parade before the populace.

Between the king and even his highest ministers, and indeed, his relations, there was a gulf fixed. No one thought to cross it; in fact it was really 'not done' to live ostentatiously:

"The Mandarins or Ministers of State and Courtiers live in separate palaces, with courtyards to them, which are very dirty. The Buildings in general, tho' raised with Lime and Stone are but indifferent, and the apartments neither clean nor well-furnish'd".

This account from Kaempfer echoes the disparaging comments which early visitors to Bangkok made about the houses of the nobility.

Although there were some streets in old Ayutthaya, it was really a city of canals. The Persians called it 'Shahr Nav' – the 'City of the Boat' – for, as the author of *The Ship of Sulaiman* noted: "The mainstay of travel and transportation in that whole region is the boat … boats are the mainstay of the populace, the very pivot of these people's lives. Their boats are their houses as well as their markets. They ride their boats wherever they wish, tie them up alongside one another and do all their buying and selling without going ashore".

Of course, boats can carry far heavier loads than horses or buffalo can drag. The Persian delegates to King Narai were proud of their horses, and irate when they had to sell them to the Siamese for a song before they left, but they admitted that boats were best. It followed that Ayutthaya, at the centre of a fluvial region, was laced with canals. However, the disadvantage of letting the water come up to one's doorstep was that it sometimes overflowed it. Van Vliet noted this problem, and also the fact that the water in many of the canals was extremely unclean.

Moreover, a city of canals needs bridges, though to Europeans, the Siamese bridges were hardly a feature of this fair town. Some were made of brick – 'very high and ugly', said La Loubère – and others of stone, particularly those straddling the canals. Some were 80 paces in length, very long for a stone bridge, especially in an area where there is none of that material to hand. The great canals and the wide, tree-lined roads were intended for Majesty to show itself in pomp to the people. They were theatrical sets, and no doubt the bridges were also designed to impress; King Chulalongkorn's beautiful bridges in Bangkok are usually classical in style. It would be interesting to know where the design for the stone bridges of Ayutthaya came from. If they were erected in the late seventeenth century, they may also have been classical in style.

The city of Ayutthaya was, then, principally a royal and religious town: the seat of kings and the home of monks. The common people lived outside:

"All round the town and on the other side of the river there are many villages, residences, houses of farmers, temples, monasteries and pyramids, and the population here is just as thick as in the town".[13]

This explains why there are the remains of so many temples outside the walls of Ayutthaya, just as many as there are inside. They are simply the remains of village wats, for the rice farmers, tradesmen and manual workers who supplied the great city with its provender and labour.

Then there were the simple traders who brought vegetables and fruit from further afield (it was difficult to grow these things close to Ayutthaya itself with its yearly inundation), and perhaps more exotic merchandise from outlying provinces. Many of the people must have lived on floating houses, moored to the banks of rivers and canals; the scene was probably similar to that in early Bangkok. Others appeared to live aboard large boats, though more probably they came from inland villages, stayed to sell their produce, moving from one water-market to another, and then returning home. The scene may have looked a little bit like the floating markets at Damnoen Saduak today, except that the boats used were 'country boats' or houseboats on which entire families could live for weeks rather than the small, open *sampans* which we associate with 'floating markets'. Moreover, when the waters round Ayutthaya began to subside, they cast off their mooring ropes and laboriously poled their way back upstream to their distant country homes. The journey might take a month; there must have been brisk trade to make it worthwhile.

There were also, however, some drier patches of firm land quite close to the city, where substantial buildings could be erected. A number of kings and princes erected *wats* there, such as Wat Kudi Dao, built by the brother of King Tai Sa. The ruins of the building in which he stayed, while supervising the temple construction, are still visible today. Next to it are the extensive ruins of Wat Maheyong, built by a king in the fifteenth century, and rebuilt by another king in the eighteenth. A third king, the King of Burma, directed the siege of Ayutthaya from this temple, and King Mahintrathiraj came here to negotiate the surrender of his capital. Wat Pradu Songtham, next to it, also has royal associations. King Uthumporn came here with a procession of royal barges, probably to present robes to the monks (*kathin*) since he was ordained here.[14] It seems strange that there should be so many royal *wats* outside the walls of Ayutthaya when there was so much waste land lying unused inside the town.

One commoner joined this elite group; this was Kosa Pan, the first Siamese ambassador to the Court of Versailles. It is not quite clear who Kosa Pan was. Some say he was the son of King Narai's wet-nurse; King Mongkut thought there was a royal connection: 'From this person extraordinary our ancestors were said to be descendants,' he wrote to Sir John Bowring. Whatever his origins, it was daring of King Narai to send a commoner on such

an important mission, and quite daring of Kosa Pan to go; the first Siamese embassy had just disappeared with all hands in a storm off Madagascar. However, Kosa Pan brilliantly fulfilled the trust put in him; endured a gruelling nine months of sightseeing, safely delivered King Narai's gifts to Louis XIV (contained in 132 bales) and made a hit with the ladies at Court, especially when they learnt that he had 22 wives. Asked if he liked the way French women dressed, he said, 'they would be better still if they were dressed in the manner of my country'. Asked what that was, he replied, 'they are half-naked'.

A brilliant man, he was later made a Chao Phraya and Phra Klang. He and his brother rebuilt Wat Samanakot in memory of their mother, but there is little of it to be seen today, which is sad as it was once very grand. Kaempfer described it as 'one of the sights of the town' and had a drawing made of it (he arrived just after it had been completed). It had no fewer than four *bots* or *viharns*, which he mentioned as 'a remarkable curiosity'.

Normally, though, the ordinary people had little contact with the grand officials who lived within the walls, and the strange and perhaps alarming people who came from far-away places to visit them. Only occasionally did the two meet; the Duc de Choisy offers us a charming vignette of country life, when he and the French ambassador escaped from the irksome life at court and were rowed out of town, out and down a rural *klong*. It is doubtful that this was just a chance encounter, but even if contrived, it must have been fun for the two to sit upon the floor and drink tea with a Siamese farmer and his family, and afterwards to bathe in the *klong* and feel the fishes brushing against their legs. "The Ambassador and I went this evening for a small trip in a little boat. We journeyed through waterways lost to view, under green trees, amidst the songs of a thousand birds and with rows of houses on stilts: mean-looking habitations from the outside, but extremely clean within. We went into a house where we were expecting to find some villainous peasants, but found only cleanliness itself: the braided mat; Japanese chests; folding screens to partition the room. We were hardly through the door before being presented with tea in china cups, surrounded by the children of the family ... At the end of our visit, I threw myself into the river, which I do every day and which is necessary for good health".

Looking through these travellers' eyes, Ayutthaya certainly seems a demi-paradise. And so the people of early Bangkok remembered it, at least those who could express themselves in verse or speech, as they looked back on life 50 years before. 'The good old days,' they called it, and similarly in the seventeenth century, Gervaise remarked that 'this town hath a great name throughout the Indies'. Most foreign visitors would have agreed. However, beneath the surface glitter, and perhaps invisible to foreign eyes, moved more sombre currents.

1. Jeremias Van Vliet, *The Short History of the Kings of Siam*. Translated by Leonard Andaya and edited by David Wyatt, Siam Society, Bangkok 1975.

2. For these and many other details, I am deeply indebted to Ajarn Chusiri Chamaraman.

3. Michael Wright, *The Journal of the Siam Society*, Vol. 80 part I p. 82. Quoted in chapter I above, footnote 5.

4. Piriya Krairiksh, in 'A Revised Dating of Ayudhyan Architecture', *The Journal of the Siam Society*, Vol. 80, part I, p. 41-43, suggests that Wat Phutthaisawan was actually built by King Narai in memory of his queen & that the buildings we see today mostly date from the restoration of the wat in 1898.

5. Tri Amatayakul, *The Official Guide to Ayutthaya & Bang Pa-In*. Fine Arts Department, Bangkok, 1972.

6. Kaempfer, *op. cit*. p. 47.

7. D. B. Bradley's, Map of Bangkok, *Bangkok Calendar*, 1859-60.

8. Piriya Krairiksh, in 'A Revised Dating of Ayudhyan Architecture', *The Journal of the Siam Society*, Vol. 80, part 2, p. 13-15, shows how descriptions of the same statue vary from one version of the Chronicles to another.

9. Piriya Krairiksh, in 'A Revised Dating of Ayudhyan Architecture', *The Journal of the Siam Society* Vol. 80, part 2, p. 15-23, is followed here. He disputes earlier attributions made by Prince Damrong. Of course, the huge base of Wat Phu Khao Thong which is so out of proportion to its slender chedi, was built earlier by King Naresuan, to commemorate his victory in a duel with the Crown Prince of Burma on elephant back, but never completed by him.

10. Piriya Krairiksh, in 'A Revised Dating of Ayudhyan Architecture', *The Journal of the Siam Society*, Vol. 80, part 1, p. 43-47.

11. From the Diary of Chao Krok Wat Pho, with a commentary by her uncle, King Rama I.

12. La Loubère, *op. cit*.

13. Van Vliet, *op. cit*. p. 12.

14. 'Report on a tour to Ayutthaya' led by Michael Smithies & Euayporn Kerdchouay. *Siam Society Newsletter*, Vol. 4, number 1, page 13.

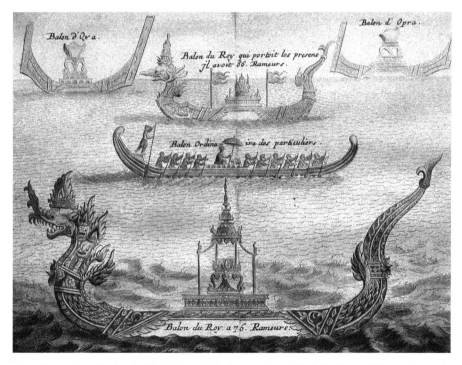

A royal procession showing the king's barge in the foreground and, in the background, the vessel carrying presents from Louis XIV to King Narai. (Courtesy of The Old Maps & Prints at River City)

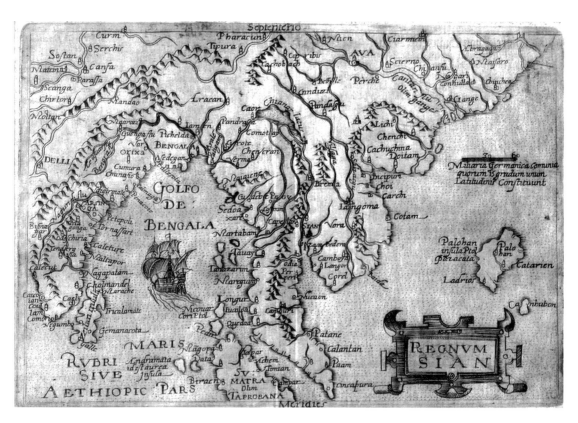

The Kingdom of Siam, Map of 'Regnvm Sian', drawn by Johannes Metellus, 1596. Notice how Siam appears centre stage, while India and China are left very much in the wings. (Courtesy of the Dawn Rooney Collection)

Ayutthaya – An over-mighty power

To build a city of such magnificence and a community of such wealth cost more than money. It cost the Thais their cherished freedom. Eventually it led to the destruction of the capital. As one reads the history of Ayutthaya, one notices a harshness, a ruthlessness, a greed quite alien to the gentle rule of the kings of Sukhothai. Thais instinctively know their place, but the kings of Ayutthaya laid it down by law. Everyone had their rank, their *sakdina*, which could be counted. A simple farmer was worth 25, a craftsman 50, a civil servant from 50 to 400. The great officers of state were ranked at 10,000, the heir-apparent at 100,000, and a slave at 5. No one escaped the net, even Buddhist monks and Chinese merchants were catalogued. What was worse was that fines and punishments were inflicted in proportion to the rank of the injured party.[1] If a rice-farmer attacked a visiting official who came to summon him to dig a canal, he would have to pay a far higher fine to make amends than if he attacked a recalcitrant slave. This all seems far too organized and elitist to be truly Thai. Work was the same.

Everyone now had to work for the state. At Sukhothai and in the northern Thai states people worked for their patron or master. The government at Ayutthaya sent out officials to keep track of everybody in their area and compel them to do manual labour for the state or to serve in the army for up to six months in every year. Van Vliet describes it well: "In the whole country, the common class of people, who are not slaves, are divided under quarter-masters. The latter have control over 1,000, 500, 400, 300, 200 or 100 men. This is done for the accommodation of the King, for if His Majesty needs people, these quarter-masters are requested to provide the number required. From this often big profits can be made. For the quarter-masters usually force first the poorest people, or those who are in worst circumstances, to leave their houses, and only by bribery are they allowed to stay at home".[2] It was an efficient way of running a state and it was one reason why the kings of Ayutthaya were able to subjugate their neighbours and impose their own rule; but it must have spread bitterness and resentment about the countryside and it may help to explain why, in the end, Ayutthaya fell, unaided.

The countryside was extremely fruitful and contributed greatly to the wealth of Ayutthaya. Here is Van Vliet again: "The country is intersected by many big and small rivers, which have an abundance of fish, there are many large and middle sized towns and villages and the country is well populated. In many places there are plenty of Indian fruits of various kinds

and the country produces many kinds of grain, especially rice, with which they could feed and still can feed several other countries. There are many kinds of birds, tame and wild animals, especially big and fine elephants, deer and elks. In short Siam is a country that has more than most other countries of everything that the human being needs". And nobody needed it more than the merchants of Ayutthaya who supplied voracious foreign traders. As today, so then, the countryside was pillaged and plundered to enrich the capital. Nowadays the buffaloes, pigs and poultry which are raised for market are carried off alive in ten-wheeler trucks to be discretely killed in city slaughter-houses, part of the profit returning to the farmers. In those days the slaughter of wild animals was done before the eyes of the horrified villagers, and they gained nothing from the trade.

Thai country people shrink from the killing of large animals. They eat fish with their rice, or frogs or field-rats or even insects. When meat-eating became popular in Bangkok, largely amongst the growing foreign community, it was the Muslims who kept the cows, for their milk and for their flesh. Even today, the huge chicken and duck farms one sees dotted about the countryside are owned and managed by Chinese entrepreneurs. Thais, who hesitate to swat a mosquito, would not kill animals for a livelihood. They must have hated what was done. The deer would have been a common and a pleasing sight, grazing quietly in the woods and spinneys. But the rich and avaricious gentlemen in Ayutthaya quite ignored the sensibilities of the country people. Gangs of men went out to hunt deer for their pelts. And when they came, the slaughter was prodigious. Perhaps between 70 and 150,000 a year were killed during the seventeenth century. Two directors of the Dutch East India Company in Ayutthaya, Schouten and Van Vliet, each reckoned that they could collect between 130,000 and 150,000 hides a year. In fact, the official records of the Company show that they exported 2,000,000 hides in the 30 years between 1633 and 1663 and nearly one and a half million in the following 30 years.[3] This works out at about 60,000 to 70,000 a year. But these are only the official figures; Dutch members of the company used to smuggle articles aboard the company ships to be sold privately on their own account. Other people must have joined in this profitable trade as, although it was a Dutch monopoly during the seventeenth century, it would have been very difficult for the Dutch, as foreigners, to enforce their monopoly in a foreign land. So perhaps the total number of animals which were killed every year even exceeded the horrifying figures estimated by Schouten and Van Vliet. The animals were shot down or hacked to death, and skinned while the bodies were still warm. Then the pelts were flung into boats or carts and borne off to the city. So horrified were the villagers by what they saw that they sometimes protested to the monks who petitioned the king, and on several occasions he banned the slaughter.[4]

Another, greater creature, beloved of the Thais, is the elephant. It seems acceptable to train them as work animals or as mounts for royalty, though most of us have never seen the prolonged cruelty needed to break such an

animal's will. The capture of wild elephants is a very ancient profession, surrounded by superstitions and associated with a special language. Much of this seems to come from India and was described by Megasthenese, a Greek ambassador to the court of the Hindu emperor at Patna about 300 BC. It is ironical that the Siamese, who exported so many trained elephants to India, or their ancestors, may have learnt the art of catching and training wild elephants from the Indians. A captured elephant is kept tied to the training post for a period of one to four months. Like modern inquisitors with their victims, the elephant's spirit was broken by a mixture of cruelty and kindness. The "animals are alternately starved and fed, coaxed and punished [often with fire]. Many animals die during this period, generally the older ones".[5]

There were many elephants kept at Ayutthaya: "Around Judia there are four to five hundred tame elephants. Some of them are taught to fight, others to carry artillery and provisions. These elephants are attended by two or three men, are fed in stables and get every day a bath in the river. They are highly valued for their strength, ability and intelligence. Some are trained every day in the art of fighting; others, males as well as females, are taught to carry artillery, tents, provisions and other necessities for the army".[6] A large number were reserved for royal use. When the king went by land to present new robes to the monks (the *kathin* ceremony) he was accompanied by a procession of 200 elephants, an awesome sight. In some parts of the country, the elephant would serve as a working animal or even as a mount, like the modern buffalo, and was loved accordingly. So it must have been repugnant to ordinary Thais to see the way in which these beasts were slaughtered for their tusks, which were then sent to Ayutthaya and traded. "The peasants form into large groups to hunt this beast. In accord with the famous saying, 'A fool kills his cows for the sake of the pasture lands', the natives slaughter this valuable wild animal for the sake of his tusks".[7]

George Orwell has written a memorable account of watching an elephant slowly collapse and die, felled by one shot from a modern, high-powered 'elephant gun'. 300 years ago, it must have been a prolonged and bloody butchery, a hacking with knives and repeated shots from feeble muskets. We cannot tell how many were killed, but the cool and factual accounts of the Dutch factors give us an inkling. To India, to Japan and to Formosa they exported 105,000 lbs of ivory in 60 years, nearly 50 tons of tusks. Not much, we may say, but this is only the visible tip of the ivory mountain. Elephant tusks were a strict royal monopoly, ordinary merchants could not dabble until the king had had his pick, and the Dutch, as foreigners, would have been relegated to the end of the line. They must have thought themselves lucky if they could collar 10 per cent of the market.

Live elephants were a valuable export, particularly (and surprisingly) to India. The author of *The Ship of Sulaiman* mentions this trade and is scathing about the rajahs who rode about on them: "One of the important sources of income is elephants and there are indeed many elephants in the jungles of

Siam. For a long time now the Siamese have been exporting elephants to the Dekkan and Bengal since these countries are not very far away. The heart of all Hindustan has been captured by the idea of leading about elephants in chains. But the cost of the elephant is so burdensome and heavy that the Indians have fallen ill. Their limbs suffer with elephantiasis and they are obliged to ride an elephant if they expect to move about. Every year merchants have been coming to Siam bringing commodities which the Siamese desire and in exchange the foreign merchants take away elephants. The king's administration itself makes money exporting elephants to India. Every year the king catches about three or four hundred elephants in the jungle and has his men tame them. Once the elephants are tame and can be ridden they are sold." And the profits were great: "A large sized elephant, five cubits high, will bring thirty *tumans* if the animal survives being shipped by sea to a foreign buyer but the merchants are doing well if they sell one in Siam for seven or eight *tumans*".

It must have been a gruelling journey for the poor creatures. Although very strong they have little power of endurance, as the British teak wallahs soon found out, and need to stop work for the day at noon. Having survived the horrors of 'training', they then had to walk for weeks (elephants walk very slowly – usually not more than 10 or 12 miles a day) across the plains of central Thailand, up into the Burmese foothills and then down through the forests and out to the shores of the Andaman sea and the Siamese port of Mergui. Next there was the appalling task of forcing the elephants to traipse across the gangway and on board ship. Finally they had to be persuaded to step on to a sloping plank down which they found themselves sliding into the hold. What a trumpeting there must have been, especially as some ships carried as many as 26 elephants. They had to be built 'exceeding Stronge' for such a weighty, and rumbustious cargo. Even so, there is a story of one which, enraged by his treatment, "with all the force he could possibly, did run his tooth through the Ship Side" and sank her. Although this and others like it have the flavour of travellers' tales, embroidered in the telling, there is no doubt that it was an extremely difficult and dangerous journey. The Andaman Sea can be exceedingly rough and the voyage was apt to last a fortnight. The Dutch East India Company at Ayutthaya was sometimes given elephants by the king as a mark of favour. But it was such a trouble to them to export the beasts that in the end they prayed to be given tin instead.

At least elephants were not wiped out in Thailand. Rhinoceroses were. Living so close to the Chinese with their craze for the less-ambiguous kinds of aphrodisiac, they had little hope. How many died we can never know. The Dutch, who must only have had a toe-hold in such a lucrative trade, were selling rhinoceros' horns at the rate of ten a year to Formosa alone. Presumably the horn was sawn off and passed down through many hands to the waiting merchants in Ayutthaya, while the carcass was left to rot or be gorged by predators in the jungle. What the Chinese merchants were able to have 'culled' we are left to imagine, but it must have run into hundreds. And

killing a rhinoceros with spears and bows and arrows is not a swift affair
Here is Mouhot's vivid description of a hunt by Lao villagers near Luang
Prabang: "I and my servants were armed with guns, and at the end of mine
was a sharp bayonet. The Laotians had bamboos with iron blades somewhat
between a bayonet and a poignard. The weapon of the chief was the horn of
a sword-fish, long, sharp, strong and supple, and not likely to break". With
these simple weapons they advanced into the forest for two miles. There
they came upon a rhinoceros "of the largest size... Without any signs of fear,
but on the contrary, of great exultation, as though sure of his prey, the
intrepid hunter advanced, lance in hand, and then stood still, waiting for the
creature's assault. I must say I trembled for him and loaded my gun with
two balls; but when the rhinoceros came within reach and opened his
immense jaws to seize his enemy, the hunter thrust the lance into him to a
depth of some feet, and calmly retired to where we were posted. The animal
uttered fearful cries and rolled over on his back in dreadful convulsions,
while all the men shouted with delight. In a few minutes more we drew
nearer to him; he was vomiting pools of blood... To myself was reserved the
honour of finishing the animal, which I did by piercing his throat with my
bayonet, and he almost immediately yielded up his last sigh".[8]

From the jungle too came the bird's plumes and peacock's tails which
provided fans for and adorned the houses of the rich. Again, we glimpse the
trade only through the eyes of the Dutch; 21,000 pieces exported to Formosa
alone, in 30 years. What must the total have been – 10 times this number?
This was no haphazard trade, trophies brought to market by individual
hunters in the jungle who were there for other prey. It was an organized and
continuous slaughter, done to satisfy the factors in Ayutthaya.

Of course, Thai country people were not aware of the need to conserve
wild animals. They may have been glad to see the end of elephants which
trampled on their rice fields, or of tigers which marauded their livestock.
And the killings must have been done by the villagers themselves, who
were paid for their butchery. But it was a trade organized by the capital for
the capital. Today it is eucalyptus trees or maize which ruin the soil and
enslave the farmers for the profit of the town. In either case the economy of
the country is distorted and the lives of the people upset for the benefit of
the capital. For the villagers it was unpleasant, for Ayutthaya it was fatal.
We read in the Ayutthaya chronicles of popular risings in the countryside,
often led by a 'holy man' or a monk (One such occurred near Lopuri in
1746). There is no suggestion that these were attempts upon the throne,
perhaps they were revolts against oppression and injustice by the
government in Ayutthaya. When, in time of need, the kings looked for
friends and allies, they found none. Not only did they antagonize the
common people – more foolishly, they antagonized their masters.

The kings of Ayutthaya seemed to expect more than was usual from the
other city states in the area. Sending tribute in the form of 'money-trees' or
even coming to drink the waters of allegiance was tolerable to local rulers,

but it was insupportable to have the young son of the king of Ayutthaya foisted upon one as one's new 'king'. This happened to Suphanburi, Sangkhaburi, Pitsanuloke and even to Sukhothai, all old city-states, and was done within 70 years of the foundation of Ayutthaya. It is no wonder that the Burmese, advancing on Ayutthaya down the Chao Phraya, were able so easily to subdue and then suborn the cities on their route. It is true that in Thailand, as in Europe, there was then no idea of nationhood or patriotism. Even the future hero-king, Naresuan, fought for some time on the Burmese side in north-east Thailand, and then went on to help them attack Vientiane. But there was usually a web of alliances between greater and lesser city states, strengthened by self-interest, which would hold against most attacks. The kings of Ayutthaya smashed through this system and replaced it with something more brittle.

To administer their growing empire and its population, the kings of Ayutthaya appointed general and provincial officials who were sent out from the capital to govern, tax or inspect. They were as unpopular as bureaucrats usually are. Their powers and duties were prescribed by law, and before they had had time to settle in to a post (and turn the system to their own advantage), they were liable to be moved on again. It was an efficient system, but it was cold and remote and caused ill-feeling.

At the centre of all this sat the king and his court. No longer the father of his people, who might come out and listen to their problems, but a god-like figure who had to be spoken of in special (and alien) language and who could only be approached through a maze of officials. It is said that the kings of Ayutthaya adopted the language and ceremony of the Khmer court passed on by those officials who stayed behind when the high tide of the Khmer empire receded. This no doubt is true, but it must have been a conscious decision on their part thus to elevate themselves above the people whom, by Buddhist teaching, they were born to serve.

Having put themselves on a pedestal, they then attempted to come down into the market place. As trade improved, so royal monopolies were imposed on the more popular goods. No one could buy or sell until the king's factors had taken their pick – at a price they set. It is true that this was customary throughout Asia and that it was not a barrier to trade; if it had been, merchants would have gone elsewhere and it is clear they didn't. It is also true that only the king, armed with his monopolies, was strong enough to compete with foreign merchants and, later, foreign companies. But it made the king extremely rich and the monarchy became a prize to be gained, and fought over.

As the bounds of empire widened, so the form of government had to become more complex – and far-reaching. The main provisions for a civil service were laid down as early as the middle of the fifteenth century. The bureaucracy was divided into two: military (the Kalahom) and civilian (the Mahatthai). Each had numerous departments which seem to have been reasonably effective. At least they were able to produce the quantities of

conscripts who were needed to fight the wars in which Ayutthaya was almost constantly engaged. But the power which these heads of government wielded, particularly the Phra Klang, who was in charge of trade, and the Kalahom, who was in charge of the army, made them able and indeed keen to support a new claimant to the throne. There was a law of succession, but it was often ignored. Instead the claimants resorted to violence, spectacular and bloody.

In 1424 the two elder sons of King Indraracha, unable to agree which of them should succeed their father, fought a duel on elephant back. At the end of the fight both lay dead on the field and their younger brother stepped up to the vacant throne. In 1533, the child-king, Ratsadathirat, was murdered by his elder half-brother, who then ruled as King Chairaja . When he died in 1547, his wife had their elder son poisoned, made her lover (a minor court official) king and executed those who protested. Eventually the nobles rose in revolt and had the usurper murdered. King Maha Thammaraja was installed as King of Ayutthaya by the Burmese themselves in 1569, when they had stormed and looted the capital. He remained there as puppet king until his death 21 years later. But his two brave sons, Prince Naresuan and Prince Ekathotsarot, more than redeemed the royal name. Together they drove out the Burmese and together, it seems, they ruled the country and restored its trade and its self-esteem. But soon this bright scene darkened once more and foreign shadows lurked and threatened.

As good King Ekathotsarot lay dying, it was whispered that his eldest son and heir, Prince Suthat, was plotting against him. Perhaps driven by the apprehensions of old age, the king had his own son executed. Sadly, it was all a fiction, put about by a palace official in league with a group of Japanese now, weirdly, serving the Thai king. Out of the muddle emerged King Songtham. Although he reigned for eighteen years and had plenty of time to do so, he never appointed himself an heir or trained anyone for the task of ruling the country on his death. This proved fatal for his family. First his younger brother, who might have become king, was murdered, and then both his teenage sons as well as all their supporters. The man behind this was one Phraya Suriyawong, the Kalahom. Having cleared his path, he made himself king. He reigned under the soubriquet of the 'King of the Golden Throne'. But he reaped as he had sown. When he died his brother and his two sons jostled for the throne. Ayutthaya had three kings in two months; what Sons of Heaven were these? The uncle, King Sri Sadharmaraja, tried to rape his niece, and was hustled off the scene by his nephew, who had already dethroned his own elder brother. Now he emerged victorious but the people who had brought him to the throne were foreign, some say Japanese, others Persian, and perhaps the Pattani Malays had a hand in it too. He is better known as King Narai.

These unedifying scenes were played out before the world. La Loubère, the French diplomat, counted 21 foreign envoys at court: the Thais retorted that there were normally 40. They reported on the wealth of Ayutthaya and

the trade to be won; they also reported on the instability of the kingdom. Much of King Narai's attention was concentrated on containing foreign threats to his kingdom, from within as well as from without. If the art of politics is the art of the possible, then King Narai was indeed a politician and, until his dying day, he skilfully balanced the diverse threats opposed to him. But, like his predecessors, he never appointed an heir to the throne. On his death the man who had been raised as his foster brother, Petraja, murdered the king's two brothers and his adopted son and forced King Narai's sister and daughter to marry him. He then made his own grown-up son, Luang Sorasak, heir to the throne and installed him in the palace of the Wang Na. He gave two other of his followers royal rank and housed them in the Wang Lang. Within a year they had both been murdered – by Sorasak!

In due course Petraja's two royal wives had sons. When the elder was 12 years old and his father lay dying, Sorasak had him clubbed to death. Petraja, in a fury, named his nephew as his heir – surely an unsought honour. But the lad stepped aside and Sorasak mounted the slippery throne. He was nicknamed 'King Tiger' and was rumoured to have taken part (disguised) in a local boxing-match, winning first prize of two baht. These and other more unsavoury stories were told about him and, whether true or not, they show how degraded the kings of Ayutthaya had become in the eyes of their people. They were now 'Lords of Life' only in the sense that they wielded the power of life or death, and wielded it for their own, sordid ends. They no longer embodied the spirit of the nation for which men would willingly lay down their lives.

But such is the Thais' innate reverence for monarchy, that even a dynasty with such squalid beginnings as Petraja's almost succeeded in establishing itself. King Tiger had the sense, or more probably the undisputed power, to name two of his sons as his heirs. Even so, he trusted them so little that he often had them flogged. When he died, his elder son was accepted as king (Tai Sa) and ruled with some success, and with the loyal support of his younger brother, Prince Pon.

Prince Pon, who had been made *Uparat*, might well have expected to succeed his elder brother but King Tai Sa, on his deathbed, foolishly bequeathed the throne to the middle of his three sons. The eldest was in the monkhood, and prudently remained there, leaving his younger brothers to fight it out with their uncle, which they promptly did – and lost.

Confusion was, once more, assured. The Phra Klang, a prominent Chinese merchant, threw in his considerable lot with the sons in the Grand Palace. Their uncle gathered his more meagre forces at the Palace of the Front and a battle royal then ensued. It was won by Prince Pon with the stout help of Khun Chamnan Channarong, who routed the royal forces and stormed the Grand Palace. He became king with the name of Boromma Thammikkarat. After his death he was referred to as King Borommakot, a lugubrious title; it means 'the king in the urn' [awaiting cremation] since he was the last king to be granted that unpleasant honour. (The preparations for this style of

burial are gruesome – before *rigor mortis* sets in, the joints of the dead person are broken, the body is forced into a foetal position, the limbs are pinned and the squatting corpse is rammed upon a spike).

However, King Borommakot ruled with wisdom and dignity. He came to the throne at the age of 53 and reigned until he was 78. Did age lend maturity to his rule? (After the fall of Ayutthaya, older Thais looked back to his reign as a golden age.) It is surprising how quickly the king and his ministers were able to use the inherent power of Ayutthaya to raise the country once more to its pre-eminence. They placed their supporter on the throne at Phnom Penh and later, toppled his successor, who was backed by the Vietnamese. The King of Burma sent an embassy to the court of Ayutthaya, after a gap of nearly 100 years. And it was to Ayutthaya that the Buddhist Sangkha of Sri Lanka sent a mission to ask for Thai Buddhist monks to come to Kandy to re-ordain its own monks and re-establish its Buddhist scriptures. The Siamese sent two missions to Sri Lanka, in 1753 and 1755. They were grand and dignified affairs. The monks bore with them Buddha images, the Tripitaka, and a letter from the king, written on gold. Fortunately, the monks had no idea of the hardships in wait for them. Their boat sank in the mud off Nakorn Sri Thammarat and it took them 18 months to reach their destination. Two-thirds of them died there. The second mission was shipwrecked off the coast of Sri Lanka, though most of the monks were rescued from drowning. These Siamese monks stayed in Sri Lanka for years. They ordained hundreds of new monks, provided them with a complete set of Buddhist scriptures and helped them to establish the annual 'Perahara' in Kandy in its present form, in which the sacred relic of the Buddha's tooth is paraded round the town – until then it had been a Hindu ceremony.[9] Sri Lanka had always been regarded as the spiritual centre of Hinayana Buddhism, so it was something of a triumph for the Siamese that they were able to send two delegations of monks to Kandy and that the Sri Lankan monks they ordained were known as 'Siam-wong'. There is an interesting wall-painting at Wat Buddhaisawan in Ayutthaya showing monks on a pilgrimage to Adam's Peak. If the Siamese contingent did indeed get to the summit, it must have been quite a climb for the usual rather portly monks brought up on the flat plains round Ayutthaya.

After these achievements, it is a tragedy that King Borommakot was unable to ensure that his dynasty endured. On the Asian stage Ayutthaya was pre-eminent; at home its behaviour seems turbulent and childish.

In 1734 a group of 300 rowdy Chinese stormed and entered the royal palace while the king was away upon a hunting expedition. In 1735 one of the king's sons attempted to assassinate his cousin, who was at the time a monk. In 1755, the king's eldest son and heir was accused by his half-brothers of having a love affair with one of his father's three queens. Both he and the queen were flogged to death. The country was now without an heir to the throne. The old king must have remembered the days when his own elder brother, then king, refused to suggest a successor and the chaos

and bloodshed that ensued. But it was only on his deathbed that he stated a preference for Prince Uthumporn as against his elder brother, Prince Anurak Montri. Inevitably, when the king passed away, there was a princely squabble. Three princes got together to oppose Prince Uthumporn, but he forestalled and then executed them and had himself crowned. But his elder brother remained obstinately in the royal palace and in the end it was Prince Uthumporn who gave way. If the royal brothers had known the fate that was ahead of them, neither would have contested the throne. King Borommaraja was to flee the flames of Ayutthaya in a small boat, as the Burmese sacked the city, and is said to have died of starvation. His brother, ex-King Uthumporn, was led off to Burma, where he ended his days recounting to his captors what he could remember of the history of the kings of Ayutthaya.

It had all begun so differently. "The inhabitants of Siam and especially the learned men still speak with admiration and great respect of the Chinese exile, their first king. Many still worship his spirit which, they think, is living amidst them. They praise him as a wonder of the world, saying that he has not only been the founder of such a powerful Kingdom but that he has also ruled the entire country of Cauchenchina up to Jamby, that he has subjected by wars the inhabited countries and has ruled many years in peace. Besides this he has been the first legislator and the founder of their religion, and although he kept the sovereign power over the world as well as over ecclesiastical affairs in his own hands, he made orderly, excellent and praiseworthy rules for the various branches of Government as far as was necessary for a country ruled by a monarch. Also he has given rules for the administration of justice, criminal as well as civil. All these laws and foundations of religion he has written himself and bequeathed them to his subjects. These original books, together with others which were added in later years, are still kept in Judia, in the King's finest temple, now called Wat Siserdpudt, and are held in great honour. At last this King, having lived more than two hundred years, came to the end of his days and died as emperor over one hundred and one crowned kings, leaving to his successors a founded and populated monarchy well provided with excellent written laws and perfect prescriptions".[10]

This panegyric to the somewhat nebulous figure of King U Thong indicates what the Siamese felt their king should be: the fount of laws, the guardian of religion, the protector of the realm. Some kings came near to this ideal, many failed utterly. What went wrong? At the root of the matter lay the succession. There was no law or even custom which people were prepared to abide by, least of all the princes. Kaempfer describes the situation well: "By virtue of the ancient laws of Siam upon the demise of the King, the Crown devolves upon his Brother, and upon the brother's death, or if there be none, on the eldest Son. But this Rule hath so often been broken through, and the Right of Succession brought into such a confusion, that at present upon the death of the King, he puts up for the Crown who is the most powerful in the Royal Family, and so it seldom happens, that the next

and Lawful Heir ascends the Throne, or is able to maintain the peaceable possession of it".

Might, then, was Right, and power was in the hands of those who could summon men to their cause. It was not the king, or his brother or his eldest son who had this power, but the great officers of state who controlled the manpower of the realm. Added to this, one needed a certain dash, a recklessness even, to risk all and carry the day. The rewards were great, but dreadful were the penalties for failure. Five times in 400 years, the entire royal family was wiped out. More and more the kings were surrounded by 'yes-men' while people of real ability and worth stayed away.

Where could a king turn to for support, not for himself, but for his heir? Some relied upon one or other of the ministries which controlled the manpower of the realm, the Kalahom and the Mahatthai. These men might be loyal to the prince whom they had brought to power, but they seldom gave the same support to that king's heirs and successors. Other kings tried to give the control of manpower to the princes. Others, again, looked to foreigners for support. And so one had the strange, and rather sad, spectacle of a king who might have a Persian or a Greek as chief minister, a Chinese and an 'Indian' as his ministers of trade, Japanese in his royal guard and Portuguese to man his guns. Some found it odd that King Chulalongkorn had a Dane to run his navy, a Belgian to manage the legal system, an Englishman in charge of the police, and many more suchlike; but it was a system adopted by Siamese kings in time of need since the days of Ayutthaya, and generally it served them well.

1. David K. Wyatt, *Thailand – A Short History*, p. 73, Yale University Press and Thai Wattana Panich, 1984, p. 73.

2. Van Vliet, *Beschrijving van het koningrijk Siam* (*A Description of the Kingdom of Siam*). Translated by L. F. van Ravenswaay, *Journal of the Siam Society*, Vol. 7, part 1.

3. These figures are taken from the Dutch East India Company records, published by G. V. Smith in *The Dutch in Seventeenth Century Thailand*. (See Chapter 1, footnote 6 above).

4. G. V. Smith, p. 171, footnote 24.

5. F. H. Giles (Phraya Indramontri), article in *The Siam Society Journal*, vol. XXIII, part 2, 'Adversaria on Elephant Hunting'.

6. Van Vliet. *op. cit.*

7. The Persian diplomat & chronicler who wrote *The Ship of Sulaiman*. (see Chapter 1, footnote 3 above).

8. Henri Mouhot's Diary abridged and edited by Christopher Pym. Kuala Lumpur, Oxford University Press, 1966.

9. W. M. Sirisena, 'Cultural Relations between Ayudhya and Sri Lanka' in the 'Proceedings for the International Workshop on Ayutthaya and Asia', December 1995.

10. Van Vliet, *op. cit*, p. 9.

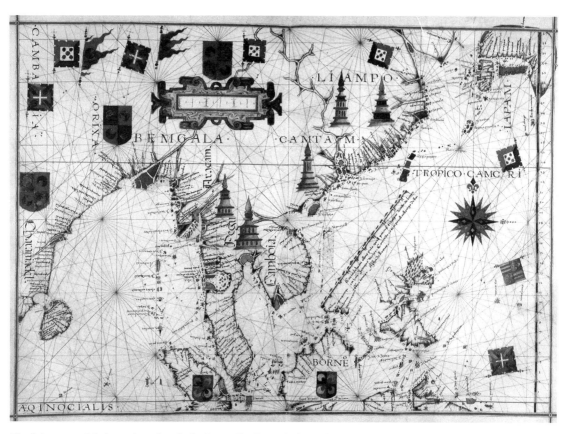

The Orient, one of the leaves from the atlas by Fernão Vaz Dourado dating from approximately 1576.
(Courtesy of the Portuguese Embassy, Bangkok)

The Portuguese and Spanish in Ayutthaya

T he Portugese were the first westerners to arrive in Siam. They turned out to be the most peaceful, useful and adaptable of all the foreign settlers. In fact they are still here; the only foreign community to have survived from the day it arrived on Thai soil.

The Portuguese drive to the East, started in the fifteenth century by Henry the Navigator, led them first to India and then to Malaya, where they took Malacca in 1511. Hearing of the wide-reaching power of Ayutthaya and its claims over the peninsula, Albuquerque sent an 'ambassador' who arrived, rather modestly, aboard a Chinese junk. However, presents were exchanged, King Rama Thibodi II sent a Siamese ambassador in return and in due course (1518), a trade treaty was drawn up,[1] the first treaty between the kingdom of Ayutthaya and any western power.

The Portuguese explorers had, meanwhile, moved on. They had already begun to trade with ports in the Persian Gulf, Arabia and in the Red Sea, from their base at Goa. From there they had moved to Ceylon and explored the eastern coast of India, Arakan, Pegu and Sorian. Next they were pushing along the coasts of Annam, Champa and Tonkin until they finally reached China itself, where they settled down at Macao. From here they explored the interior of China and Japan. It was a Portuguese Jesuit, Bento de Goes, who made the first known overland journey by a Westerner from India to China, in 1605. And it was another Portuguese Jesuit, Father Andrada, who 'discovered' Tibet in 1622. Portuguese merchants, meanwhile, were moving towards the lucrative spice islands. They bought and sold goods in Sumatra and Java, at the Molucas Islands, Ternate and Tidore. In the Celebes they did business at Macassar. They found their way to Borneo, Banda and Bintang and also Sunda and the Flores Islands and Timor, and a dozen other places.[2] It is possible that they reached the coast of Australia. At the same time they were developing their great empire on the other side of the world, 'The Land of the Holy Cross', or Brazil. But the spice islands were their most valuable discovery in terms of trade. Unfortunately it was difficult to decide whether the islands 'belonged' to them or to Spain by the terms of the treaty arranged by the Pope. In the end the Portuguese government paid Spain 350,000 gold ducats in 1524, an enormous sum at that time, to stay out of Eastern waters, except for the Philippines.

The reason the Spanish could claim the Philippines is curious. During the later years of the fifteenth century, it was Spain and Portugal alone who were racing to discover trade routes to the Spice Islands, and finding (and

founding) a great many other bases on the way. Conflict was bound to occur. As both countries were Catholic, they submitted the problem to their spiritual head, the Pope in Rome. Calling for a map, albeit then an extremely inaccurate one, Pope Alexander VI drew a vertical band through Cape Verde and round the world, slicing the globe in two. All unknown lands to the east of the Line of Demarcation were open to the Portuguese to explore and convert; this gave them Brazil. All unknown lands to the west fell to the Spaniards, which is why the Philippines eventually became a Spanish colony and remained so for 300 years. (One somewhat bizarre consequence of the Spanish occupation of the Philippines was that Spanish galleons were sometimes to be seen sailing up and down the Chao Phraya river trading with Ayutthaya, as we shall see).

Sailing across the globe led the Portuguese to make many improvements to the ships of the day. They were, for instance, the first Europeans to use the rudder, while to sail across the stormy Atlantic they developed a stout ship with a capacious hold, the forerunner of the galleon. To find their way along these myriad coasts and seek out safe watering places, they compiled maps and sailing directions, known as *roteiros* or 'rutters', which were kept secret. It is interesting that Christopher Columbus, who married the daughter of a Portuguese sea-captain, inherited his father-in-law's maps. The Portuguese had already worked out a fairly accurate estimate of the size of the earth, and it was probably these Portuguese maps which persuaded Columbus, and his Spanish backers, that the shortest way to the East Indies, lay to the west.

Everywhere they went, the Jesuits sailed with them. Trained as mathematicians and astronomers, they were great map makers. Father Ricci published a map of the world in China in 1602, so that the Chinese might comprehend its extent. (They did, after all, claim to be at the centre of it). To protect their trade routes, which extended to the limits of the known world, they built over 100 fortresses and bastions along the shores of Africa, Southern Asia and the East Indies. One of their greatest fortresses, 'A Famosa', can still be seen, in ruins, at Malacca. This city was apparently well worth defending: "Men cannot estimate the worth of Malacca, a city that was made for merchandise, fitter than any other in the world. Whoever is lord of Malacca has his hand at the throat of Venice". Thus wrote Tomé Pires to his king in 1516. A perceptive remark, for it was via Malacca that goods from the Spice Islands passed eventually into the hands of the Arabs and so to Egypt, where they were bought by the Venetians and sold by them throughout Europe. Spices were a very profitable cargo. Later, the British East India company merchants reckoned they could make a profit of 1,000 per cent on each ship-load of pepper they were able to bring safely back from the Indies. Pepper had long been known in Europe and was extremely valuable. In the fourteenth century peppercorns were worth their weight, literally, in gold; and because of their purity, were regarded as a more reliable token of exchange than gold itself.

When one thinks of the distances to be covered, the sea lanes to be guarded, the fortresses to be garrisoned, the fleets to be manned, the trading outposts to be maintained, one imagines all this to be the work of some great imperial power. But Portugal was a tiny country. It had not more than one million people, most of them farmers. They often had to defend themselves against the attacks of their mighty neighbours, the Spaniards; and, like most European people at the time, they were frequently decimated by plague.

As well as seeking trade, the Portuguese brought Western inventions to the East, and introduced plants, fruits and vegetables from one country to another. Although they introduced the printing press and moveable type to Japan in the sixteenth century, unfortunately they did not bring it to Siam, which only benefitted from moveable type in the nineteenth century. The same opportunity was lost regarding the treatment of leprosy long endemic in Thailand. The Portuguese set up hospitals and built a leprosarium in Macao in 1569 but the first Thai leprosarium was not built until the end of th 19th century.

The Portuguese did introduce new drugs such as 'cinchona' and 'ipecacuanha'. From Brazil, they brought sweet potato and maize, tomatoes, watercress, lettuce, cabbages, okra and pimentos. Among the fruits they brought were custard apples, guava, papaya and the pineapple, which became fashionable in seventeenth century Europe both as a fruit and as a form of decoration in stone. They also brought tobacco back to Lisbon, claiming it had medicinal qualities. The French ambassador to Portugal was one of those who examined this curiosity from the New World and sent a report on it to Paris. His name was Nicot and this has passed, perhaps a little unfairly, into the languages (and the lungs) of the world as 'nicotine'. More usefully, they took coffee to Brazil where, of course, it became a staple crop. This coffee came from Asia; other plants the Portuguese brought back from Asia were oranges, tangerines, tea, lilies, tea-roses, chrysanthemums and camelias. The Portuguese were intrigued by Asian drugs. Tomé Pires described them nearly 500 years ago (in 1516) and Garcia da Horta wrote a book on the medicines of Asia and published it in Goa in 1563.

Only a few ripples of this tidal wave of curiosity and discovery which surged across the oceans of the world in the sixteenth century seemed to travel into the Gulf of Siam. Life in Ayutthaya was relatively unaffected by their presence but this was a consequence of the way the Portuguese settled their colonies and trading posts.

It was due to Albuquerque, the governor-general of Portuguese territories in Asia. Professor Edgar Prestage, who wrote so much on the Portuguese voyages of discovery, said of Albuquerque, "(his name) is still the greatest, not only of the Portuguese in the East, but in the annals of the Indian Ocean. His captains and men deserve well of us for... the achievement of the Portuguese in the East would have done credit to a great power, and when carried out by a small kingdom, they read like a romance". (Some might call it a rape; for it was an empire won by the sword. When Albuquerque

captured Goa in 1510 his troops entered the town and murdered all the Muslim defendants. He then forced their women to marry his soldiers and so people the town with a permanent garrison). But in countries where the Portuguese settled and traded, he encouraged his men to marry the local women. Their children would become the clerks, the artisans, the shipbuilders in the country of their birth. This disgusted narrow-minded westerners: "their children, got upon black women", as Kaempfer wrote with disdain in the seventeenth century, "a poor, gibbering half-caste", as Crawfurd wrote of the port official sent to meet his party in the early nineteenth century. In fact, it was a clever and an enlightened policy. These children, and their children after them, spoke the language as natives and understood the customs of the places where they worked, in a way that merchants brought out from Europe could never do. Their mothers were the accepted wives of their European husbands and their children were brought up as part of the family. In Portuguese territories these descendants of settlers were given special privileges and often distinguished themselves in the army, in courts of justice, in finance and in the civil service. For a mother country with such a tiny population, it was the only way to run her colonies.

Ayutthaya was no colony, but the Portuguese settlers did serve the kingdom in many, and often distinguished ways. They were the first westerners to arrive and, because of Albuquerque's policy of intermarriage, they are still here. Their arrival in 1511 caused a stir – no one in Ayutthaya had ever seen a white man before. King Rama Thibodi II, with that courtesy which Thai royalty has always extended to foreign delegations, however unexpected their arrival or odd their appearance, ordered a captain and 200 of his soldiers to accompany the little band to the palace. But news of their arrival went before them and hundreds of people rushed out into the streets to peep and peer at these strange, white-skinned men with their long, white beards.[3]

After this first, tentative contact, a number of missions were sent until a Treaty of Friendship and Commerce was drawn up in 1518, the first between Siam and any Western country. The famous 'Bowring' Treaty of 1855 between Siam and Great Britain, which led to diplomatic and trade contacts between Siam and many other Western countries, was made some 340 years later than the treaty with Portugal. The Portuguese, who had already had some experience in dealing with 'native princes', gauged the needs of their new ally, and sent that usual and most deadly gift of the West – guns, and the men to fire them. Although the Arabs were the first to bring guns to Asia from the West, the Portuguese were the first to send a detachment of soldiers with guns, show Asians how to use them and later, how to make them for themselves. (There was to be a Portuguese gun foundry at Ayutthaya).[4]

Just before this treaty was signed, the northern kingdom of Chiang Mai had annexed Sukhothai and Kamphaeng Phet, which King Rama Thibodi II felt were within his sphere. Now here was a force to hand with which to teach his rival monarch a lesson. So, this little contingent of Portuguese soldiers, with their muskets, soon found themselves being marched off to

Lampang. It must have been a strange experience for these farm-boys, fresh from the vineyards of Portugal, to find themselves tramping across dried-up rice-fields under a tropical sun, living on rice and *nam pla* for weeks; and surrounded by laughing and chattering 'natives' eager to talk to them but having hardly a word as yet in common; and all off to some foreign field to fight some unknown foe. In the end they met the Chieng Mai contingent on the banks of the river Mae Wang and defeated them. One would like to know whether they brought some cannon with them, lashed to boats and toilfully hauled upstream for weeks. Or whether the issue was settled with the crackle of musket fire. One pictures a short and not very bloody affair. After all, the muskets of those days were very inaccurate but quite alarming; so, too, must have been the faces of those Portuguese soldiers. (One recalls how the Siamese in Ayutthaya rushed into the street to stare at the Portuguese when their delegation first arrived.) And to see 100 or more of these strange creatures suddenly popping up in a rice field, and then firing some strange new weapon at you, must have made the boldest conscript turn and run. Whatever did happen that day, we are told that, after it, the north remained quiet for 30 years.

The Burmese were the next to come upon the Siamese secret weapon. Attacking Ayutthaya in 1549, they found themselves being fired on by guns laid out in forts around the city. But the fire was smartly returned, as the Burmese had also equipped themselves with a Portuguese contingent! "And so", as the Thais say jovially, "the *farang*s were now fighting the *farang*s". From now on, Portuguese and sometimes Spanish, and later Japanese, troops were to be found in Asiatic armies. When King Naresuan attacked and defeated the Cambodians, he found Spanish and Portuguese soldiers of fortune amongst his bag of captives. One of them was to have a distinguished future. Diego Velloso married a Cambodian princess and became the ruler of Baphnom. There is said to be a bust commemorating him on a pedestal at Neak Luong, near the Mekong river.[5]

King Chai Rajathirat, who came to the throne not long after the Portuguese arrived, used a contingent as his own private bodyguard. It is said that they were better shots; they may also have been more loyal. (Not perhaps because they were inherently more honest than the Siamese; simply that they, as foreigners, were more difficult to suborn). Certainly, the Portuguese did acquire quite a reputation as sharp-shooters. In 1581 there occurred one of those spontaneous rebellions of country people, led by a self-proclaimed 'holy man', which indicate that the life of the Thai farmer was not as idyllic as frequently portrayed. This one broke out quite close to the capital, between Ayutthaya and Lopburi. It was close enough to alarm the court. A 'foreign' sharp-shooter (almost certainly a Portuguese) was called up and shot the holy man. After this his followers, demoralised, drifted back to their homes. Nine years later, when King Naresuan fought the Burmese Crown Prince on elephant back, it is said that the Thai king, wounded in the duel, called on two Portuguese musketeers to shoot his

enemy dead, which they promptly did.[6] A garbled version of the same incident appears in *The Ship of Sulaiman*, where the Persian embassy was told that King Naresuan, much provoked, "attached a firearm beneath his elephant prod ... took aim with his goad and before the (Burmese) prince knew what had happened, he fell from the happy elephant of life on to the earth of humiliation and was dead".

It is interesting to note how often in the annals of sixteenth century Thai history, one stray shot killed an army leader, whereupon the soldiers, leaderless, prudently melted away. King Naresuan himself had already been involved in one such episode when he shot and killed the Burmese general, Surakamma, who was sitting on his elephant on the other side of the river Satong. After this the Burmese pursuit petered out. To commemorate this event, King Rama I commissioned a musket which is among the 'eight weapons of sovereignty' presented to the Thai monarch at his coronation. It replaced King Naresuan's own musket which was preserved by the Thais for 200 years but perished in the sack of Ayutthaya. On another occasion, well-known to all Thai school children, Naresuan pursued a Cambodian nobleman, Phraya Chin Chantu, who had first sought sanctuary with the Siamese and then betrayed them, down the Chao Phraya river by war canoe and out into the Gulf. A lucky shot from the Cambodian ship hit the cannon mounted in the bows of Naresuan's boat and smashed it to pieces. Guns, first introduced by the Portuguese, had indeed become the arbiters of battle in sixteenth century Thailand.

The Portuguese were also renowned as designers and builders of forts and fortifications. In 1550, after the first Burmese siege of Ayutthaya had been called off, King Chakraphat of Ayutthaya had the old earth walls levelled and replaced with ramparts of brick. As the walls are approximately 11 kilometres long it must have required tens of millions of bricks to construct them, even if, as one supposes, the core was filled with earth. There was little call for bricks at Ayutthaya, except to build a new temple (even the the Grand Palace was made of wood) so one can imagine the construction of hundreds of kilns outside Ayutthaya, such as one can still see off the main road which bypasses Ayutthaya to the east. And these kilns must have been kept busy, day and night, for months, to supply the sudden demand from the capital. It seems likely that the Portuguese, who are said to have sent out soldiers to instruct the Siamese in the art of western warfare and help them construct fortifications, would have helped in the design of the walls and bastions. These bastions or gun-towers projected at an angle beyond the walls and enabled the defenders to fire at point-blank range into the flanks of the besiegers, huddled up against the walls.[7] When the Burmese returned at the beginning of 1569, they laid siege to the city for eight months without gaining an entry. In the end, they began to construct a causeway across the river and right up to the foot of the walls in an attempt to breach them. However, realising their difficulties, they resorted to a more devious stratagem. The king and his advisers were credulous,

certain Thais were treacherous and the Burmese were in. It is a fact, sad but true, that on both occasions when the Burmese entered Ayutthaya, they were only admitted through this treachery from within. With effective leadership and determined resistance, the Siamese might have held out for another year.[8] That, or the Burmese would have been forced to withdraw due to the rising flood waters of the Chao Phraya. At any rate, the brick wall, perhaps built with Portuguese help, had justified itself. The Burmese were so impressed they pulled down the walls of their own capital, Pegu, and rebuilt them in the new Siamese style.[9]

Meanwhile Portuguese merchants were capitalizing on the popularity of their soldiers, and coming increasingly to trade. It is said that they sent rice and ivory and benzoin, indigo, sticklac and sapanwood down to Nakorn Sri Thammarat and Pattani and brought back tin. They also brought the art of neilloware to Nakorn Sri Thammarat about 400 years ago and it is still the main product of that town. But really very little is known about this early trade, or of the Portuguese merchants. In 1511, Albuquerque sent one Manoel Fragoso to stay for two years and write a report on what he found. Dr. Joaquim de Campos (writing in 1940) believed it to be extant, but it has never turned up. There are a number of Portuguese accounts of Ayutthaya in the sixteenth century which are by far the earliest of any European descriptions, but they are unreliable. We can say with certainty that only one of the writers, Pinto, had ever visited the city himself. His description of Ayutthaya is mostly renowned for the phrase, 'the Venice of the East'. Perhaps we should see this comparison as a comment on the wealth and importance of Ayutthaya since the Portuguese regarded Venice as the greatest trading city on the Mediterranean, rather than as a comment on the number of her canals. He also observed that there were no less than seven mosques in Ayutthaya, showing that the Muslims were well established residents in Ayutthaya by the middle of the sixteenth century. Several writers heard a Muslim name for Ayutthaya, which sounded to them something like 'Shakr-i-nao' or 'Sornau' or 'Sher-i-naui'. This is surely a corruption of 'Shahr Nav', which is what the Muslim author of *The Ship of Sulaiman* called Ayutthaya in the seventeenth century. It means, simply, 'the City of the Boat', and was the way Muslim traders normally referred to Ayutthaya. The Muslims, like the Portuguese writer, Pinto, saw Ayutthaya as a city of water-borne trade.

At any rate, despite the predominance of Muslim and Chinese traders in Ayutthaya there was still room for *farang* merchants. By the middle of the 16th century there were said to be 300 Portuguese living outside Ayutthaya, Some no doubt were soldiers of fortune, but many must have been merchants. They seem to have settled here, married and had large families because when the King granted them a piece of land for their community, it stretched for no less than two kilometres along the western bank of the Chao Phraya. It is said that at one time there were some 2,000 households and three churches, whose foundations have been located only 200-300 metres

apart, were built to serve the community. All this suggests a fairly densely-inhabited little community or 'island'. It was in fact sometimes called 'The Island of the Portuguese', instead of the more common 'Ban Portuges', since it was surrounded on the landward side by a canal.

Despite this presence the history of the Portugese gradually merged with that of the common people of Ayutthaya. Portuguese became the *lingua franca* for foreign merchants in Ayutthaya, the only language by which Dutchmen and Chinese, Macassars and Swedes could, through an intermediary, speak to each other. This suggests that the descendants of the early settlers, even if only fractionally Portuguese, could still manage the rudiments of that difficult language. Indeed, Portuguese persisted as the international language right up into the nineteenth century. When the Thais and the Americans signed the so-called 'Roberts' Treaty of Amity and Commerce in 1833, the two sides could not read and understand the two copies of the treaty, written in each other's language. So two translations were appended, one in Chinese, and the other in Portuguese.[10] This was 300 years after the Portuguese had arrived. How had a working knowledge of the language persisted so long?

Even today, we use Portuguese words in everyday Thai speech, as when we refer to bread as *khanom pang* or a hall as a *sala*. Portuguese sweetmeats have also passed into the everyday life of the Thais. *Thong yip, thong yot* and *foi thong* are said to have come from the Portuguese. One can still see them being made, by ladies of enormous girth and no doubt Portuguese ancestry, in that curious enclave of Portuguese descendants on the west bank of the Chao Phraya, just below Wat Kalayanamit. It is said that they were introduced to Thailand by the Portuguese wife of Phaulcon, the 'adviser' to King Narai. However, as the Portuguese had already been in Siam for 100 years or more, it is much more likely that they had long taught their Thai wives how to cook some of their favourite puddings.

The Portuguese merchants were unlucky in their timing. For much of the 16th century the Siamese were at war with Burma, Cambodia and Chieng Mai. It was difficult at such a time to send men out into the countryside to collect goods from the interior to export to Malacca. Besides, administration in the capital would come almost to a halt with the king and his counsellors away for months at a time; all trade was in the hands of the king and merchants could not traffic with foreign countries unsupervised. Far worse was the fact that twice in 20 years (in 1548 and 1568), the Burmese invaded Siam. They swept down from the hills into the central plains with armies of several hundred thousand men and after months spent subduing local resistance or, more probably, intimidating small towns into lending them men and provisions and boats, settled down to invest Ayutthaya. In times like these, one can imagine the little Portuguese community feeling very frightened and lonely. They were still the only foreigners at Ayutthaya. Help was far away, in Malacca, several weeks' sailing from Siam. The prosperous Portuguese village with its three churches would draw the eyes of the

plundering Burmese, especially as it lay unprotected outside the walls. If the enemy drew close, perhaps the city gates would be opened and they themselves would be allowed inside. Safe themselves, they would watch their possessions looted and their houses and churches put to the torch.

Eventually, in 1569 Ayutthaya was sacked by the Burmese and thousands of prisoners were led away, including the king who died on the long march to Burma. Unfortunately we have no Portuguese accounts of what happened, and the Thai records, such as they are, were concerned with the deeds of kings not commoners. Wars in Asia were waged more to gain manpower, especially skilled workers than to punish the enemy. So one can imagine that the Burmese took back with them many Portuguese, or men and girls of Portuguese descent, the men for their skills, the girls for their fair skins.

The first Burmese destruction of Ayutthaya was not intended to obliterate the city. Indeed the Burmese needed it as an outpost of their power on the Chao Phraya, for their eyes were set on eastern horizons and they needed to secure their rear. So they installed a puppet king and left a garrison. Gradually, life must have returned to normal and such Portuguese as remained went back to their settlement. The Lao, under King Setthathirat, were now the only people left to oppose King Bayinnaung of Burma. In 1574, the Burmese attacked the Lao city of Vientiane, destroyed it and led away to Burma all possible claimants to the throne. The Burmese were now masters of the subcontinent from Arakan and Manipur to the frontiers of Vietnam. The Thai kingdoms were at their lowest.

In 1580 the Thai puppet government was allowed to rebuild the walls of Ayutthaya and from then on Prince Naresuan was fighting and scheming to regain the kingdom. But the state was poor. No junks were sent to China for 10 years (1600-1610) compared with six or seven a year at the beginning of the sixteenth century. There was virtually no trade with India and unstable conditions had driven the international merchants away. Without its entrepôt trade Ayutthaya was nothing – a city of ostentatious but dilapidated buildings and silent quays. It had sunk back to the level of any of its inland client states, Chiang Mai or Sukhothai.

The Spanish

King Naresuan came to the throne of Ayutthaya in 1590 and spent the 15 years of his short reign re-establishing the traditional boundaries of the Siamese trading empire. Cambodia was once again made a vassal state, and the little trading kingdoms dotted along the Malay shore, Pattani, Ligor, Phattalung and Songkhla, acknowledged Ayutthaya as their suzerain. To rebuild his kingdom, like King Narai 100 years later, he turned to foreigners for help. The Portuguese were the best known westerners in the region and had bases at Malacca, Goa and Macao; but there were other foreigners about and King Naresuan prudently spread wide his net. He wrote a letter to the Spanish governor of the Philippines asking the Spaniards in Manila to come and trade. When the treaty was signed in 1598, the Siamese allowed the Spaniards unrestricted trade and freedom from all duties. Such terms had never been offered before. It may show pressing need; more likely the king and his advisers felt that the Spaniards would never be a major power in this region, as they only had this one base in what was then the Portuguese half of the world, assigned to the Portuguese by the Pope in the Treaty of Tordesillas.

This estimate of the Spanish proved correct. They never attempted to establish a 'factory' or trading post in Ayutthaya, preferring to send galleons from Manila to pick up what trade they could, relying on the very advantageous terms given them in the treaty of 1598. But having no local intelligence, they never fathomed the Siamese, and treated the Chao Phraya as though it were the Spanish Main. Twice, in later years their swashbucklers were taught a sharp lesson.[11]

One evening, in August 1624, a Spanish trading galleon with about 350 men on board, saw a Dutch merchantman, the 'Cleen Zeelandt', laboriously hauling up river to Ayutthaya in the gloaming. Forgetting, or not caring, where they were, the Spanish closed with the Dutch ship and boarded her. To the amazement of the Thai villagers along the river banks, enjoying their evening wash, these two groups of foreigners, for no apparent reason, then set upon each other in the middle of the calm waters of the Chao Phraya. Red faced and infuriated, they buffeted and slashed at each other. One can imagine the Siamese ironically cheering on the two sides and watching for the occasional body plopping into the river, to be fished out later on the end of a large pole and searched for booty. Eventually, the Spaniards gained the upper hand, imprisoned the Dutch crew and stole the cargo, which consisted largely of silver bullion. They then settled down for the night. However some responsible people had gone upstream to tell the government in Ayutthaya what had occurred. When King Songtham heard about this violation of the freedom of his river, he sent for the Spanish captain to come to the Court and explain his extraordinary conduct. Don Fernando de Silva, perhaps surprised that such a petty monarch should dare protest, returned

a perfunctory excuse, and prepared to leave. He had underestimated, like many others, the spirit of the Siamese to defend their own; and was to pay for his mistake with his life.

King Songtham rapidly assembled five or six ships, manned them with Thais (and possibly some Japanese) and sent them downstream in haste to capture all the *farang*s and both their ships. The Thais scrambled aboard the Spanish galleon and fell upon its crew with gusto. Lithe and agile, the Siamese are natural fighters, ferocious and skilled at close combat. For the loss of 25 of their own, they killed 150 Spaniards, including the captain, and put the remaining 200 in chains. These were led away to prison in Ayutthaya and kept there for two years. The Dutch, who were really only unwilling spectators, lost nine. Eventually, the Spanish governor of Manila sent an embassy to ask for their release and they were freed. The King restored their ship to the Dutch but kept the cargo. Eventually, and with great difficulty, the Dutch got compensation for 60 per cent of it. The King also, and more reasonably, kept the Spanish cargo. When, two years later, he released the Spanish from prison he also, magnanimously, returned their cargo. Embarrassingly, when the royal warehouse was opened, it was found that almost all the goods had already been stolen, probably by royal officials.

This skirmish should have been a lesson to European seamen that the waters of the Chao Phraya were under the very effective control of the King of Siam; here they could not buccaneer at will. It was a lesson they were slow to learn. In May, 1628, two Spanish galleons appeared at the Bar of the Chao Phraya. They were part of a fleet which had been sent out from Manila, in the dying days of 1627, to cruise the seas off Pattani in the hope of capturing Dutch ships laden with peppers, and these two had strayed up to the head of the Gulf. Lying off the Bar, they spotted some junks putting out to sea. There was no indication whatsoever that they were Dutch pepper ships, but by now the Spaniards' blood was up. They seemed far from the hand of justice and the lumbering junks looked rich and easy prey, as indeed they proved to be. Three were set on fire and sunk; but such prisoners as were taken turned out to be, somewhat embarrassingly, Thais and Japanese. One of the junks, a very large one weighing about 600 tons, belonged to the King of Thailand, and another to the Regent of Nagasaki.

Again, the Spanish reaction from Manila shows that they had little idea of the power or importance of Ayutthaya. They were soon to learn that they were dealing with no petty chieftain or effete Oriental princeling. A year later, somewhat casually, 15 or 16 Spaniards turned up on board a passing Chinese junk; their mission, to apologise for the misunderstanding. As they had no letters of note from Manila and no prisoners to return, the King, very reasonably, threw the whole lot in prison. His temper now raised against the Iberians, he then had all the Portuguese in Ayutthaya rounded up and thrown in prison as well! This seems harsh as many of them had lived in Ayutthaya for years and had served the kingdom well; and they were in no

way in league with the Spanish, whose presence in the East Indies they resented. However, the Portuguese were later able to play a pretty trick on the King. In July, 1633, a Portuguese galleon arrived at Ayutthaya, carrying an embassy from Malacca. They bore with them a suitable present for the King and a request from the Portuguese governor to release those Portuguese from Macao who had been amongst those arrested earlier. The two sides must now have felt more relaxed about the earlier incident, because in September, the prisoners were allowed to go aboard the Portuguese galleon to meet their compatriots and perhaps have a good square meal. Suddenly, the Portuguese galleon raised its anchor and slipped off down the river. The Siamese were taken so unawares that they did not even pursue it in their warboats. Later, they discovered that the whole gambit had been a hoax. The governor's letter was a forgery and the self-styled embassy was but a group of individual Portuguese who had got together to free their compatriots!

Despite these spectacular battles on the Chao Phraya, the Spanish were never a serious threat either to the security of the country or to the Muslims and the Chinese (or, indeed, to the Siamese Court) in their trading ventures. The Portuguese were a different matter. They were the main western colonial power in Asia. Their bases stretched from India to China and Japan. And they had a reputation for putting a stranglehold on trade. Their nearest base was at Malacca and from here they began to nibble at the fringes of the Siamese trading empire shortly after King Naresuan came to the throne (1590). In particular they had their eyes on the ancient and lucrative trade between India and South-east Asia, which traversed the Bay of Bengal. To do this, they needed a base on its eastern shores. The best harbour was at Tenasserim; but this the Siamese regarded as traditionally theirs and had just regained it from the Burmese in 1573. But, in 1599, a Portuguese adventurer called Philip de Brito attacked and captured the Burmese port of Syriam and was attempting to bring the whole of lower Burma under his control. If he was not stopped, he would certainly be able to take Tenasserim away from the Thais and then extend Portuguese control all the way down the coast to Malacca. Ayutthaya's role as the main entrepôt between China and the Middle East would be destroyed again, just after it had been re-established, and she would sink back once more to the level of one of her own vassals, a little inland port subsisting on coastal trade with its neighbours. How could this be averted and Tenasserim be saved?

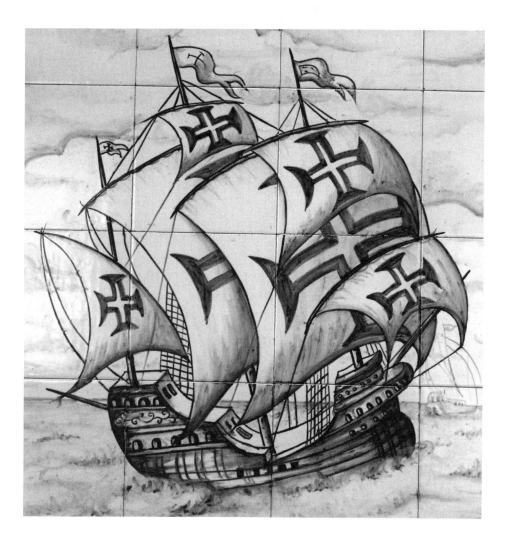

1. Dr. Joaquim de Campos, 'Early Portuguese Accounts of Thailand', *The Journal of the Siam Society*, vol. XXXII.

2. J. M. Braga, Conselheiro da Uniao das Comunidades de Cultura Portuguesa, *Portugal and Asia*, published in honour of the Bangkok Bicentennial, 1982.

3. An article written by Saowaros Panyacheewin on the interview with the Portuguese ambassador, Dr. José Eduardo de Mello-Gouveia. *Bangkok Post*, Sunday 18th, September 1983.

4. Verbal communication from the Portuguese ambassador to Thailand, Dr. José Eduardo de Mello-Gouveia during a Museum Volunteers Study Tour to the Portuguese Embassy, 15th January 1982.

5. De Campos, *Early Portuguese Accounts of Thailand*.

6. There are two Portuguese accounts of this little-known end to the affray, one by Bocarro, who wrote not long after the event; and a second in the *Conquista de Pegu*, which says that the Burmese prince was hit by a 'dart'.

7. *The Origins of Siamese-Burmese Warfare* by Dr. Sunait Chutintaranond in proceedings for the International Workshop 'Ayudhya and Asia', December 1995.

8. David K. Wyatt, *A Short History of Thailand*, p. 95. (See Chapter 4 footnote 1).

9. Dr. Sunait, *op. cit.*

10. *Bangkok Post*, Sunday 18th September 1983. See footnot 3 above.

11. G. V. Smith, *op. cit.*

HEDENDAEGSCHE
HISTORIE;
of
TEGENWOORDIGE
STAET VAN ALLE
VOLKEREN,
Twede Deel.

I. C. Philips inv. et fecit 1730.

TE AMSTERDAM
By ISAAK TIRION MDCCXXX.

The title page of the 'Atlas van Zeeland', 1760, by Isaak Tirion. The Dutch East India Company (V.O.C.) is here portrayed as a queen bestowing the benefits of trade upon the grateful natives of Southeast Asia. (Courtesy of the Dawn Rooney Collection)

The Dutch in Ayutthaya

T he Portuguese had been the greatest western power in the Far East for 100 years. Where could King Naresuan look for help against them? It so happened that about this time a little group of Dutch merchants appeared in South East Asian waters and set up an office at Pattani which, we may recall, was under Thai 'protection' Could they be of use against the Portuguese? King Naresuan invited them to Ayutthaya, knowing little about their land. The Portuguese had already told him that the Dutch had no land of their own, being little more than sea pirates. This was discouraging, and it was not long since it had been true.

Philip II had inherited the provinces where the Dutch lived and which were then known as the 'Low Countries' when he became King of Spain in 1555 (he also became King of Portugal in 1580). The Protestant Dutch rebelled against this distant, Catholic, rule. After years of fighting, the seven northern provinces eventually became independent in 1609 and took the name of the Netherlands. However, at the time King Naresuan contacted the Dutch merchants at Pattani, theirs was not yet an independent or even a united state, able to support him officially against the Portuguese. Nevertheless the Dutch merchants, like all westerners, carried powerful guns on their ships and were not too particular who they turned them on.

The Dutch had first come in Portuguese ships and had worked for years in the counting houses and along the quays of Portuguese outposts in Asia. Now they were beginning to arrive in their own ships to buy spices to sell in the Netherlands. Ironically, it was Philip II who had provoked them to this. In 1595 he had forbidden all countries to sell spices to the Dutch, hoping to strangle their trade in this most valuable of commodities. But the Dutch were now powerful enough to equip their own ships and to send them off to South East Asia to find those spices for themselves. They had gained a good knowledge of the spice ports while they were sailing in Spanish and Portuguese ships and were able to publish Spanish and Portuguese charts of South East Asian waters for use by their own mariners.

So it was that the first little Dutch trading mission, consisting of four ships, set off in 1595. It was not very successful. Two-thirds of the crew died and one of the ships had to be abandoned. The others straggled home in 1597. Even so, the expedition returned a profit, and excited interest. Within a year five companies had been formed to despatch their modest fleets to the Indies. Incredibly, two of these merchant ventures sent their ships out across the Atlantic to reach the Spice Islands via the Americas, a distance

twice as far as the voyage round Africa. In addition, the routes round Cape Horn or through the Straits of Magellan are among the most dangerous in the world for sailing ships, especially when returning weighed down with cargo. Why did they choose this route? They can hardly have been that afraid of Spanish and Portuguese freebooters along the eastern way. Perhaps it simply shows how little people still knew of world geography at the end of the sixteenth century. Not surprisingly, the two expeditions which set off westwards failed disastrously. Of the other three, one succeeded spectacularly. One success out of five was not a very encouraging percentage, but the Dutch at that time had the commercial daring of the modern Chinese. By 1601, they had sent 14 voyages to South East Asia.

Success brought its own problems. Seeing so much interest in their spices, Asian merchants raised their prices, while with so much cargo arriving on the quays of Amsterdam, the Dutch buyers, naturally, lowered theirs. Sometimes when the Dutch ships sailed home to Europe, the Portuguese would emerge from their bases and punish those who had sold to the interlopers. At other times, the Dutch commanders and their crew behaved so arrogantly that the local rulers and their people would refuse to sell to them upon their return.

Eventually, and somewhat reluctantly, the different groups of Dutch merchants agreed to unite. Under the aegis of the great Dutch statesman, Johan von Oldenbarneveldt, the Dutch East India Company was chartered in March 1602 and in the end became the greatest of all the European chartered companies trading with the East. It had 10 times as much working capital as the English East India Company and 20 times as much as the French.[1] It raised this immense sum of money through joint stock companies, in which even ordinary people could buy shares. This mechanism, by which people who did not know each other at all could be persuaded that it was safe (and profitable) to invest money in a joint enterprise was the most brilliant and valuable of all Dutch inventions. The company soon became involved with Ayutthaya and maintained a presence there for most of the seventeenth and eighteenth centuries – the only western country so to do.

The Thais have always been adroit at assessing the Western powers ranged against them and then playing one off against another, even when they have had no direct knowledge of those countries. On this occasion, King Naresuan picked a winner and picked it early. Only 20 years after they first opened their own office at Pattani, the Dutch felt strong enough to attack the Portuguese at Macao in 1621, though they were driven off. Twenty years later they captured the huge fortress at Malacca which had been in Portuguese hands for 130 years. Eventually they drove the Portuguese out of Japan and Ceylon. Amongst the Europeans, they were now masters of the Eastern seas. Within 50 years of their arrival, they had displaced the Portuguese.

So how did King Naresuan manage to entice the Dutch to Ayutthaya and

then persuade them to build up a presence there? His lure was a subtle one. He sent a message to the Dutch at Pattani offering to take a Dutch emissary or 'ambassador' with his own embassy to China; thus helping the Dutch to enter into trading relations directly with China under the wing of the Siamese. Chinese silks and porcelain were very popular with the Europeans. Clearly, if the Dutch could buy them direct from China they would make a much higher profit than if they had to buy them from middlemen in Pattani. The Dutch admiral in Pattani responded eagerly and sent a small group to Ayutthaya with two cannon, gunpowder and iron cannonballs, perhaps as a reminder of the sort of help that the Dutch might proffer later. He also sent money and goods to trade in China. But after two years hanging about, waiting for a royal junk to go to China, the little Dutch contingent was recalled in 1606. Unfortunately King Naresuan had died in 1605.[2]

The Portuguese may have been glad to see it go. They knew very well why it had come, and they knew it had come at the request of the king. Perhaps they saw it as a threat to their position. After so long were they now to be outflanked by a bunch of rebels and heretics? It was difficult for them to know what to do. Later that same year the first Portuguese Jesuit priest arrived. Was this their response to the Dutch? It seems extraordinary that the Portuguese, who were such avid proselytizers of the faith, should have sent almost no missionaries in 100 years. Perhaps the early Portuguese traders had warned the Society of Jesus that Siam would prove a barren soil to sow, and they only sent one now for political reasons.

The Siamese were disappointed in the Dutch, but they did not give up. Ekathotsarot was now king and followed the same policy as his elder brother, Naresuan. After trying for two years, he got together a party of intrepid Thai officials to act as an embassy which he hoped the Dutch would convey to Holland. There were three ambassadors and a retinue of 12. They must have been men of daring – no Thais had ever been to Europe before. They were to need all their resolve. It was to be an arduous journey. First they went to the Dutch factory at Pattani. From there they were shipped in a company vessel to the East India Company's office at Bantam, where the company directors took one look at the size of the party and declared, flatly, that it would be too expensive to send. Fortunately, a Dutchman who had been in Ayutthaya, was able to persuade them that the King of Ayutthaya (quite reasonably) would regard this as an insult. Still, the company pared the mission down to two ambassadors and a retinue of three, and sent them on their way.

After a voyage of eight months, they arrived in the Netherlands on 8 September 1608. (So far as one can tell, they were the first Thais to set foot on European soil). Three days later, no doubt still feeling queasy after their journey, they were bustled off for an audience with Prince Maurice. They presented the king's letter contained in a beautiful gold box, itself enclosed in ivory, as well as a number of costly gifts. The Dutch were, no doubt, impressed; and set out to impress their visitors. They were not a landless

nation of sea pirates, as described by the Portuguese and to this end they escorted the Thai mission on a tour of the famous Dutch ports of Hoorn and Enkhuizen. By a lucky chance, the Siamese ambassadors were present when a new and remarkable Dutch invention, the telescope, was first demonstrated. This was certainly not the product of a group of 'sea pirates'. Perhaps as a consequence of this, Dutchmen in Thai mural paintings are often shown holding a telescope. The same portrayal is often to be seen in Chinese and Japanese art.

Their work done, the Thais then had to stay on in the Netherlands for over a year. The Dutch planned to send them home in the fleet of the first Dutch governor-general of the East Indies, and this took a long time to assemble. No doubt it was meant to impress the delegation with the might of the Dutch in eastern seas, but it must have been extremely boring for these five Siamese to spend a year so far from home, in an often harsh climate, and with almost no means of communicating with their hosts. After a hard journey they reached the East Indies 11 months later. They were then sent across to Pattani and eventually left for home in a junk, having been away for nearly four years. Few Thais had endured so much for their country, but their mission had achieved its effect.[3]

The arrival of this Dutch fleet in the East Indies in 1610, caused much agitation to the Portuguese Viceroy of Goa who sent a mission to Ayutthaya (also bearing gifts) to ask that the Dutch be expelled from the capital. Not for the last time in dealing with Western powers, the Siamese showed themselves both daring and adroit. Instead of caving in, they boldly offered the strategic port of Mergui, next to the Thai port of Tenasserim, to the Dutch. This would further split the Portuguese in Syriam from their base at Malacca. It would also help to guard the Siamese port of Tenasserim from the Burmese. The message was clear: for the Siamese, the Portuguese were now only one of several foreign powers seeking to trade with Ayutthaya. As the King of Portugal wrote on an earlier occasion: "[This] will prove a great inconvenience to Malacca and for the commerce of the South ... this King of Siam is one of the greatest of those parts both in power of men as in wealth, and if the rebels introduce the exercise of war and artillery as it is understood they are endeavouring to do, it will be an irreparable evil".

The Thais had to wait some time for their gamble to pay off. Although they had now restored their influence in the region, trade was slow to pick up after the Burmese destruction of Ayutthaya. The Dutch could see little reason to trade there. They had been offered premises inside the walls of Ayutthaya in the Muslim section as early as 1608, from which they could deal with their visiting merchant ships. This was in itself an honour – foreigners were not normally allowed to live within the city. But although the Dutch maintained a presence in Ayutthaya, they sent very few ships. Between 1619 to 1632 only 35 ships arrived, slightly more than two a year and certainly not enough to justify keeping a permanent staff there.

However, trade eventually revived and, in 1635, the Dutch East India

Company felt it worthwhile to ask the king for a large piece of land outside the city walls and beside the Chao Phraya. They would build warehouses to store goods from up-country and company ships could berth alongside. These products might be seasonal, such as rice or coconut oil, or they might be products such as gold, benzoin and gumlac brought by the Lao merchants who only occasionally came paddling all the way down to Ayutthaya. In either event, the price dipped when the goods arrived, so it paid to buy and hoard till they were scarce once more and prices rose. This request for land demonstrated the sort of long-term commitment the king was hoping for and he responded generously. The site can be seen to this day – it lies immediately south of the old Chinese temple, Wat Phanan Choeng. Here the Dutch built a fine lodge which the Siamese called 'Tuk Daeng', or the Red Building. The reason it was red was that it was built of brick – most unusual in Ayutthaya where only temples were built of this material and even the king's palaces were constructed of wood. There was a drawing made of the lodge in 1719, and it shows that its Dutch gables resembled those which can still be seen on the first buildings in Atsadang Road, near the Grand Palace in Bangkok.[4]

The company director lived in the lodge with two or three of his assistants, their rooms furnished strictly according to rank. Then there was a dining hall and a number of smaller houses to accommodate the considerable Dutch staff and their wives. There was a chief surgeon and his assistants, several carpenters, a bricklayer, a butler, a cooper, a smith, a quartermaster, four or five Dutch soldiers and a number of sailors to man the company boat. There were stables for horses, sheep and other animals; several warehouses, a bottling room, a kitchen, a mess-hall for the servants, and, that other necessary of western compounds – a prison. And beyond that a garden, an orchard and a graveyard.

One of the people buried there was the director's mistress. A redoubtable Mon lady called 'Cao Soet', she was the wife or mistress of three Dutchmen, including two of the directors, Van Vliet (1636-1641) and Van Muijden (1646-1650). She was friendly with the ladies at court and did much to facilitate relations between the Dutch and the government. She died in 1658 and was buried in the company graveyard. A number of graves were marked with high white *stupas*. One commemorated Isaac Moerdijck, a director of the company who was murdered by the company cook. This was bad luck, really – he had worked in Ayutthaya for 16 years and had finally just been appointed director. He was given a royally-sponsored funeral.[5]

When the company prospered, the compound must have been a lively place. Many of the Dutchmen were married, some to Dutch girls often sent out by orphanages to get the girls off their hands, but many more to local women, and there were plenty of children scampering about. When the men were posted, they left their Thai wives or girlfriends behind sometimes with money to maintain them, doled out by the company director. To their surprise they found that they were not allowed to take their children with

them, or even to send them to Batavia for education. Eventually, in 1641, the King abandoned this principle; but one feels that he did so reluctantly and then only to gain some greater benefit. For westerners today it is difficult to understand Thai rules on the nationality and rights of children and their mothers. It is interesting to come across the same rules in force 300 years ago. Van Vliet tried for 10 years to get permission for his three daughters by Cao Soet to come and visit him in Batavia. She opposed the trip and it was only after she died, 17 years after her husband had left, that the king allowed the children to visit their father. Earlier, when a Dutchman came to Ayutthaya to marry Maria, the eldest daughter, presumably with the father's blessing, and take her away, the King refused outright.

It seems strange that newcomers were content to take on the 'wives' of their predecessors. The reason is simple. Most ordinary Dutch members of the company seldom left the compound. They had no need to go outside to look for goods since the king's factors or private merchants brought their wares to them. They did go to Thai festivals in *wat*s and must have wandered about in the surrounding area, but had no opportunity to meet ordinary Thais, or indeed other races, in their homes. Life for them was as insulated as it still is today for ordinary members of most diplomatic missions. Another reason they spent most of their lives inside the company compound was that there was simply nowhere to go. The city of Ayutthaya consisted of palaces and temples and one or two streets of merchants' houses. The rest of the vast interior was empty land. Ordinary Thai people lived in villages outside and the only way to get to them was by boat. Casual contact was almost impossible. Other nationalities lived in their own compounds outside the city walls. Like Chinatown today, westerners were free to walk about and stare at the locals as they went about their daily tasks, but there was really no way to strike up a friendship.

One relaxation for the Dutch was to take one of the small company boats and explore the *klong*s or take a trip up and down the Chao Phraya. We know that this was common practice for an amusing reason. In 1663 relations between the two sides were bad and Batavia decided to close the Ayutthaya office for the time being. However, the Dutch director felt that the king might stop the Dutch staff from leaving (they had been thrown into prison on a previous occasion and had once been told, terrifyingly, that they would all be trampled to death by elephants the next day) so there was cause for alarm. The director acted with aplomb, quickly telling all his staff to gather a few possessions together and set off down stream in the company pleasure boat as though they were out for a day trip. Once out of sight of the guard houses on the river bank, they were to hurry downstream as fast as they could to the mouth of the Chao Phraya, where they would find two Dutch ships which would take them aboard and away to safety. Meanwhile he bravely went to see the Phra Klang to distract attention from the Dutch compound and the furtive and hurried evacuation there taking place. It was not until the next day that the authorities discovered what had happened.

The Thais admire style and dash and, so far as we know, let the matter rest.

Even if they did take a boat down the river, the only place they could visit was Thonburi and its numerous temples. Here again one went about by boat as there were no streets (if early Bangkok is anything to go by). The only place the Dutch could reasonably visit and get out and stretch their legs was their large storehouse near the mouth of the Chao Phraya. They built it at about the same time as their 'factory' outside Ayutthaya. The purpose of it was to store heavy goods, such as sapanwood, so that cargo ships could draw alongside in deep water and then leave for the open sea without the tedious two-day haul up river and down again. It was known locally as 'Baang Amsterdam' which apparently means 'made of wood', but on western maps it is marked simply as 'Amsterdam'. At any rate it was later rebuilt in brick, and we know this because we can still see the remains of it on the west bank of the Chao Phraya, near Samut Prakarn, at the village of Bang Plakot. One can make out the remains of stout brick walls, half submerged; also a pit that may have been a well, and part of a 'gate'.[6]

Baang Amsterdam and Tuk Daeng are really the only two western commercial premises built in the days of Ayutthaya. They remind us that the Dutch East India Company was the only western organization which tried to establish itself permanently in Ayutthaya, and succeeded. To do this, its officials had to work closely with the court. It is intriguing to read how they ingratiated themselves into Siamese society. We are fortunate that they kept such copious records and that these have almost all survived. They run in an almost unbroken line from 1604 to the fall of Ayutthaya. There is one volume of reports for each year and, on average, they are between 100 and 200 pages long. The English East India Company papers really only exist for a period of 12 years near the beginning of the seventeenth century and a 10-year stretch towards the end; many have been badly edited. The French records begin in 1662, but were mostly written by missionaries or diplomats. What is fascinating about the letters of the Dutch is that they are concerned with day-to-day events in Ayutthaya. The writers were well-informed; they had often been in the country for 20 years or more, many could speak Thai and had Thai or Asian wives. They paint a picture of a group of westerners who set out quite deliberately to live and work within the Thai system; and the Thais reciprocated.

The directors of the company were given Thai ranks such as Ok Phra or Ok Luang and the insignia to go with them, such as a gold betel box or a gold sabre. Only one director was given the highest rank, that of Ok Ya. Ironically, he was recalled to Batavia for dishonesty. With rank went duty: to attend some of the King's Council meetings. Directors who could speak Thai were able to take part in Council discussions. (This was a help because it enabled them to short-circuit the Phra Klang who could not be trusted to repeat what he had been asked to say to the King.) One director was actually given voting rights. All this assured them a certain status and respect within Thai official circles. It also allowed them to take part in official ceremonies

and celebrations, such as the royal processions by land and by water; probably the *Kathin* processions. They took part in drinking the waters of allegiance and contributed money to build temples. When the king was going to pass down the Chao Phraya in his state barge, the company buildings were decorated with flowers in his honour. They were happy to prostrate themselves before Majesty because they knew this won them respect with the Thais.

But behind this facade of friendship and mutual respect, what did each side want of the other? Primarily, the Dutch wanted to make a guaranteed profit from their trade with Ayutthaya, otherwise, of course, the factory would be closed by the head office in Batavia. The Kings of Ayutthaya wanted craftsmen to teach them western skills; they desired ingenious Western artifacts; and sometimes they asked for support against their enemies. Clearly there was room for a deal.

When the Dutch first came to the Far East, their heads were filled, like everybody else's, with tales of the wealth of far Cathay, and of the prizes that could be won by the first power to seize that trade. They soon found that it had been sewn up long ago by the Asians themselves. So, instead, they asked the king for monopolies on certain goods, and sent these goods where they were wanted, particularly to Japan.

The kings of Thailand have always made their money out of international trade, and have always claimed a monopoly on it. No visiting traders might sell to other people the goods they had brought until the king's factors had purchased what their master needed at the price he set. And they could not buy local goods from local traders until the king's own warehouses were empty. At first sight it would seem that the effect of such restrictions would be to drive away small traders from overseas. But the king usually did not claim a monopoly on all goods, and his advisers were careful to adjust prices and quantities so that the practice did not stifle trade. The main effect of royal monopolies was to expand the power of the king at the expense of the ruling elite, to increase the wealth of the city and diminish the prosperity of the countryside, and to strengthen the state of Ayutthaya and weaken its landlocked neighbours, especially Lan Na (the small kingdoms of northern Thailand) and Laos.[7]

Because the kings made their money through monopolies, they were naturally reluctant to assign them to others, especially in time of war when they needed all the money they could get. On the other hand monopolies were a convenient way of winning favours. Fortunately for the Dutch, just when they were thinking of abandoning Ayutthaya from lack of profit, King Prasat Thong found himself very much in need of help and was prepared to pay for it. The southern provinces of Songkhla, Pattani, Phattalung and Nakorn Sri Thammarat had rebelled and were at war with each other. The Portuguese were looking to dabble. Cambodia to the east and Burma to the west were both planning to attack. The only independent military and naval force in the region belonged to the Dutch East India Company. The king

offered them a monopoly to export deer and other hides mostly to Japan, and a contract to buy and export sapanwood. In return he asked for help against his enemies.

This monopoly on the export of deer hides turned out to be extremely profitable for the Dutch. It was an unpleasant business, slaughtering millions of deer, but the Dutch were not squeamish. In a good year they could make a profit of 300 per cent, and the Japanese would buy all they could supply. Sapanwood was valued highly for the red and violet dyes it could yield. The Dutch could easily load it into their freighters, moored in deep water off 'Baang Amsterdam' and ship it off round the Malay peninsula. This was not a trade in which Thai junks could compete, so it was not a costly gift for the King to make. But it sometimes yielded the Dutch a profit of as much as 1,500 per cent. Then there was the tin brought down to the little coastal kingdoms of the south from the mines in Malaya; another bulky item which it was easier to consign to the Dutch. This was an astute gift because it made the Dutch involve themselves in keeping the peace in the south.

As the Dutch became more practised in Asian trade, they began to traffic in goods between one Asian port and another. They brought in silver and copper from Japan. The silver they used to purchase other goods in Ayutthaya and the copper they sold, perhaps for casting bronze Buddha images and cannon, or to be sent on to India. They brought into Ayutthaya cloves, nutmeg and mace, and they took back Thai coconut oil which sold well in Batavia for use in the oil lamps, which the Dutch had taken with them from Holland. From there the lamps found their way to Ayutthaya and the same type is still used in Thailand today. They are called *kaew kalapa*, *kalapa* being the Indonesian word for 'coconut'. We can see one of these lamps depicted in a mural at the Lacquer Pavilion, Suan Pakkad.[8] Perhaps the most popular Siamese product was the excellent timber which, even then, was being extracted from the forests. It was trans-shipped to Batavia where the Dutch shipwrights fashioned it into their sturdy men-of-war which routed the Portuguese and made the Dutch masters of the seas from Coromandel to Cathay. The Portuguese ambassador made this point clearly when he said to the Phra Klang at Ayutthaya that the Dutch ships were so strong only because of the good Thai lumber with which they were made. If the Thais cut off that supply, he suggested that the Dutch would no longer be able to control the waters of the Gulf and 40 Portuguese ships a year could safely and profitably come up the Chao Phraya to trade with Ayutthaya. This was a forlorn hope, and the Siamese knew it. The Portuguese had just been thrown out of Malacca by the Dutch and were everywhere on the retreat. They had nothing in Asia to match the Dutch East India Company, based on Batavia and already comfortably ensconced in Ayutthaya.

Even so, Dutch trade with Ayutthaya ebbed and flowed, and sometimes ceased altogether. Three times the office was shut down, once for four years when Japan closed her ports to foreign trade. When King Narai led a huge army of local conscripts against the north, the supply of country goods

dried up and visiting junks turned for home, their holds unfilled. On another occasion the Dutch families in the compound feared for their very lives. One day, in 1640, they were amazed to see cannon being trundled into position and swivelled round to point straight at their flimsy walls. King Prasat Thong had been told that the Dutch were planning to send ships up the river to seize Thai property to repay themselves for a debt they felt they were owed. (This was completely untrue, but the story had been put about by a disgruntled Siamese official.) The king reacted in the spirited way that the Siamese do when their sovereignty is threatened. He told the director, Van Vliet, that all the Dutch must leave the country within a day or be seized, spreadeagled upon the earth and be trampled to death by elephants. Fortunately, both parties quickly realized how they had been put at loggerheads and the matter was set right. But it showed by what fragile threads their presence was secured.

For a variety of reasons, then, the Ayutthaya office did not show a consistent profit. Indeed its very presence in this frivolous and exotic city was an affront to the sober-sided Dutch directors in Batavia. The reports that came back all too often inclined towards the Siamese position in any dispute with head office. After 20 years in this land of Cockayne, the Dutch themselves came back bewitched, sporting their outlandish titles and showing off their golden betel boxes and their ridiculous Siamese hats with their golden bands. In Batavia they moped for their native wives and they pined for their children. How right then that the venal Van Muijden, the man most highly honoured by the Siamese, should be brought low before the company court, convicted of corruption. How apt that Van Vliet, who had written so fluently about the land he loved, should be forbidden by the Governor-General himself, ever to return to Asia. As for the deplorable Joost Schouten, convicted of a more fleshly corruption, burning at the stake was the only way the company could purge itself of his taint. It is no wonder then that the head office in Batavia wanted to close down this troublesome and erratic office.

They did not do it for the simple reason that they themselves would have starved. Constant wars in Java cut off their local supplies and they would have died in 1624 and in 1626 if ships from Ayutthaya had not brought them rice. Thai rice continued to be a staple export to Batavia for another 50 years. Similarly, the great fortress of Malacca, which the Dutch had stormed in 1641 and captured from the Portuguese, would have had to be ignominiously abandoned if Ayutthaya had not supplied it with rice. The Malay hinterland could simply not provide it. It might seem as though the plains of Ayutthaya were the ricebowl of Asia even then, in the seventeenth century. In fact, they could not produce all the rice that was required. The Thai farmers depended entirely on the vagaries of floods and rainfall. In 1625, Batavia got 1,400 'lasts' of rice (1 last = 1,530 kg), but it had asked for 2,000 lasts. Two years later, it was able to buy only 10 per cent of that, because the crops had been ruined by exceptionally high water in the plains

round Ayutthaya which had rotted the rice heads. But Thai rice was so highly valued that when Thai ships arrived at Batavia with rice, even when there was already enough from local fields, the Dutch would buy it at inflated prices, to ensure the supply continued in leaner years. Having discharged rice, the Thai vessels would sometimes take on board a cargo of frisky Javan horses to bring back to Ayutthaya. ("As zesty as the people are mutinous", says La Loubère.) Were they used in warfare, or for racing, or was it then becoming fashionable to ride about on horseback as the Europeans did?

So the Ayutthaya office was allowed to continue. It weathered the storms of 1688 when all the other foreigners were expelled from Ayutthaya and stayed on until Ayutthaya itself went up in flames in 1767. It was the only western trading company to remain in Siam almost continuously throughout the seventeenth and eighteenth centuries. One reason for this was certainly the adroitness of the Dutch directors here, who matched the Siamese in diplomacy. Another was their willingness to meet the king's requests for help: these varied from a squadron of warships to a pair of spectacles; it might be a sudden demand for 20 Dutch hats in assorted colours, or a ship's carpenter to build a new yacht.

The Siamese were obviously, and rightly, much impressed by Dutch ships which often appear in mural paintings. Dutch warships quickly swept the Portuguese and Spanish out of South East Asian waters; ships which had seemed invincible to the Thais for the past 100 years. The Dutch merchantmen were just as impressive. They carried huge loads and regularly made the tricky voyage down the east side of the Gulf of Siam on their way to Japan yet, in almost 100 years they only lost two ships on this route.[9] The Siamese and the Chinese, in their junks, lost far more as the numerous wrecks off the Pattaya shore alone testify. The Dutch warship or 'flute' was invented in 1595 by Pieter Jansz Liorne. It was small, low and manoeuvrable and could pour a swift and devastating volley into the flanks of the unwieldy carracks and galleons of the Spanish and Portuguese. By 1600 Amsterdam led the world in the design and building of ships. The Siamese have always been quick to seize on Western inventions, and so it was not surprising that King Ekatotsarot who came to the throne of Ayutthaya in 1605, at once asked the Dutch to provide him with shipbuilding equipment and shipbuilders.

Other kings also employed Dutch experts. For instance a Dutch carpenter designed and built a royal yacht for King Prasat Thong. As well as using it on the Chao Phraya, he also sent it all the way down to Pattani with Dutch soldiers aboard, to help put down a rebellion there. Dutch sailors were using the Chao Phraya almost daily, so it is not surprising that it was a Dutch cartographer who drew the first map of the Chao Phraya in 1630. It was also a Dutch artist who painted the first picture of Ayutthaya that we possess. A somewhat fanciful view of the celestial city, it can still be seen in the Rijksmuseum in the Hague.

King Songtham asked for a Dutch engineer to build him a road so that the devout could visit an impression of the Lord Buddha's Footprint which had just been discovered beyond Saraburi. It quickly became an object of deep veneration but to reach it, one had to take a boat up the Pasak as far as the landing stage at Tha Rua and then face a tough trek through the jungle. In order to make the road as straight as possible a Dutch engineer was sent out with a telescope. By climbing tall trees he was able to take sightings of the mount where the Phra Buddha Baht is located. Part of this road are still in use at Bang Song Sok and villagers there call it 'Thanon Farang Song Klong', or 'the road of the foreigner with a telescope'. To tamp down earth roads as well as to drive piles into the ground, the seventeenth century Dutch brought with them a lifting- or pulley-block. These were left behind and taken over by the Siamese. Pile drivers of this Dutch design were still in use in twentieth century Thailand.

In Ayutthaya there were numbers of small bridges over the minor *klong*s, but these were a nuisance for boats. So the Dutch introduced an elegant version of the drawbridge then in use in the Netherlands. A copy of one of these can be seen in Atsadang Road. Other relics of the Dutch presence can still be found in Bangkok. Outside the Ministry of Foreign Affairs there is a small ship's cannon, on which one can just distinguish the letters 'VOC' attributing it to the Dutch East India Company, and the letters 'M' and 'Z', which show that it was cast in the city of Middleburg in the province of Zeeland. The large and beautifully decorated canon outside Government House was made in 1641 and given by the Dutch to King Prasat Thong.

On temple walls one often finds the Dutch depicted in old murals. They are often shown looking through a telescope – presumably at the enemy. There is a painting at Wat Suwannaram of such a scene. While the *farang*s busily prepare for the fight, a Siamese courtier with a miniature telescope is examining at close range a passing lady's breasts. The Dutch dressed in sober fashion, as one would expect, and so they are portrayed by the Siamese artists. Plain dark hats, often tall like top-hats, beards and moustaches and long curly hair flowing down over their shoulders. When the French arrived they must have thought them very old-fashioned, as they in contrast dressed in fashionable, gaily coloured clothes, neatly made wigs (which must have been very hot) and for the soldiers, epaulettes. There is a most unusual painting of a Dutchman and his wife in Wat Bang Khuntien; the Dutch lady is wearing a Javanese sarong and kebaja, and carring her baby. Presumably they had just arrived from the company office in Batavia, although it was not common practice for Western wives to accompany their husbands to the Far East 300 years ago.

King Narai was intensely interested in all things Western, so the Dutch sent him spectacles, telescopes and microscopes, clocks, clothes and hats. Like King Mongkut 200 years later, he was fascinated by astronomy. People have long thought that it was the French Jesuits who introduced him to this science, since there is a famous engraving of them showing the King an

eclipse of the moon, but in fact it was the Dutch. It was also the Dutch who sent craftsmen – goldsmiths and gunners, painters and sculptors, cannoneers and carpenters. There was a Dutch steersman to steer the royal yacht, and a Dutch doctor to attend to the royal health. He remained for years. (This was an amazing innovation for the seventeenth century. Even in the nineteenth century King Mongkut had the greatest difficulty in persuading the court doctors, who knew nothing of Western medicine, that he should consult Dr. Bradley).

Although the Siamese never saw Dutch soldiers at war, they did see seventeenth century Dutch handbooks of military strategy which have many pictures of soldiers, and maybe it was this that encouraged them to ask for Dutch advice. At any rate in an old Siamese book on the art of warfare, called the *Tamra Pichai Songkram*, we find Dutch soldiers explaining military strategy to the Thai and telling them the best way of making gunpowder. (Gunpowder had, of course, been invented in the East and long known here; but in the seventeenth century Dutch gunpowder was more powerful than that made anywhere else).

At first, in the middle years of the seventeenth century, the Siamese asked for military and naval help, usually against their rebellious fiefdoms. Most of these were in the Malay peninsula where the Dutch themselves were anxious for peace so that their supplies of tin would not be interrupted.

The first target was to be Pattani. The Siamese got together a naval expedition and the new director of the Dutch factory, Joost Schouten, was sent back to Batavia to ask for Dutch ships to stiffen the Siamese attack.

Unfortunately, this first joint exercise ended in fiasco and recriminations. When the six Dutch ships arrived off Pattani there were no Thai to be seen. In fact, the Thai expedition had prudently left the scene when faced by 100 warships backed by two Portuguese men-of-war. Less sensibly, the Thai commanders told the king that they had had to abandon the siege because the Dutch had never arrived. A week later a Dutch warship nosed its way into the naval basin at Ayutthaya, its decks covered in Muslim prisoners and with news that the fleet had sunk six junks. The Thai commanders were severely punished.

Ten years later it was the Dutch who were asking the Siamese to help them against a rebellious partner – this time Cambodia, which had just seized the Dutch company assets and murdered a Dutch peace mission on its way to the palace. The Siamese sent a naval expedition. It arrived at the mouth of the river but never encountered the Dutch East India Company fleet and sailed away unscathed. When the Dutch did arrive, the Cambodians sailors fell upon them, presumably while their ships lay at anchor, wreaking such damage that the Dutch navy fled the river.

Five years passed, and then this somewhat unco-ordinated alliance lumbered into action yet again, this time to subdue Songkhla. But when the Dutch fleet arrived at Ayutthaya it found to its annoyance that the king had called off the attack with the arcane excuse that his mother and daughter

had just died. After this the Dutch company abandoned all attempts to follow the Siamese into the baffling arena of politics in the Malay peninsula. Instead they supplied men, material and expertise.

From time to time they would use their dominance of the Gulf to attack the king's enemies upon the high seas or interdict all trade with a rebellious vassal. They would put Siamese soldiers on their ships and transport them to the seat of the rebellion. They would lend money and supply canon; they lent Dutch steersmen to navigate the king's junks to China and Japan; they provided a Dutch armourer to accompany the king's next expedition against Songkhla; but they would not, as the Director General put it, "support Siam in a war against another sovereign state". Above all, though they could hardly say this openly, they would never support any claimant to the throne; however just his claims. The Dutch had been in Ayutthaya long enough to realise this was a thorny thicket; those who entered it seldom emerged unscratched. Other foreigners were less prudent.

The Dutch reluctance in this regard puzzled and irritated King Narai who had to fight his way to the throne with the help of Japanese, Thais, Pattani Malays and, perhaps, Persian Muslims. They were small, volatile and undistinguished groups of people and the king did not wish to be beholden to any of them. He looked to the Dutch, but in vain. For this, and a number of other reasons, relations deteriorated and the Dutch actually closed their compound at Ayutthaya. Eventually, good sense prevailed and a treaty was drawn up between the two parties in 1664. Both sides gained from it. Siamese trading ships on the high seas were guaranteed the protection and assistance of Dutch men-of-war, which was valuable to them as their trade with the West grew. The Dutch were given back their monopoly on deer and cow hides, to be theirs in perpetuity. This treaty between King Narai and Pieter de Bitter, acting on behalf of the Dutch company (and, ultimately, the Dutch government) is the first royal treaty between Siam and a Western country. More than 300 years old, it can still be seen in the archives of Jakarta. It is written in Thai, Dutch and Malay and has served as an example for later treaties signed by Siam with other Western powers. So the Dutch scored a double first in diplomacy in the seventeenth century: the first Western country to receive a diplomatic mission from Siam, and the first Western country to sign a royal treat with her.

Twenty four years later, King Petraja expelled most foreigners from Ayutthaya and threw the missionaries in prison, but he renewed and extended this Treaty and Alliance of Peace with the Dutch. So, with this royal protection behind them, the Dutch now went back to doing what they did best; busying themselves in trade and small domestic crafts – statecraft they left to others, the English and the French.

1. Ruud Spruit, 'Thailand and the Dutch'. A talk given at the Siam Society on 30th October 2002.

2. G. V. Smith, *The Dutch in 17th Century Thailand*. Centre for Southeast Asian Studies, 1974 and 1977.

3. Dirk van der Cruysse, *Siam and the West*. Silkworm Books, Chiang Mai 2002. He points out that there is no direct evidence that they ever reached home. (Page 50)

4. Elisabeth Bleyerveld-van't Hooft, A talk on 'The Dutch Presence in Siam' summarized in the Siam Society Newsletter, Vol. 3, no. 2.

5. G. V. Smith, *op. cit.*

6. Elisabeth Bleyerveld-van't Hooft, *op. cit.*

7. David K. Wyatt, *op. cit.*

8. Elisabeth Bleyerveld-van't Hooft, *op. cit.*

9. G. V. Smith, *op. cit*, p. 79.

This memorial marks the site of the United East India Company (VOC) office which stood outside the walls of Ayutthaya from 1634 until the destruction of the city in 1767.

'A General Map of the East Indies' by Richard Blome, 1683. It is dedicated to the Deputy Governor of the (English) East India Company and shows the vast hinterland of India from which the members of that company might draw great profit.
(Courtesy of the Dawn Rooney Collection)

The British in Ayutthaya

Other westerners who came up the Chao Phraya behaved very differently from the Portuguese and Dutch. Some, it is true, were fascinated by what they found, and worked to promote trade and goodwill between Europe and Siam. A few even abandoned their country's cause and settled down happily to serve the Siamese. But too many merchantmen and traders, soldiers and fortune-hunters behaved with arrogance and insensitivity. They swaggered about the streets, eager for a fight and contemptuous and ignorant of all they saw around them.

Their governments or companies in Paris and London knew nothing of Siam, and certainly learnt little from those they had sent out. One is constantly amazed by the quality of their representatives. Coates, who came from Cambodia to re-open the Ayutthaya office of the English East India Company in 1662, soon became a pirate captain in the Bay of Bengal preying on his own East India Company ships. One of his successors so offended the government in Ayutthaya that he was whipped and wandered the streets with a board around his neck like a common criminal. The behaviour of the French was sometimes as bizarre. Desfarges, the leader of the French troops sent to occupy Bangkok and Mergui, and himself a Marshal of France, ended by offering his allegiance to the King of Siam.

With representatives like these, it is no wonder that the merchant companies and their governments often issued orders which were as grandiose as they were absurd. A French expedition which arrived in the Chao Phraya with 500 soldiers, many of them ill, was expected to take over the country and protect the French missionaries while they converted king and people to Christianity, before proselytizing the rest of South-east Asia. The aims of the English East India Company were more modest; but so were their means. They sent out one (hired) merchantman, armed with 24 guns, which was to occupy the Siamese port of Mergui, build a fortress and then compel the government at Ayutthaya, which happened to be three weeks away over the Tenasserim hills, to remove the very profitable Japan trade from the Dutch who had held it for half a century, and transfer it to the English.

Here then was a most dangerous combination. Two governments in Europe, half a world away from Siam, in outlook as well as in distance; France the greatest power on the Continent, England aspiring to challenge her; each with a trading company in which king and government had an interest, each claiming a monopoly of trade in the Far East; their affairs managed in Siam by men incompetent at best, more often venal and

uncouth; their ventures to be played out in a rich and peaceful land which appeared to welcome foreigners, and which seemed to have neither the will nor the means to resist them. It is no wonder, then, that the French and British missions should have collapsed so rapidly and been driven out (unlike any other foreign mission) by the government itself. What should astonish us is the skill with which the Siamese, by a mixture of subtlety and daring, were able to subvert their aims, smother their military power and divert their allegiance. Broken and confused, they left of their own accord. They did not realise the legacy of hatred and distrust they had left behind them.

It had all begun so differently. The first two travellers, French and English, arrived humbly and on foot. By coincidence, each had already walked across India. One was a merchant, the other a missionary. For a missionary, as for a merchant, it was the best way to find out local conditions for oneself. Also it was probably no more dangerous than going by ship.

The first Englishman to visit Siam was, apparently, a certain Ralph Fitch, a London leather merchant, who reached Chiang Mai in 1587. His account of his travels illustrates the lure of the fabled East and its treasures, which so enticed him and his friends, a group of sober city merchants, that they gave up a comfortable livelihood in London and risked their very lives to come and see things for themselves.[1]

In the sixteenth and seventeenth centuries most mercantile powers in Europe were looking for ways to enter the rich Far East trade, long controlled first by the Venetians and then by the Portuguese. In 1581 a group of merchants in the City of London had formed the Levant Company to open trade with the Middle East. In February 1583, five of them set off to the East to investigate prospects for themselves The leader was a London merchant called John Newberry, who carried with him letters from Queen Elizabeth I to the Emperor of India and to the 'King of China'. His deputy was Ralph Fitch. It says much for their tenacity (and luck) that three of them managed to reach the Emperor Akbar, ensconced in his magnificent new capital at Fatehpur Sikri, and presented to him the letter from Queen Elizabeth. At this point the party split up. The leader, John Newberry, decided to return to England, but was never heard of again. He was probably murdered along the way, perhaps in the Punjab. William Leeds, who was a jeweller, was recruited into the service of the Moghul Emperor to work on his magnificient collection of jewellery. Only the doughty Fitch went on.

His adventures had hardly begun. He travelled for two years in India, visiting Allahabad, Benares, Patna and Cooch Behar. Then still unflagging, he set sail for Burma, visiting the Shwedagon Pagoda before setting off on a 20-day journey overland for Chiang Mai.

He reached the capital of the then independent state of Lan Na at the end of 1587. The cool weather and the beauty of the people and their town, led to a two-months' stay. "Lamahey", as he wrote, "is a very faire and great Towne, with faire houfes of ftone, well peopled, the ftreets are very large, the men very well fet and ftrong, with a cloth about them, bare headed and

bare footed; for in these Countries they weare no Shooes. The Women bee much fairer than those of Pegu". (Burma). Noting both the physique of the men and the beauty of the women, he took matters further, describing in detail how the men enhanced their 'priue members' for "they say the women doe desire them". (A strange and rather painful practice to which the very hardy, or the very desperate apparently still resort to this day).

Despite these alluring byways, Ralph Fitch did not forget that he was there to hunt out trade. His report on the gold and the silver, the musk and the chinaware to be had in the Chiang Mai markets attracted the attention of the English East India Company. As a result, in 1615, it sent Thomas Samuel and Thomas Driver to open a trading office in Chiang Mai; the first Europeans to establish a commerce between northern Siam and the West.

Ralph Fitch's zest for travel and trade was not exhausted yet. He returned to Burma and then set sail for the great Portuguese factory at Malacca. Having passed Mergui twice, it seems strange that he never stopped to look at the overland goods being brought in from Ayutthaya. But King Nandabayin of Burma had just invaded Siam with a huge army, so perhaps trade had, for the moment, dried up. Thence returning to Burma for the third time, he crossed India again on foot and, traversing the Middle East, by camel, picked up an English ship in Tripoli (Lebanon). He arrived back in England almost exactly 3,000 days after he had set out.

When he got home he found that his family had given him up for dead and divided up his possessions. The city merchants, however, were fascinated by what he had to tell them and in the end Richard Hakluyt persuaded him to write an account of his adventures. This was an arduous task for him as he had not dared keep a diary in case he was arrested as a spy, and, in addition, he was not a fluent writer. He begins: "In the yeere of our Lord 1583, I Ralph Fitch of London Merchant, being desirous to see the Countries of the East indie … did ship my self in a ship of London called the Tygre where in wee went for Tripolis in Syrie; and from thence wee took way for Alepo which wee went in seven days with the Carovan". One of the people who read his story was, apparently, William Shakespeare! In *Macbeth* one of the three witches croaks: "Her husband's to Aleppo gone, master o' the Tiger". These words so closely resemble the opening words of Fitch's account that it seems almost certain Shakespeare must have read at least part of it.[2]

His story and those of other travellers to Asia encouraged merchants to venture their capital on eastern trade and in 1601, the English East India Company was formed. But it was another 11 years before the first company ship arrived in Ayutthaya and even then it arrived without the captain or his mate, who died at Pattani. We learn this fact from a memorial to them which used to appear every year in the personal column of the *Bangkok Post* on the anniversary of their death: "In memory of Captain Anthony Hippon of the Hon'ble East India Company, master of the Globe, who died at Pattani on 9th. July 1612. Also remembering Thomas Smith, master's mate, who

died there two days later". (Unfortunately the connections that moved a reader of the newspaper to commemorate their deaths 400 years ago was not revealed).[3]

King Song Tham had just come, bloodily, to the throne, and, needing trade to ensure prosperity and peace, he gave the English company the right to establish a 'factory' at Ayutthaya and another at Pattani. Neither flourished or was able to compete with the Dutch. Perhaps they were too far from their main base in India; or perhaps they lacked the commercial skills and enthusiasms. One senses they were out for the quick profit (often for themselves, rather than for the company) and never took the trouble to learn the market. Nevertheless, the company directors, as subjects of King James, knew how to propitiate a monarch. 60 miles off the north coast of Western Australia, lies the wreck of the English East India Company ship, the 'Tryal', which went down in 1622. A little off course for Ayutthaya, she was carrying gifts for King Song Tham. The ship's manifest calls them, disparagingly, 'spangles for the King of Siam'.[4] At any rate, by 1623, the East India Company gave the Dutch best and closed their factory. They did not return for another forty years.

When the company did come back, it was at the invitation of the king. King Narai seems to have looked overseas both for support and for the advancement of his country. Indeed, "he was the first Siamese monarch to recognize the need for progress along European lines".[5] So, when the English East India Company was turned out of Cambodia in 1659, some of the staff fled to Ayutthaya. King Narai welcomed them and, in 1661, 'ye olde factory house' was reopened and put in the charge of Thomas Coates. Unfortunately he turned out to be one of the biggest ruffians in the English community.

The king offered concessions to the company but they seemed preoccupied and did nothing. He asked for gunners and engineers and they ignored him. (This request for arms and armourers was so common that it has almost the air of royal 'tea money'. Nearly all foreign missions, wishing to establish themselves in Siam were asked to supply armaments and the men to operate them.) In fact the English in Ayutthaya were not disinterested in trade. They simply preferred to trade on their own account, rather than support the 'monopoly' of the company. This right had been granted by a royal charter, given by James I to the company directors in London early in the seventeenth century. Exactly the same was done in Holland and in France. Those who granted the charter and those who received it expected to make a fine profit from their monopoly. But those who bought and sold company goods and risked their lives on company service half a world away saw no reason why they should not also profit from the trade passing through their hands. They were known as 'interlopers' and the word has a pejorative ring, but all indulged and few saw themselves as corrupt. In the case of the Dutch who, as we saw, had a large office or factory here, the system worked quite well. The company and

its members each made a profit. But in the case of the French and even more of the English East India Companies, official trade almost collapsed.

The English factory, opened in 1662, was soon closed and did not reopen until 1674. Even then the company officials in London did little to help. The first consignment of goods they sent out for sale in the East was £5,000-worth of English broadcloth, good protection against piercing English winds, but useless in the Tropics. (It was eventually used as a caparison for the royal elephants).[6] So, the company servants turned to private trading and cooking the books. Some of them found profitable and congenial service with the Siamese. Other Englishmen appeared. George White, a strong and independent character, happily took service as a pilot working out of Ayutthaya. His brother Samuel became master of a Siamese vessel sailing between Mergui and Masulipatam on the coast of India. One of his cargoes may have been elephants, caught in the annual round-up at Ayutthaya, trained and then sent off to India.

In 1678 a new director arrived from Bantam. His name was Richard Burnaby and he was sent to Ayutthaya by the directors in London to investigate the complaints of one of their 'writers', a young and seemingly self-important young man called Samuel Potts, the protégé of an English nobleman called Lord Berkeley, who had presumably come out to make his fortune. In the same boat as Burnaby, there came a young assistant-gunner, a Greek called Gerakis. He had run away from home as a boy and had been working for the English, in one capacity or another, for the past 20 years. The last nine he seems to have spent in South-east Asian waters. At any rate he spoke Malay and Portuguese fluently. These were the languages of trade in the region (apart from Chinese) and they served him magnificently.[7] Within eight years the young assistant-gunner was Superintendant of Foreign Trade and a confidant of the King of Siam.

Gerakis and Burnaby had both been working in Bantam. They were about the same age. They were both men of talent and ambition, though race and background allotted them very different tasks in the company. They knew and liked each other. As their ship wended its way up the Chao Phraya towards Ayutthaya and the troubles of the East India Company, Burnaby felt more and more that he needed someone with him whom he could rely on. He had no friends in the town; the English interlopers there would resent him, the company officials would obstruct him, and he could not even speak to the Siamese. So before he went ashore he asked the captain of the ship if he could release Gerakis (or Phaulkon, as his English friends called him) to act as his interpreter. Technically this was illegal, so Captain and Director connived to have Phaulkon jump ship and his name written off the roll.

Once ashore, Burnaby turned to investigate the company books. What he found appalled him. No proper records of trade had been kept at all; the English employees had been busy borrowing money from the Siamese, using the company as collateral, and then engaging in private trade. When

Burnaby tried to put things right, the staff turned against him. Frustrated, he asked George White, now settled in Ayutthaya with his English wife, and honoured with a minor title by the Siamese to join him in company service. There was some irony in this as George White was technically an 'interloper'; certainly his sympathies lay with the independent English traders then busy in Ayutthaya. However, he gave his considerable talents to help Burnaby reform the company affairs. Here he met Phaulkon and explained his views on private trade and the role English merchants might play in the commercial affairs of Siam. At White's house, Phaulkon met George's younger brother, Samuel, over from Mergui on holiday. They, too, met and liked each other. Phaulkon, Burnaby and White were to form a triumvirate for trade which was to lead eventually to the massacre of all the English in Mergui; and to the East India Company, which at present they were serving, declaring war on the King of Siam.[8]

It was a world of shifting loyalties, at the Siamese Court and amongst the foreign counting-houses. Burnaby and White immersed themselves in it. They chartered a ship, filled it up with guns and powder and sent it off down the Chao Phraya – not to help the government, but to render aid to Songkhla which was in rebellion against the Siamese! Their man in charge was Phaulkon. When the boat with its bulky and unambiguous cargo was passing Nakorn Sri Thammarat, it was wrecked in a storm. Phaulkon and his crew struggled ashore, clinging to planks. They were taken straight to the governor, who was suspicious of this solitary white man and his little crew, sailing towards the rebels. The simplest thing would be to lock them all up, but Phaulkon faced the governor. Already he spoke tolerable Siamese, although he had only been at Ayutthaya for a little over a year. He was in the employ of the English East India Company, he said, and they were carrying goods for sale to the ports along the peninsula. If they had done wrong, their case must be heard at Ayutthaya. So they were sent back, with an escort, to Ayutthaya. Burnaby and White were aghast. But they were daring and resourceful men, and Phaulkon was a good actor. So they offered his services as an accountant and interpreter to the Phra Klang, the Siamese official in charge of finance and trade, who would most likely be considering their offence in the end. This most effectively mudded the waters. The Phra Klang was delighted to have someone who had had 20 years' experience of western trade and book-keeping, and who spoke English, Siamese, Portuguese and Malay. The affair of the cannon, safely on the sea-bed some 1,000 miles away, was soon forgotten. Moreover, the East India Company now had someone in the Treasury who would be sympathetic to their cause. Both sides looked forward to easier times ahead. They reckoned without the young secretary.

Phaulkon, true to his name ('The Eagle') soon soared to realms far above the heads of those who had given him his chance to fly. The Phra Klang put him in charge of the king's storehouses. So diligent was he that, within a few months, the Phra Klang was mentioning his name to King Narai himself.

The king suggested that the young Greek be asked to arrange and cater for the entertainment of visiting dignitaries from abroad. This was no sinecure at a court where foreigners were so welcome, but it offered many chances for turning things to one's own advantage. Phaulkon was shrewd enough not to take them. Instead, when the Muslims who had held the post before him, presented a bill for monies owed, he was able to prove that in fact it was they who were lining their pockets at the king's expense, and it was they who owed money to the king. Whether this was true or not, Phaulkon had picked his target shrewdly.

The Muslims were unpopular, and more in evidence than they are now. Traditionally, they supervised all trade between Siam and Muslim countries to the west. They knew the markets and the language, so this was sensible; but they had become hereditary controllers, posts passed from father to son. The trade was taken almost out of the hands of the Siamese. Then the Phra Klang died and Phaulkon felt able to expose the danger to his successor.

In particular, he pointed to Tenasserim and Mergui where the Muslims were hereditary governors of the province and were responsible for collecting all the royal revenues. Here, too, they had falsified accounts and cheated the king. By now Phaulkon was Superintendant of Foreign Trade and eventually he was able to propose that his friends Burnaby and White should replace the Muslims.

For the moment they had both left Siam and company service. The new head of the English factory was the deplorable Potts. Through his complaints the last two directors had been dismissed. George White had resigned in disgust and gone back to London and when the assistant Ivatt protested, he too was sacked. Having laid waste the office, Potts now turned to higher game. Instead of courting Phaulkon, he attacked him for not repaying money he had borrowed from the company and wrote to the directors in London that Phaulkon had "domineered and insulted with great and insufferable insolence" and that they "must unavoidably root out this bramble who is now arrived at the helm of the Government". What were they to make of it all? Puzzled, they sent out two inspectors called Strangh and Yale. Penny-pinching to the last, the directors told Strangh and Yale that they must take goods with them to sell in Ayutthaya to pay for the cost of their voyage. Potts meanwhile seems to have gone quite off the rails. It is said he went about town calling the Minister for Foreign Trade a "Greek, a powder-monkey and a cabin-boy" – all the less tactful for having at one time been true. In the end the English factory went up in flames, taking Potts' house with it. Some thought he had set fire to the place himself to destroy evidence of his own peculation (a practice not unknown today); others suggested that he had been lurching drunkenly about the building and had knocked over a lamp. Whatever the cause of the fire, Potts was whipped and wandered the streets of Ayutthaya with a board around his neck proclaiming his crime. In the end he went off and lived on a boat.

Those whom he had driven out were doing rather better. Phaulkon's

plans for his English friends were coming into effect. White should be created Sharbandar of Mergui, and Burnaby, whom Potts had sacked, should be made governor of the town. Ivatt would be sent to Masulipatam as agent of the King of Siam on the Coromandel coast to receive the royal cargoes and see that they were profitably sold. He would also have to find Indian cloths and other products to sell in the markets of Siam.

Nearly all Siamese trade destined for India, the Arab lands and Europe passed through Mergui; and it was largely this trade which had made Ayutthaya rich. It seems incredible that Phaulkon should propose, and that the king and his advisers should accept, that the keys to this trade should be put into the fickle hands of three foreigners; but such, apparently, was the Siamese fear of the Muslims who traditionally controlled Tenasserim.

At any rate Burnaby, Ivatt and White were given Siamese orders of nobility and summoned to Lopburi to receive them from the hands of the king himself; an unusual honour, granted perhaps to impress on them the need for loyalty and good conduct. (If so, it had little effect.)

It was at this moment that the two inspectors, Strangh and Yale, sent out by the board in London, arrived. There was very little left for them to inspect. The factory was in cinders, the records had gone up in smoke, and the director was living on a boat. The Greek, whom Potts had described as 'this bramble' was even now presenting three English interlopers to the king to receive titles and be sent off to govern a Siamese province.

In this looking-glass world it was difficult to know which way to turn. Unfortunately, the inspectors had brought no letter from the King of England and instead of presents, they had with them goods they wished to sell. When they had an interview with the Phra Klang things did not go well. They demanded that the Siamese government stop trading with people whom the company regarded as interlopers, and that it buy £30,000 worth of goods from the company every year. They demanded everything and gave nothing. At one interview, it seemed as though the Phra Klang was actually asleep, and they were left to negotiate with Phaulkon. Angry and frustrated, Strangh decided to appeal direct to the king, but arriving in Lopburi he found the king was out "ridding upon his Oliphant" as he later put it. Quite forgetting his dignity before the Court, Strangh went scampering off across the grass after the royal party. Unable to match the pace of a company of elephants, he was left a lonely figure in the swirling dust. Finally, after waiting a month for a pass to leave Lopburi, he lost patience and slipped furtively out of town. Inevitably, he was caught and brought back "with innumerable indignities and abuses more", to be given his official permit to leave.

With the departure of Strangh, the official presence of the British East India Company at Ayutthaya was ended. However when Burnaby, White and Ivatt arrived in Mergui, now as servants of the king rather than the Company, a new and turbulent era began. Probably they realised that time was against them and that they must make their profits quickly before

traditional government returned. So they busied themselves with developing trade in their own, inimitable way, in other words by preying on the trade of others.

White found there was only one Siamese warship in harbour. He promptly put an English captain (the ubiquitous Captain Coates) aboard her and sent her off to harry Muslim vessels in the Bay of Bengal. To a swashbuckler such as Coates, any craft with 'natives' aboard was fair game. Cruising the Coromandel coast of India, he seized a treasure ship belonging to an Armenian millionaire which was said to be worth £500,000 and was lying anchored upstream of Madapollam. He then blockaded the river and burnt any boats which tried to pass. Unfortunately, some of them belonged to the head of the local East India Company office, Robert Freeman. Head office in Madras was provoked into sending out a warship against Coates. It arrived too late.

Back in Mergui White began acting with equal recklessness, as soon as he had built himself a ship and armed it. When he heard that there was a rich merchantman waiting in the roads to enter Mergui to sell her cargo, he sent out his frigate, captured her, and brought her into port. She turned out to be a Muslim vessel called the 'Meer Facquer Deun' from Masulipatam. The Muslims in Mergui were now to see for themselves how their new governor would behave. He confiscated the cargo, said to be worth £25,000, put an English captain aboard and sent her out to look for further prey. (It should be recalled that she had come from Masulipatam where the King of Siam had an agent, Ivatt, a colleague of White's, whose charge was to encourage trade between India and Siam; and that White's duty was to arrange for the purchase of such goods, not to steal them). For the moment the Muslims were powerless, but retiring behind their shuttered windows, they waited their chance.

During the next six months White's pirate captains, for such they were, seized seven ships, brought them to port and robbed them. One of them belonged to the luckless Robert Freeman. Other ships were stopped upon the high seas and forced to make payment before they were allowed to proceed.

Eventually, Phaulkon felt constrained to recall Samuel White to Ayutthaya. He had been in Mergui for almost three years and his filibustering was now well known. Indeed there is evidence that his cronies peached on him. Worried and sick with a fever he had caught on the trail, he arrived in Ayutthaya. Too ill to plead, he wrote to Phaulkon to exonerate himself. But justice had to appear to be done. A board of enquiry was called to consider the Muslims' case against him, Phaulkon himself being one of the two judges. They duly sat, pondered the evidence and gravely announced that they found White innocent of any misdemeanour. This illuminates an attractive side of Phaulkon's character. He had no need whatsoever to exonerate White, who had not carried out his orders. In fact he had acted in a more blatantly dishonest way than the Muslims he had

replaced. Phaulkon stood up for White solely out of gratitude to his brother. Nevertheless, even Phaulkon could not protect White in Mergui. The latter must hurry back and clear up before trouble broke out there too. Gathering together what money he had in Ayutthaya, he despatched it home to England by an English ship then in port.

White then hurried down the Chao Phraya to Bangkok, where he was met by worse news from England. The East India Company directors in London had finally decided to move against him and his pirates at Mergui. The news speeded him on down the coast towards Pranburi where he would plunge inland and make for the Tenasserim hills and the safety of his boat in Mergui Bay.

When he reached Mergui he milked his fief of every penny he could find and prepared to be off. First, he had to pay the sailors and the garrison of Mergui for the months he had been away, managing at the same time to pad the roll with fictitious names so making himself £2,460. By another stroke of the pen he sold back to the king his own naval stores, and netted a further £2,800. Two armed frigates were sent off to the Bay of Bengal "to bring in whatsoever ships they should meet and could overpower, without any respect to their passes". This was indiscriminate piracy, but would pay well. Two armed merchant ships, which he had stolen, he sent off to trade under French colours (to save them from being recognised as his by the East India Company, and confiscated). Finally, he prepared his own escape. A fine frigate had been a-building on the stocks at Mergui. When armed with 22 guns the 'Resolution' would be more than a match for any ship Madras might send out against him and White decided to use her for his escape. (Technically, of course, she belonged to the King of Siam.)

Two days before White intended to leave, an English ship appeared, the 'Curtana', a merchantman with 24 guns on board. This was the punitive force the East India Company's directors had despatched to deal with White. It was commanded by a young and somewhat inexperienced captain, called Weltden. His orders from London would have taxed an admiral. He was to capture Mergui, arrest White and bring him back for trial. Before this he was to build a fort and from it demand of the Siamese the right to trade with Japan (a right at present held by the Dutch, who were well ensconced two weeks away at Ayutthaya). Then he was to order all Englishmen in the service of the King of Siam to leave with him at once. Finally, he was to seize Siamese ships in reprisal. He had never been to Mergui, he had no charts of the harbour and, probably, had never seen a shot fired. How he was supposed to winkle out the pirate White from a well-fortified Siamese port, of which he was still the Siamese governor, was not vouchsafed to him.

White saw the weakness of Weltden's position and played upon it. He made friends with Weltden while he planned his own escape. Meanwhile the Siamese and the Muslims were puzzled. There were now two armed British merchantmen in this Siamese port. Weltden had been there a fortnight and appeared on the best of terms with White. Perhaps they were

intending to join forces and attack the town, in which case the Muslims had better act first. And so it was, the following night, as White and Weltden, arm-in-arm, were moving a little uncertainly down the hill from White's house to the jetty and a boat waiting to take Weltden back to his ship, that the Muslims attacked with machetes in the darkness. White leapt into the boat, gathered up Weltden who had been struck down but had struggled into the water, and urged his rowers out to the waiting 'Curtana'. Now the destruction began on shore. White's house was the first to be burnt; then the shipyard where he had built his marauding frigates. Next the crowd turned upon the English in the town. Burnaby, the English governor of Mergui, and one-time head of the East India Company in Ayutthaya, was surprised by a mob of cut-throats who crept up to his door in the darkness. In the end every Englishman in the town was killed, some 60 in all.

After many further adventures, White (the prisoner) and Weltden (his captor) escaped together – Weltden in the 'Curtana' and White in his own ship (or rather, the King of Siam's ship) the 'Resolution'. Near Madras, where the East India Company were waiting to put him in irons, White gave his guards the slip and on Christmas Day, sailed away to England where his fortune was awaiting him.

Two final ironies end this strange tale. There had been a revolution in England and the power of the Stuart kings, who had given a charter to the East India Company and invested in it, had been replaced by Parliament and a king (William III from Holland) much under their control. Public opinion had turned against monopolies such as the East India Company exercised. Samuel White decided, boldly, to challenge their right to label people such as himself as 'interlopers'. His case went to the House of Lords and he won it. He might have gone on to sue the company for damages. but that pleasing spectacle was denied us by his death. Having spent the last 10 years amassing a fortune and consigning it to his brother's care in England, he died within six months of his return.

With White's death, all connection between the English East India Company and Siam came to an end, though individual English merchantmen continued to sail up the Chao Phraya river until the fall of Ayutthaya to the Burmese 100 years later. Like so many English commercial undertakings, the East India Company's ventures in Siam had been badly planned and badly carried out. The directors in London had an arrogance born of insularity, ignoring reports from their branch office in Madras. The English in Madras set out to line their own pockets with private trading. The behaviour of White, with his cronies in Mergui and Ayutthaya, was insensitive and towards the end tyrannical.

If the English trading venture in Siam dwindled away to nothing for some very English reasons, the French diplomatic mission to Ayutthaya was flamboyant in its aims and appearance, and dramatic in its fall. Where the English had sent 19 soldiers, the French sent 600. The English had hoped for a modest return on trade; the French aimed to convert King and Kingdom to the Catholic faith.

1. Michael Edwardes, *Ralph Fitch – Elizabethan in the Indies*. London, Faber & Faber, 1972.

2. Major Roy Hudson, An article on Ralph Fitch in the *Bangkok Post* for January, 23rd. 1977.

3. *Bangkok Post*, personal column, annually on 9th. July.

4. See the report of an Australian archaeological team which began diving on the wreck in 1985. *Bangkok Post*, July 30th. 1985.

5. Luang Sitsayamkan, *The Greek Favourite of the King of Siam*. Singapore, Donald Moore Press, 1967.

6. Ian Morson, 'Four Hundred Years – Britain and Thailand. An informal presentation'. Bangkok. Nai Suk 1999, p. 53.

7. Maurice Collis, *Siamese White*. London, Faber & Faber, 1965, p. 50 onwards.

8. Michael Smithies, *A Resounding Failure*. Chiang Mai, Silkworm Books. 1998, p. 57-61 quoting François Martin.

An English merchant ship flying the flag of St. George.

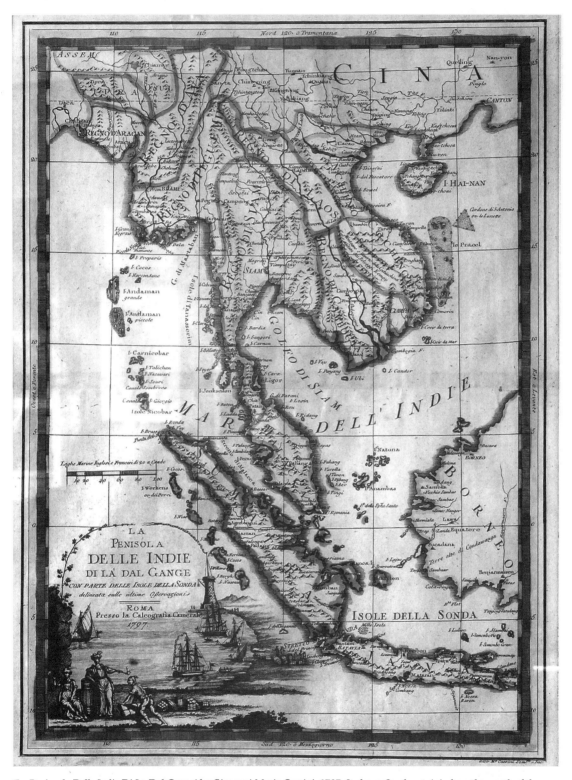

'La Peninsola Delle Indie Di La Dal Gange' by Giovanni Maria Cassini, 1797. It shows Southeast Asia from the mouth of the river Ganges to the Sunda Straits; an area already well-known to the merchants of Portugal and Holland. The English meanwhile, were incapable even of taking advantage of the concessions they were given in Ayutthaya.
(Courtesy of the Dawn Rooney Collection)

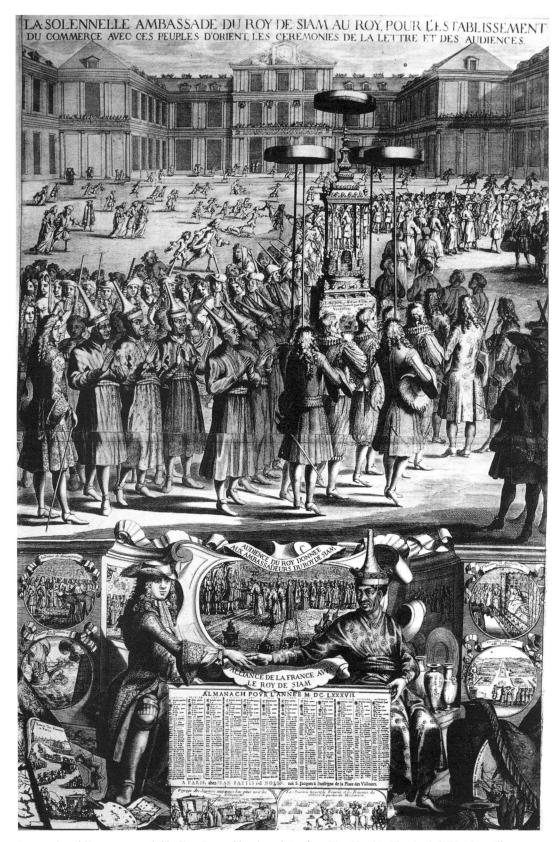

A procession of Siamese envoys, led by Kosa Pan and bearing a letter from King Narai to King Louis XIV at Versailles.

The French in Ayutthaya

The first Frenchman to come to Ayutthaya, so far as we know, was a missionary, Monseigneur Lambert de la Motte, Bishop of Béryte (or Beirut). He had been sent out by the Société des Missions Etrangères and was on his way to China. He had already crossed India on foot (like Ralph Fitch) and now, after 25 months, was in Mergui. All that stood before him was a gentle voyage up the Tenasserim river, a walk or ride of some 25 miles over the 800 foot summit and then down onto the coastal plain just south of present-day Hua Hin. This trek formed part of the trade route between China and India and was reckoned to take between 10 and 20 days. In the dry season there was a stream of porters and boatmen conveying cargoes of porcelain, scented woods, silks, calicoes and dyes between Ayutthaya and Mergui. A. Kerr, retracing the bishop's route, took six days.[1] Bishop Lambert and his companions undertook the journey in the wet season and took a month. One of them wrote an account of their experiences, which presents them in a pitiful and even somewhat ludicrous light.[2] "Our transport consisted of three boats. Each boat had a crew of three men; a section of it was roofed with thatch. …We did our cooking and slept in the boats for it was too dangerous to go ashore on account of the carniverous beasts, such as tigers and rhinoceros, and of wild elephants and buffaloes, which teem in the forest stretching away unbroken on both banks of the river." (Europeans of the seventeenth century apparently thought the rhinoceros ate human flesh. They would have been better warned to beware the mosquito. Samuel White, forced to travel in the wet season, caught malaria in these forests and nearly died of it.) The bishop, however, was almost drowned. As he sat in his boat, the boatmen would pole laboriously upstream against the swift-flowing current. When they came to rapids, they would quietly slip overboard and patiently haul their cargo through the foam. During one such manouevre they lost control of the boat "which was carried down and dashed to pieces against an uprooted tree in midstream. …By the mercy of providence the Bishop caught a branch and hauled himself up … remaining there for some time surrounded by rushing waters". It is not difficult to picture that episcopal figure in its ample garments, hanging upside down from a branch, like some giant slow loris, as the muddy waters swirled just below. They took with them his passport which had slipped out of his pocket. So the entire party then had to retrace its steps to Mergui to apply for a new one. When they eventually reached the head of the river and were able to proceed on dry land, they found that was even more alarming, and uncomfortable. The only transport was buffalo carts,

which "afforded us more torture than convenience". So, they walked – and picked up blood-sucking leeches. At night their terror of the jungle reappeared. "To keep off the wild beasts, we built a stockade (of thorns) every night with the cattle and the baggage in the centre. …We never passed a night without hearing rhinoceros and, particularly, tiger prowling round us." So, the bishop and his two companions slept in the buffalo carts as some slight protection. They must have passed some restless nights.

They reached Ayutthaya in August 1662, five months after their arrival in Siam, and were charmed by their reception. They were allowed to minister to the poor, heal the sick, give lessons to children and to preach to all who wished to hear. In 1664 they were joined by other missionaries under Monseigneur Pallu, Bishop of Heliopolis (or Baalbec). He fell in love with Siam and the Siamese and wanted to bring her all the help he could. Twice he made the dreadful journey back to Europe, recruiting architects and craftsmen whom he brought to Ayutthaya. The king did indeed employ some of them, such as the skilled architect Father Thomas, who helped to construct forts along the banks of the Chao Phraya. Ironically, these forts were later used by the Siamese to attack and expel French troops who had been sent up the Chao Phraya to protect the French missionaries. Father Thomas also worked on the king's new palace at Lopburi and other buildings still standing today.

The bishop and his colleague, de la Motte Lambert, now made a mistake which was to misdirect and eventually destroy the whole French enterprise in Siam. In other countries French missionaries were rejected, in some they were murdered. Here they were welcomed and encouraged so it seemed clear to the bishops that King Narai was interested in Christianity. Perhaps he would allow his capital to become a centre for propagating the Christian faith throughout South East Asia? In less than a year, Monseigneur Pallu returned to Europe and gave the Pope a glowing account of the progress of Christianity in Siam. After this he was received by Louis XIV himself. Each eventually provided the bishop with a letter to King Narai which Bishop Pallu brought back in 1673 after a gruelling three-year journey. This was a triumph for the Catholics at Ayutthaya. The bishops knew very well that for the Siamese the letter was all-important; the accompanying envoys counted for little. Now they had letters of greeting from the king of the most powerful country in Europe and from the spiritual leader of the most wide-ranging Church in Christendom. Moreover these letters were not sent in answer to a Siamese embassy to Europe, but rather at the request of the missionaries themselves. They determined to make the most of their success. The presentation of the letters must be a memorable occasion. Indeed it was, but not at all in the way they had hoped.

The normal procedure was for foreign ambassadors to remove their shoes, kneel on the floor and prostrate themselves before the curtained window where the king would presently appear. The Royal Letter would be placed on a gold vase which was mounted at the end of a gilt pole more than three foot long. When the curtains were drawn back and Majesty was revealed, the Phra Klang or possibly the ambassador himself would raise

the Royal Letter towards the seated king. He would graciously extend his hand, take and read the letter and then perhaps ask a few questions of the foreign ambassador crouching on the floor six feet below. It was not an arrangement which facilitated an easy flow of conversation or any exercise of diplomatic skills, which had to take place later, behind the scenes, in discussions between the foreign envoys and the Phra Klang, and then later between the Phra Klang, the Council and the King. The presentation of the Royal Letter was a ceremony designed to emphasize the sublime nature of monarchy, floating free of the mundane. To be glimpsed, perhaps, but certainly not to be touched or argued with.

The Bishop of Béryte had now been at Ayutthaya for 11 years. He had been received by the king and must have known the protocol. Nevertheless he and the Bishop of Heliopolis insisted on wearing their shoes, insisted that they be spared the humiliation of kowtowing to the king and that they should sit on the floor while the letter was presented. This had never been requested before. Even the Dutch knew the form and followed it. For four months the argument went back and forth and eventually the French, as they saw it, won the day. There the Bishop sat, with his silver-buckled shoes on and his priests, also sitting, ranged behind him. The Dutch, however, at whom all this display was aimed, knew better. Their informants at court told them that the Siamese nobles had been shocked by the boorishness of the French. What was more, some of the costly presents the Bishop had brought from the King of France and the Pope had been left behind in Indonesia!

King Narai ignored the gaucherie and ineptitude of the French, professing himself delighted to receive recognition from two of the greatest potentates in the western world. (In fact Louis XIV and the Pope were merely signalling their polite approval for what they had been told King Narai was doing to foster the Christian religion). In due course, the Catholic mission was given a piece of land outside Ayutthaya and it seemed that the king would pay for the building of a Christian church. Surely this was proof that the pagan King Narai was interested in Christianity. Had he not already listened to the Bishop of Béryte expounding the tenets of the Christian faith? If the king came over, would his people lag behind? The missionaries grew a little dizzy at the prospects which appeared so, when King Narai talked of a Siamese mission to the French Court at Versailles, they were quick to supply an interpreter, a certain Father Gayme. This was the best way to put their point of view to the French king himself.

It was not an easy matter for the Siamese to organise and transport a diplomatic mission to Europe. In the first place they always sent three envoys, not one. This was prudent. In those days when life was uncertain and travel dangerous, a Siamese mission might continue even if two of the ambassadors died. A western mission would have to return. But it was hard for the Siamese to find three men with the presence necessary to represent their country at a western court. (The one and only previous mission to Europe had been almost 50 years before). Eventually Phraya Pipat Kosa was chosen as first envoy. He was probably the most experienced diplomat at Ayutthaya, having already led three embassies to China, but he was an old

man and his spirit must have quailed at a sea voyage six to ten times as long as the journey to Peking. Two other envoys were chosen and 20 Siamese nationals in support. With them went the enigmatic Father Gayme. They also took no less than 50 crates of gifts, and a pair of elephants complete with their own provinder.

They all set off from the quay at Ayutthaya on 24 December 1680 in a small French ship, 'Le Vatour', heading, not for Europe at all, but for the East Indies. From there they would board a much larger vessel which would take them to Europe. In those days the Dutch, the French and even the British tended to sail straight to a large port in the region and from there take a smaller vessel to their destination. One reason may have been that many harbours were up river and inaccessible to larger vessels, certainly the case at Ayutthaya. So the Siamese delegation, with its costly gifts and its letters for the Pope and le Roi Soleil inscribed on sheets of solid gold had to kick their heels in the shabby little town of Bantam for eight months. Eventually they were given passage on the beautiful French ship, 'Le Soleil d'Orient', and off they all sailed to France. They were never heard of again.

Three years later, in September 1683, Thomas Strangh arrived in the Chao Phraya. He was out from London, on behalf of the East India Company, and brought the sad news that 'Le Soleil d'Orient' was now much overdue and was presumed lost at sea with all hands. The mystery has never been explained. Some said that she was attacked by Dutch pirates and sunk; others tell a happier tale. On the island of Madagascar grow pomelo trees, of a kind apparently foreign to that region but well-known in Siam – the 'Som-O'. (It was normal to take fresh fruit on a long voyage as an antidote to the hard tack). Legend has it that 'Le Soleil d'Orient' was wrecked off the shores of Madagascar, and that some of the Siamese contingent struggled ashore through the surf. They rescued some of their possessions and settled down to live out their days in this distant land. The pomelo trees stand as their memorial.[3]

The French tried to get things started again. But how were they to approach the king, having just drowned all 23 members of his first delegation? Perhaps an indirect approach was best. Phaulkon now had influence with the king, and so a Jesuit priest, Father Thomas, visited him and talked discreetly of Catholicism. A representative of the French East India Company, based in Surat, called on him to ask his opinion on opening a trading office in Ayutthaya. (And noticed approvingly that he had a large picture of Louis XIV on his wall).[4] Finally, the much-travelled Bishop of Heliopolis, Monseigneur Pallu, arrived for the third time from France, carrying another letter from Louis XIV and one from the Pope. When he presented these precious documents to the king he brought Phaulkon with him as interpreter.

King Narai was impressed by Phaulkon and pleased with the French. He gave them permission to build a church in Lopburi and he ordered a second mission to France to find out what had happened to the first, and to ask what could be done to strengthen the bonds between France and Siam. Not surprisingly, it was a small affair, two Siamese envoys, Father Vachet and

another French priest, to act as interpreters, and four Siamese boys who were to be brought up in France. In such a modest fashion, they left Ayutthaya in January 1684 aboard an English merchant ship. It arrived at Margate and the Siamese were then well received in London before being taken on to France. (Earlier, when their ship had been attacked by pirates, it was two English warships which came to their rescue).

The little Siamese delegation reached Paris in October 1684, and in due course were presented in private to the king at dinner. Louis XIV had recently acquired a new mistress Madame de Montespan. Under her influence he had become extremely devout so it was to be expected that talk at table would soon turn to religion. "The Marquis de Seignelay presented to the King the Envoy of the Siamese Ruler together with his officials. His Majesty was seated at the supper table and put sundry questions to him regarding the States ruled by the King of Siam, also concerning the progress of the Gospel in the divers fields in which the Apostolic Vicars (or French bishops) are labouring with their missionaries. His Majesty listened with satisfaction to his replies".[5] Father Vachet evidently painted a rosy picture. Unfortunately the French took him for the leader of the Siamese mission and, as the sole authority on Oriental matters then in Paris, respected his view, while the Siamese envoys gave the impression that they cared little what their interpreter was saying.[6]

Father Vachet next spoke to the Jesuits at Court. He suggested that King Narai might be converted to Christianity, given his fondness for things French and the influence of his Greek minister who had already become a Catholic, and that this might pave the way for the entrance of Christian (i.e. French) troops. Things were indeed getting a little out of hand and, as such things do, they began to acquire a momentum of their own.

A grand embassy was assembled in less than three months and came sailing up the Chao Phraya in October 1685, carrying another letter from Louis XIV. Here, it seemed, was a rapid and magnificent response. The leader, picked by the King, was the Chevalier de Chaumont, a recent convert from the Huguenot faith and, like many converts, a zealot for his new creed. There also came the flamboyant and epicene Abbé de Choisy who had joined the party at his own request and was to stay behind to baptise King Narai if so desired. In fact he himself was only ordained once he reached Ayutthaya. In Siam he was delighted by all he saw and wrote one of the most lively and vivid accounts to have come down to us. The third important member of the French party was a Jesuit priest and mathematician, Father Guy Tachard. He became a firm friend of Phaulkon, so much so that the next French embassy felt he had taken the side of the Siamese and refused to let him sit at conference with them. There was also a group of six Jesuit astronomers and their telescopes. Within two months of their arrival they were fortunate to observe a total eclipse of the moon at Lopburi. King Narai, like King Mongkut in the 19th century, was a keen astronomer and took part in their observations. Later an observatory was built on to the Catholic church of St Paulo at Lopburi. The French also sent out an engineer called La Mare to draw plans of the towns through which they passed. However King Narai

appropriated him to design forts for the Siamese.

The whole group arrived, somewhat alarmingly, in two French warships, enormous by Siamese standards. 'L'Oiseau', a battleship, mounted 36 guns, the frigate, 'La Maligne', 24. As de Chaumont's intention was not intimidation, he stopped off at the Bar of the Chao Phraya and sent messengers to announce his arrival. The Siamese, under Phaulkon, assembled one of the largest collections of royal barges ever to be seen on the river: 12 gilded vessels and about 200 accompanying craft. Its apparent purpose was to receive and honour the letter from Louis XIV but it would also separate the French from their ships. Stranded up river at Ayutthaya, they could not bring the force of their guns to bear upon the Siamese, nor could they summon their boats upstream. In such elegant fashion, the Siamese would use the Chao Phraya to trap their enemies, often without their realisation. However, the Siamese might have been less keen to receive the embassy if they knew what de Chaumont proposed to say.

As he explained to Bishop Laneau, who met them at the Bar, Louis XIV had been informed that King Narai was much inclined to accept the Christian faith, and that on the appearance of an ambassador from France, he would surely do so. Upon reading the text of de Chaumont's proposed address, Bishop Laneau was appalled. Sermon-like in tone, it spoke of nothing but religion, and neglected the normal salutations from one monarch to another. As for converting King Narai, many preliminary steps would have to be taken. A difficult consultation with Phaulkon took place (he spoke no French and the Abbé de Choisy had to interpret in Portuguese which he had only begun to learn on the journey out).[7] However enough of the meaning came across for Phaulkon to realise the seriousness of the situation for him as a Christian adviser to the King, and indeed for the whole French mission. Taking the only course open, he announced that he would interpret for de Chaumont to King Narai. Chaumont knew the issue would be fudged but could do nothing. So, both sides resorted to display.

Chaumont produced the royal letter. The Siamese received it at Paknam with a fanfare of conch shells and trumpets and placed it under a tiered and richly gilded canopy, in a magnificently decorated royal barge, flanked by two others, and accompanied by two Siamese officials of the first rank. Behind came the French delegates in a barge of almost equal splendour. For de Choisy, it was his first sight of Siam after a sea voyage of more than six months, and from his somewhat lonely seat he took in every detail of the passing scene. In all there were some 12 gilded barges and perhaps 100 other craft. It must have been a magnificent sight, probably never before seen by those who lived along the lower reaches of the river. Normally, when the royal barges were brought out, they paraded only along the stretch of water above and below Ayutthaya. It was two or three days' journey to row them down to Bangkok and Paknam. One would expect the banks to have been crowded, as did the Abbé. But not a soul was in sight, not a boat put out. "I was shocked by this deserted land: but Monsieur de Metellopolis had told me that normally the river was teeming with boats and that the villages were well-populated. The reason that we could see nobody was out of

respect for his Excellency. It is exactly the same when the king passes when one only glimpses those who have not had a chance to hide themselves". It was a slow journey, gruelling for the rowers, who sometimes broke into song to keep their rhythm and their spirits up.

At night, after covering some 15 miles or so, the whole flotilla stopped. Special rest-houses had been constructed for the French. Built on piles over the water and made of plaited bamboo, they had three rooms: one to receive visitors, one for the ambassador, and one for all the others who slept together hugger-mugger. The Siamese had taken great pains to furnish them as grandly as they could. "It was completely furnished with Chinese beds, Persian carpets and Japanese blinds . . . in all creating an elegant impression which one would not have expected to find among a people who go barefoot". At dinner the envoys were served with thirty different dishes of European food. The mind boggles at the effort needed to produce such a lavish display after dark, in a rickety bamboo hut on the muddy bank of the Chao Phraya, miles from Ayutthaya.

Eventually they reached Wat Prote Saht where they were to stay while details were worked out for presenting Louis XIV's letter to King Narai. This was no easy matter, given the very different Siamese rules on royal etiquette, in which proper respect entailed prostration in front of the king. For the French it seemed humiliating that the representative of the Sun King should crawl and grovel before a dusky Oriental potentate. De Chaumont saw that the royal letter, which commanded as much respect from the Siamese as would have the presence of Louis XIV himself, must be kept in his possession. So, when the royal barges drew up at Wat Prote Saht and the royal officials walked down the pier with an umbrella behind them, to receive the letter and bear it ashore ahead of the French delegation, de Chaumont handed it on its golden tray to the Abbé de Choisy and together they marched firmly down the walkway with the royal parasol hovering a little uncertainly over their heads.

The main problem remained of how to hand the letter to King Narai. De Chaumont wished to hand it direct to the king. Phaulkon, who had the trying task of arranging all the details of the visit, finally allowed his patience to give way a little and ended the matter by saying, untruthfully, that de Chaumont would find the royal tribune would be low enough for him to hand the letter across to the King.

The party could now leave by boat for the royal landing stage and thence on foot to the Grand Palace. At seven a.m. 40 court officials arrived to receive the letter and place it in its own royal barge. But again de Chaumont enacted his little charade. Let us view the moment through his own eyes. "The mandarins, having entered, prostrated themselves, with their hands joined upon their foreheads, and their faces on the ground. In this attitude they thrice saluted the King's letter, I being seated in an armchair near the letter. This honour has never been rendered except to the letter of his Majesty". (There is a whiff of arrogance in the passage, as though prostration was rightfully accorded by the *nu pieds* to the seated Frenchman).

"The ceremony concluded, I took the letter with the vase of gold, and having carried it seven or eight paces, I delivered it to the Abbé de Choisy… He walked on my left-hand, a little behind, and carried it to the bank of the river, where I found a highly-decorated and gilded barge, in which were seated two mandarins of the first rank. I took the letter from the Abbé de Choisy, and having carried it into the boat, placed it in the hands of one of the mandarins, who put it under a canopy which was very lofty and highly gilded. I afterwards entered another very magnificent barge which followed close to that which carried the letter of his Majesty". Everybody now scrambled into their assigned barges and the 200-strong procession made its way to the royal landing stage. De Chaumont describes the scene:

"Two other barges, as handsome as my own, in which were mandarins, kept on either side of that which conveyed the letter. Mine, as I have said, followed (the royal barge with the letter), the Abbé de Choisy being in one immediately behind, and the noblemen who accompanied me and my suite being in other boats; those of the high mandarins were very handsome and took the lead. There were about 12 gilded barges and nearly 200 others, which were rowed in two columns. The letter of the King, with the two barges that guarded it, and my own, were in the centre. All the natives inhabiting Siam joined the procession, and the broad river was entirely covered with boats. We journeyed in this manner to the town, where the cannon saluted me (probably from Phom Phet), which had never been done for any former ambassador; all the ships in port did the same;...on landing, I found a gilded carriage, which had never been used but by the King himself". One imagines de Chaumont stepping eagerly towards it; but the Siamese were now in control. They had the precious letter, and that went in the carriage, drawn by horses and pushed by men. (It was probably heavy going; the time was now mid-October and the streets of Ayutthaya would have been rough and muddy.) De Chaumont was guided tactfully to a palanquin, de Choisy to another.

Thus they proceeded into the Grand Palace and to the hall where their audience was to take place; the French and the grander Siamese on horseback, the rag-tag-and-bobtail *farang* who lived in Ayutthaya shuffling along behind. But then a hitch occurred. The curtained balcony at which the king was to appear was nearly nine foot from the ground, not six as Phaulkon had said. How was de Chaumont to hand the letter across to the king? "The vase of gold in which the letter had been deposited, had a large golden handle, more than three feet long, and they had supposed that I should hold the extreme end of the handle, to raise the vase to the height of His Majesty's throne; but I instantly determined to present His Majesty's letter to the King, holding the cup itself in my hand. …Monsieur Constance (Phaulkon), who accompanied me, crawling upon his hands and knees, called to me, and made a sign to me to raise my arm so as to reach the King. I pretended, however, not to hear what was said, and stood still. At length the King, smiling, rose, and stooping to take the letter in the vase, leaned forward so as to show the whole of his person. As soon as he had taken it, I made a low bow and returned to my seat", De Chaumont was so pleased

with himself that, when he went back to Paris, he allowed prints to be made of the moment when the King of Siam had been obliged to humble himself before the envoy of the King of France. The engraving has almost the air of a 'clip' from a documentary, a moment frozen in time: the Siamese courtiers, their bottoms and their fingers raised, their faces buried in the carpet; Phaulkon whispering and gesticulating anxiously while trying to maintain a Siamese posture of respect; de Chaumont, his elbow tucked firmly into his waist, holding his master's letter teasingly almost out of reach of the Siamese king; Narai good-humouredly leaning right out of his box to take the elusive letter. It is clear the artist intended to portray the Thais as servile and a little ludicrous; in contrast to the manly bearing of the Frenchman.

Such hauteur shocked the Siamese and did nothing for the French cause; but one must view King Narai through de Chaumont's eyes. Here was a monarch who was about to abandon his heathen practices and bend his knee to the one true God; a little humility at the start would not go amiss. In fact de Chaumont had just told King Narai what was expected of him – or he thought he had. "The King, my Master ... beseeches you..to consider that the supreme majesty with which you are invested, can be held only from the true God who governs heaven and earth. Of this you will be more fully aware, should you be willing to hear the bishops and missionaries, who are here at present...".

After the presentation of the letter, King Narai had been pleased to continue the audience for over an hour, after which the French party were taken on a tour of the Grand Palace before enjoying a grand lunch at Phaulkon's house. That evening King Narai gave a state banquet in their honour. The next morning de Chaumont was summoned to a second royal audience. All seemed to be going well. Talk turned to the question of the Dutch. The king felt they were preparing to attack his kingdom and would certainly try to obstruct the French East India Company who, truth to say, seemed to have neglected their trade with Ayutthaya.

What was needed (as Phaulkon later explained) was an offensive and defensive alliance between France and Siam. This would have pleased those at Versailles who were in favour of a forward policy in Siam, and who wanted to send out French troops. But this was not de Chaumont's task, whose sole object, as he explained, was to convey the earnest desire of his monarch that King Narai should take instruction in the Christian religion. To his astonishment, King Narai stood up without saying a word and left. The curtains were sharply drawn to. The audience was at an end. What had gone wrong?

Phaulkon came hurrying round. What King Louis wanted was most laudable but would take time. As the moment was not yet ripe, he had omitted all references to Christianity and the conversion of King Narai and his Court in his translations of the royal letter and de Chaumont's address. De Chaumont was dumbfounded. This was the whole point of his entire mission, which had been sent out at the behest of the King of France himself. And now this Greek, this ex-cabin boy, this jumped-up jackanapes had scuppered their whole expedition. He accordingly wrote out a lengthy

memorandum to the king, which would be presented by none other than Phaulkon himself. What then passed between King Narai and his Minister, we shall never know. What emerged was an ingenious policy for blunting and diverting the thrust of the French mission. De Chaumont could not be sent back empty-handed. He was offered a trade treaty to console the Board of the French East India Company. It appeared to offer them the right of free trade, though of course the numerous royal monopoly goods were excluded. They could open trading posts where they liked, though of course the Dutch already had their hold on the centre of that trade, in Ayutthaya. They could even take over the Siamese port of Songkhla and fortify it for their own use. In fact it was in more or less permanent rebellion against the Siamese. To satisfy the French king's curious missionary zeal, Catholic churches were to be put up, the Jesuits were to be allowed to teach, and an observatory was to be built for them at Lopburi; it can still be seen beside the church of St. Paulo. A number of Siamese families were persuaded to send their sons abroad for a French education – the first Thai students ever to go to Europe. Among all these activities, de Chaumont was given his first ride upon an elephant, "but I found its paces so uncomfortable that I had rather ridden 10 leagues on horseback than one upon the back of one of these animals". Further and more serious discomforts were being designed for him.

The Siamese saw the dissension between the Jesuit Fathers and the members of the French foreign mission, and played upon it. (Their perception of the situation was made more acute by having a westerner as their chief negotiator.) Phaulkon approached Father Tachard, sought his confidence and won his friendship. Would he, rather than the rigid de Chaumont, present Phaulkon's new plan to the French king? This, in essence, was for a more subtle form of evangelism, starting with missionary work in the provinces, later to be supported by the presence of some French troops downstream at Bangkok. Tachard was surprised and flattered. He told Phaulkon that de Chaumont and de Choisy really had no influence at Court but that he, as a fellow Jesuit, could speak to the king's confessor, Père de la Chaise, a fact of which Phaulkon was already aware and had been depending upon.

Meanwhile, Phaulkon reminded de Chaumont how often in the past three months the French envoy had spoken of his desire for friendship between the two sovereigns. King Narai had given proof of his friendship; de Chaumont should assert that this friendship was reciprocated by King Louis and that France and Siam were allies. It was a small gesture, he murmured, but one that would be deeply appreciated. De Chaumont did not see the trap set for him – perhaps he was anxious to be off – and agreed without demur.

It sometimes seems as though foreign emissaries were rewarded by the Siamese in direct proportion to the success the Siamese had in thwarting their aims. Having outflanked de Chaumont, who achieved nothing that he was sent to do, the Siamese gave him a 'Pan Thong' (vessel of gold), one of the highest honours a king of Siam could bestow. The Abbé de Choisy, who had made the trip in order to receive King Narai into the Catholic fold, and

Father Vachet, who had so successfully derailed the whole project by telling Louis XIV that the Siamese king and his people were ripe for conversion, were each given a gold crucifix.

Phaulkon accompanied de Chaumont all the way down the Chao Phraya to Paknam and saw the party on board the waiting French warships, 'L'Oiseau' and 'La Maligne'. With them went three Siamese envoys to the Court of Versailles and 12 Siamese students. The chief envoy was the famous Kosa Pan, a younger brother of the late Phra Klang, and quite as able. The second envoy had already led a goodwill mission to the Emperor of China; and the third envoy was the son of the Siamese diplomat who had led a goodwill mission to Lisbon. They did not go unaccompanied – they were said to have eight 'nobles' with them and 20 Siamese servants. They also took their own interpreter (after their unfortunate experience with Father Vachet) who, surprisingly, spoke Portuguese rather than French. (He was a Portuguese born in Siam). It will be recalled that Portuguese was the *lingua franca* in Ayutthaya and Phaulkon used it when speaking to the French delegation, so it was reasonable for the Siamese to assume that they would be able to use Portuguese in Europe.

Once clear of the Bar, the French urged de Chaumont to make for Songkhla and establish a French base, as it had, after all, been offered to them by the king. De Chaumont had the sense to refuse to go near the place, or even to hoist the French flag, arguing that it was unlikely that a Muslim ruler in perpetual revolt against Siamese claims of suzerainty would meekly hand over his state to a handful of French sent down by the King of Siam. Once in Batavia, however, where the party stopped to revictual their ships, he announced to the world that France and Siam were now allies.

In Paris this was seen as a mistake. King Narai could now claim to be an ally of the most powerful country in the West; all he had given the French was his permission to attack and try to seize a troublesome Muslim vassal some 2,000 miles away. It was clear that Phaulkon had been too clever for de Chaumont. Nevertheless the alliance could not be denied since the French still hoped to convert the country to Catholicism and had permission to send out troops. So the French set about preparing another and much grander expedition to Ayutthaya, while they entertained the Siamese delegation and showed them the wonders and magnificence of their new-found ally. The Siamese must have found it a punishing schedule, being in France for seven months with engagements almost daily.[8] The French went to a great deal of trouble to impress and inform them. Perhaps their most interesting visit was to the royal printing works, where they were shown Greek and Persian fonts. When Kosa Pan asked if a Siamese font could be made and was told that it could, "Il fit une manière de cri" and lifted up his eyes to heaven.[9]

Meanwhile some of de Chaumont's party had remained behind at Ayutthaya, where the king had asked Forbin and La Mare to build some forts. There were already two at Bangkok and they are described by Gervaise. "Where the river divides (i.e. just below Wat Arun) the only defence is a kind of crescent where are mounted 24 pieces of cast iron

cannon, which have been fairly well made. Facing this, on the other bank (on the Bangkok side) there is a rather compact little fort with over 30 cannon. The two forts are guarded by 100 Christian soldiers (of Portuguese descent). They are drilled daily, but are born cowards".[10] Apparently King Narai agreed with this disparaging estimate and asked Forbin to put up a much larger fort on the east bank. It was probably built on land opposite Wat Arun. Ironically, this was the fort later occupied by the French troops who came with La Loubère; and it was the Siamese who destroyed it after they had tricked the French into leaving.

These forts were intended to protect Ayutthaya from attack from the sea. King Narai also planned to defend Ayutthaya against attack down the Chao Phraya from the north. For this purpose he despatched La Mare from Lopburi in January, 1687. He and his Jesuit companions reached Indraburi within a day and a half. This small market town was important because three great roads met here, one going to Burma, another to Laos and a third to Cambodia. Here the French engineer was to plan two forts, one quite small, probably on the bank of the Chao Phraya; the other, much larger, three or four miles away to the east. He only had time to glance at the sites before the boatman told them it was time to leave for their next task.

This was an interesting one. The two Jesuit mathematicians were to visit a hill near Chainat which was said to contain a large quantity of magnetite, or magnetic iron oxide. Cartographers at that time were much perplexed by the way in which magnetic compasses gave different readings in different locations. They were not then aware of the so-called 'magnetic north pole' and were searching for some set of rules which could explain these variations. One theory was that the compass needle was affected by local deposits of magnetite and as one could never detect and plot all the magnetite mines in the world, so it was impossible to formulate rules to explain the behaviour of the magnetic compass.[11] This was the theory that Fathers Visdelou and Bouvet were now sailing up the Chao Phraya to investigate.

The journey seems to have been a pleasant one, with perhaps a whiff of danger. They had been warned to look out for crocodiles "which are in great number in this part of the river. In fact, at seven in the morning, a little below a village called Talat Kao, we saw everywhere fresh signs which these beasts had left on the bank on which they dragged themselves, and the marks of their claws were imprinted on the banks where they crawled amongst the reeds which border the river". That afternoon they reached Chainat which "if the Siamese are to be believed, has been at one time a considerable Town and the Capital of a Kingdom". Here, they had to abandon their boats and travel overland for two days towards the north-east, before reaching a large lake which sounds like Bung Boraphet since it sustained "fish and crocodiles". Once again there were remnants of a little city state at the side of the lake, including some ramparts. The next day they reached their destination.

Their journey may have served another, undeclared, purpose, namely to map out the upper reaches of the Chao Phraya. Perhaps it was they who helped to compile the map of the Chao Phraya and the description of the

river which appear in La Loubère's book. The author himself only says: "That which I here present is the work of an European, who went up the Menam... to the Frontiers of the Kingdom; but was not skilful enough to give all the Positions with an entire exactness. Besides he has not seen all; and therefore I thought it necessary to … correct it by some Memorials which were given me at Siam". The 'European' could well have been La Mare, supported by the bearings taken by his two Jesuit colleagues. From their own account it is clear that they communicated with the local Siamese, even if they were (rightly) sometimes sceptical of what they heard. La Loubère was able to show how two branches of the Chao Phraya split off at Chainat, one being the Menam Suphanburi, (which later becomes the Tha Chin); the second being the Menam Noi which runs along parallel with the Menam Yai and does indeed rejoin it near Lopburi. Where La Loubère seems to go wrong is in showing the Suphanburi River curving round to the east also to meet the Menam Yai but possibly there was a branch canal which joined the two rivers in the seventeenth century.

La Loubère's map is also correct in showing that the Chao Phraya has four tributaries; that Pitsanuloke and Sukhothai are on different rivers, and that the tributaries finally unite just north of Nakorn Sawan. All this information could have been given him by La Mare. (See map on page 133)

La Loubère also talked to Siamese who had been on an expedition to subdue Chiang Mai some 30 years before. From them he learnt about the Menam Ping, though he calls it the Menam (Chao Phraya), that Chiang Mai was connected with Siam by water and the time the journey took: "The Siamese do say that the City of Chiangmai is 15 days journey more to the North than the Frontiers of their Kingdom, that is to say at most, between 60 and 70 Leagues, for they are Journeys by Water and against the Stream". (The frontier he places slightly to the north of Fang.) Earlier western maps had all shown a large lake near Chiang Mai and had made it the source of the four main rivers of Siam. La Loubère was sceptical: "The Siamese which were at that expedition, do not know that famous lake ..: which makes me think either that it is more distant than our Geographers have conceived, or that there is no such Lake. (Also) it may be doubted that the Menam springs from a Lake, by reason it is so small at its entrance into the Kingdom of Siam, that for about 50 Leagues, it carries only little boats capable of holding no more than four or five persons at most" (an accurate description of the Ping River).

While some Jesuits explored the upper reaches of the Chao Phraya, others explored the heavens. Shortly after they had arrived, in 1685, there occurred a total eclipse of the moon. The Siamese were not surprised; it had already been accurately predicted by a Brahmin priest at King Narai's court. King Narai was much interested in astronomy and invited the Jesuit priests to bring their telescopes to Wang Yen, his palace at Lopburi. They hastened to comply: "We caused to be transported to the Talé-Poussone our telescopes and a spring clock very trustworthy and regulated by the Sun. …After resting three or four hours we re-embarked to go to the gallery where we were to make the observation. It was then nearly three hours after midnight.

As soon as we had arrived, we set everything in order. We prepared for the King a very long telescope of five feet in a window of a saloon which opened on a corridor in which we were. The Penumbra being well advanced the King was informed and came at once to that window. We were seated on Persian mats, some with telescopes, others with the clock, others ready to write the time of the observation. We saluted His Majesty with a profound bow, after which the observations were begun."It is interesting to see how the royal telescope was arranged so that King Narai stood up to use it, well above the heads of the seated Jesuits. He put to them some pertinent questions. "For example: Why the moon appeared upside down in the telescope? Why one could still see the part of the Moon which was eclipsed? What time was it at Paris? What could be the utility of such observations made at the same time at two places such a distance apart?" One thing it did enable the Jesuits to do was to check the longitude of Ayutthaya, measured three and a half years before. They found Ayutthaya to be 98.5 degrees east of Paris, which was only about one degree out.

The Jesuits were still in Siam when an eclipse of the sun took place two and a half years later in April 1688, just before the French were forced to leave and only three months before the death of King Narai. He already looks a sick man in an engraving by a French priest. In fact he was suffering from dropsy and asthma but made an effort to come to the window and observe the proceedings. It is a sad but curious fact that Thailand's two astronomer-kings, King Narai and King Mongkut, both died shortly after they had observed a total eclipse of the sun.

Meanwhile, the French had been preparing their largest and most lavish embassy to the court of King Narai. It arrived in September 1687 and anchored in the mouth of the Chao Phraya, five warships packed with over 1,300 men. What was its intention? Strangely, if one had could have asked the leaders of the French expedition, La Loubère, Cébéret, Desfarges and Tachard, one would probably have received four different answers. La Loubère, an astute but somewhat crusty lawyer, had the task of persuading King Narai to let the French missionaries set about converting the whole of Buddhist Siam. Cébéret, a director of the French East India Company, who had come with his son and was due to go on to India, was to renegotiate de Chaumont's trade treaty. Neither of them was to decide anything without first consulting the Jesuit priest, Father Tachard. His role was unclear. He had returned to France with secret instructions from Phaulkon to be transmitted to Louis XIV himself. Did he now carry secret orders from the king? Certainly his behaviour was very odd. As soon as they were in sight of land he bustled ashore and made his way rapidly upstream to Lopburi, to seek out his friend Phaulkon, for he knew, and was alarmed by, the instructions given to the fourth member of the group, the elderly Marshal of France, General Desfarges.

Unlike the general himself, the orders he carried were bold. He was to demand entry to Bangkok and Mergui for his troops. If this was denied, he was to seize the fortresses of Bangkok, gather in provisions and prepare to withstand a siege for up to 18 months, by which time reinforcements would

have arrived from France – a forward policy indeed. If, however, the Siamese proved as pliant in politics as they seemed to be in faith, he was allowed to provide a bodyguard for the king and swear allegiance to him, to train his soldiers and support him against his enemies. Truly, Desfarges had to be prepared to face in every direction.

Unfortunately, the general was accustomed to the simple loyalties and tactics of a European battlefield. The enemy soldiers were those one saw ahead, and at them one charged. Here the only person in the know, the only person who might have been able to interpret his orders to the king, was the mysterious Father Tachard, who had scuttled off after making it clear that he thought the general's orders were totally impractical.

Moreover the general and his men had had a trying journey out and were not at full strength. 636 officers and men were down to less than 500, and many were too weak to fight. A quarter of his force were dead and he still did not really know who the enemy were. It had all begun so differently. Perhaps he had heard from freebooters of the riches that could be picked up on the side; perhaps he had heard of de Choisy's enthusiasm for the country and its people. Whatever the reason, he had brought two of his sons with him; he was leading them to their death.

Eventually, these differences of aim and outlook were to break the embassy apart. Tachard was to say, once the French troops were in the fortress, that his duty had been accomplished and he would now serve only Phaulkon. Desfarges' later behaviour so disgusted la Loubère and Cébéret that they would not let him sit in conference with them. Eventually they quit the country without him or his men. Tachard only travelled back to France in the same ship as la Loubère so that he could submit his account of the trip at the same time as, or if possible before, his leader.

All this was, of course, hidden from Phaulkon and the Siamese. When they discovered these rifts they would play upon them. For the moment what they saw was five French ships riding at anchor at the mouth of the Chao Phraya, packed with men and, as Phaulkon very soon learned, their orders were to occupy Bangkok. The Siamese options were debated in the royal council and it was decided with only one dissentient voice that Desfarges should be allowed to occupy the fortresses of Bangkok, because they had no way to stop him. The man who dared speak out against Phaulkon was Petraja. It has been said that by doing this he was being patriotic, but in fact it would have been disastrous for the Siamese to oppose the French at this point.

If only the Siamese could have eavesdropped on the council-of-war then going on aboard the French warship. There la Loubère was asking Desfarges to seize the French-built fortress of Bangkok, and he was replying that he could not do so because so many of his troops were ill. Their position was not a comfortable one. They were still anchored in the open sea off the Bar; they had not been ashore for seven months; they were still suffering from dysentery and scurvy and had seen some 200 of their fellows committed to the deep, and they were continuing to die.

At this point, a small boat bearing the agent of the French East India Company, M. Vérét, arrived on the scene. This unsavoury character was later withdrawn by the company for embezzlement, but as the first person whom la Loubère and Céberét met, they listened to him with interest. The burthen of his talk was that Phaulkon had become all-powerful, and overbearing in his mien and was not to be trusted. (The latter was in fact on to him, so Vérét needed to denigrate him first). While the envoys were still digesting this surprising information, Father Tachard disconcertingly returned bearing the draft of a treaty which would allow the French troops to land, on condition that they and their officers put themselves in effect, under Phaulkon's sole command.

The French envoys had three unenviable choices: to sail back to France, which after seven months at sea would provoke a mutiny; to capture Bangkok which Desfarges said was impossible; or to accept Phaulkon's terms. Relunctantly, they chose the last course. So after three weeks tossing about in rough seas off the Bar, the troops now found themselves in the calm waters of an anchorage off Bangkok. Desfarges went ashore and inspected the two French-built forts. Estimating 1,200 men to defend them both, he disembarked his troops into the fort on the west bank only and prepared to receive King Narai who was expected to come down the river that same day and receive their oath of allegiance. To Desfarges' amazement, it was Phaulkon who appeared to take the salute. (The king, apparently, was 'ill'.) So, the French soldiers found themselves publicly honouring the man whom M. Véret had warned them was a charlatan.

The two envoys then came upstream to inspect their troops and their quarters. The soldiers were squelching about in the mud – it was mid-October, near the end of the wet season, and the river would have been almost overflowing its banks – and many had dysentery. To their astonishment, La Loubère and Céberét also found that the fort was inhabited by about 400 Siamese and men of Portuguese descent, who were mingling freely, and no doubt happily, with the French troops.

Phaulkon, meanwhile, had departed upstream, with some of the best French officers and men to train the Siamese troops in Ayutthaya and Lopburi. He gave them presents and paid for their food himself. When Desfarges followed, no doubt to see what had happened to his men, he was most warmly received by Phaulkon and found himself soon won over. Abandoned by anybody who could explain the situation, the two envoys turned to Tachard for assistance in their mission. He replied, coldly, that he had fulfilled his duty by obtaining entry for the French troops into Bangkok. From now on, Phaulkon was his master. The two had become friends, so much so that the Jesuit Father went and lived in Phaulkon's house.

At this point, Kosa Pan arrived in Bangkok. At least he could speak French and might explain what was happening. But he had come only, it seemed, to find out what honours la Loubère and Céberét expected at their forthcoming royal audience. His coolness surprised them, but in fact the French had already made an enemy of the one person who might have explained their position. In Paris they had made him look a fool. Now

Phaulkon used Kosa Pan, and his knowledge of the French, to help expel them from Siam. Kosa Pan must have relished his task.

The French ambassadors entered the royal barges which had been brought down the Chao Phraya for them, and moved slowly and in state upstream towards Ayutthaya. And, of course, away from their soldiers and their warships. Once in the capital, Phaulkon was able to keep them waiting a further fortnight. First, he discovered that some of their gifts for the king had been damaged on board ship and would have to be sent for repair. Then he wove intricate and irritating webs around the exact meaning and status of 'special envoys'. La Loubère became agitated. Finally, the royal parasols were whisked away as they entered the Grand Palace and they had to walk bareheaded through interminable courtyards. Céberet felt it had been done deliberately to annoy, and said as much.

The first audience went smoothly enough, but then they discovered that nothing had yet been done to instruct King Narai in the Christian religion. Phaulkon blamed the Bishop of Metellopolis, saying his Siamese pronunciation was so bad that the king would not be able to understand. The bishop was stung – he had been in the country for 25 years; Phaulkon had been there a mere 10. He rounded on his accuser. Father Tachard, when consulted, said loftily that they should all wait for the Jesuits. So, la Loubère and Céberet decided that they must follow King Narai to Lopburi and tackle him direct. Phaulkon, their interpreter, jibbed. When pressed he broke into a rigmarole which featured such words as 'Hollande', 'Castille' and 'Sancta Maria de Loretta'. King Narai may well have wondered why he was being subjected to this gibberish. He got to his feet in silence, their last audience was at an end. Their mission had failed.

Despite this, the French troops and their warships remained in Bangkok. So Phaulkon now turned his dangerous charms on their commander, Desfarges, and his officers. They were given lavish dinner parties, with foreign wines, classic Siamese dances (and dancing girls) puppet shows and fireworks. Hunting trips were arranged and the king gave an audience to Desfarges and his subordinates. Coats in brocaded silk and gold chains were handed out. Desfarges himself was given a net of gold filigree set with a diamond in its centre. Foolishly, the old man wore it constantly, draped over his French army cap. He slept at Phaulkon's house and dined at his table. Summoned by the king, he pledged his sword to him.

His troops, meanwhile, leaderless in their fort, behaved as badly as Phaulkon hoped they would. The Siamese were scandalised and called for their removal. Then Phaulkon discovered the French soldiers had another use. With them had come a new French invention, an explosive shell or 'bombe', guns to fire this new invention and the 'bombardiers' to man them. After a demonstration, Phaulkon requested the whole squad with its arms, as a bodyguard for the king. La Loubère reminded the besotted Desfarges that his orders were to take them back to France and that if they remained in Siam he would have to bear personal responsibility. This, Desfarges happily accepted. He went down to Bangkok, put his bombardiers and their arms aboard ship, and himself brought them to Ayutthaya and offered them

to the king. La Loubère was so disgusted that he gave orders for a ship to be made ready for him to return to France immediately. Even Phaulkon, for once, was taken by surprise and hardly had time to prepare the gifts, including three baby elephants and a rhinoceros, which King Narai was sending to Louis XIV. After his farewell audience with the king at Lopburi, la Loubère went straight downriver to Bangkok without waiting for Tachard, on to the Bar and out into the Gulf, where he boarded the French ship, 'Le Gaillard'. Father Tachard came hurrying down behind him, accompanied all the way by Phaulkon. Phaulkon must have been grateful to the Jesuit for so successfully, and unwittingly, derailing the whole French project. One wonders what Tachard thought he had gained. Certainly, he was anxious to get back to Paris as quickly as la Loubère and present his own account of what had taken place.

The French did not return quite empty handed, however. Phaulkon was too subtle a player to humiliate those whom he had vanquished. Cébéret, who was one of the 12 directors of the French East India Company, sent out to renegotiate the trade treaty which de Chaumont had signed, was able to obtain almost exactly the terms which his company had demanded.

Shortly after la Loubère and Tachard had left, King Narai fell seriously ill. It was thought, rightly, that he had not long to live. At times like these, it was normal to secure the King's person (or to pretend to do so) by surrounding the Grand Palace with troops. It was done, for instance, when King Mongkut was dying. As a Siamese general and as a boyhood friend of the king, it was natural that Petraja should now enter the Grand Palace in Ayutthaya and assume control of the palace guards, and, in effect, of the king. Phaulkon was at Lopburi and summoned Desfarges to his house to plan a counter-attack, using the French troops still in Bangkok. Desfarges was eager to help and had no difficulty in recruiting 90 men from Bangkok to go and arrest Petraja. (They were probably looking forward to a fight, especially against such slightly-built people as the Siamese). They reached Ayutthaya and caused a stampede when they swaggered into the market. Desfarges was surprised; his men meant no harm. He went forward to enquire and was told the king was already dead. Perhaps he was too late to help his friend? He went to the French East India Company office to enquire. Here he met the agent, M. Véret, who hated Phaulkon and had already been all the way down to the Gulf to warn the French against him. He told Desfarges that the king was assuredly dead and Petraja was in command. He then put the general, doubting, in a boat and rowed him across the river to the French missionaries. They had their own reasons for hating Phaulkon. He had supported the Jesuit Father Tachard when he told la Loubère that the missionaries and their bishop were incapable of instructing the king and the task should be left to the Jesuits. So, the missionaries now told Desfarges that the rumours were almost certainly true and that he should proceed with great caution. Desfarges dithered; eventually, he chose the prudent course. He loaded his men and their equipment back into their boats and sailed down the river to Bangkok, even though he had by now received reliable information that Phaulkon and the king were still alive.

Phaulkon was now quite alone. The king, his heart weakened by constant attacks of asthma, lay dying in his palace at Lopburi, supported only by his sister and daughter, and ministered to by the palace women. Outside Petraja was all-powerful. He had Phaulkon seized, tortured to reveal his treasure, and executed during the night in the woods outside the city. He was only 41.

As for the king, Petraja let nature take its course. King Narai died about five weeks later in his palace at Lopburi. His body was taken down the Lopburi river by boat to Ayutthaya, where it was given a royal cremation.[12] As for the king's two brothers, they were lured away from Ayutthaya, seized and executed.

Petraja now turned to deal with the French. The day after he had despatched Phaulkon, he sent his soldiers against Desfarges in the fortress at Bangkok. They were probably not well enough armed to storm the fort which the French, who were then the best military engineers in Europe, had themselves designed. On the other hand, Desfarges only had 250 men to defend a fortress which he had estimated needed at least 800 within its walls. His ships, meanwhile, he had allowed to go privateering in the Gulf. So he commandeered a junk, put on board 17 men and told their commander, a brave young officer called St. Cricq, to make for the open sea, find his ships and tell them to return to Bangkok. St. Cricq himself was to proceed to the coast near Hua Hin and send messages to Mergui to summon the French garrison there, about 120 strong, to return at once to Bangkok.

St. Cricq and his men set off down the river, trying as best they could to look like a band of departing Chinese merchants. They had got no further than the big bend in the river below Bangkok, perhaps near Klong Toei, when a number of small Siamese vessels spotted them and swarmed out into midstream, boarding the vessel. St. Cricq, seeing what was going to happen, dragged onto the foredeck a barrel of gunpowder, split it open and as the Siamese approached, ignited it, blowing them all to oblivion. Somewhere deep down in the muddy bed of the Chao Phraya lie mingled the broken bones of those Siamese and French who died together, for no good cause, 300 years ago. Nevertheless, after this, the siege of Bangkok slackened and the French ships which had been out in the gulf were able to sail upstream unhindered and anchor under the fortress walls.[13]

One day, some two months later, the lookouts were amazed to see another French warship, the 'Oriflamme', come sailing slowly up the river. Had help been sent to them from France? The men rushed to the parapets to watch. To their astonishment the ship continued its stately progress up the river and disappeared in the direction of Nontaburi. Met by a party of Siamese at the Bar who offered to guide them to Ayutthaya, the crew and captain had been hoodwinked into thinking that nothing untoward had occurred. They were persuaded to ignore the French troops waving from the fort and told to proceed to the capital where the captain could present himself to the authorities in the proper manner, and the crew could relax.[14]

The French troops in the fortress must have despaired. In fact the 'Oriflamme' had been sent not to rescue them, but to reinforce them, having

left France months before news arrived of the French defeat. De l'Estrille and his 200 men were to find out what was happening and to assist Desfarges and la Loubère in their endeavours. One can imagine their frustration when they finally went ashore at Ayutthaya and met the French missionaries and merchants. They had just travelled almost halfway round the world, at sea for some seven months, only to learn that King Narai and Phaulkon, the two men they had come to help were both dead; la Loubère had left months ago, and Desfarges and the remnants of his force were bottled up in Bangkok with no ships to take them home and no food to feed their would-be rescuers.

It took time for all sides to accept the reality of the situation, and only Petraja could initiate a *détente*. After two months he arranged for the French to hire two merchant ships to sail back to France with the Oriflamme. Poor old Bishop Laneau, Desfarges' younger son and the egregious M. Véret were to be held by the Siamese until their ships had been sent back and paid for. The French were to be allowed to leave with full honours of war (whatever they thought that might mean) and their weapons would be returned to them when they reached the customs house at Ban Chao Phraya near the mouth of the river. At this point the Siamese would return Desfarges' younger son to his father, and Desfarges would return the Siamese hostages whom he had been allowed (somewhat generously) to carry down stream.

Whoever these hostages were, they must have thought that they would be away from home for perhaps three or four days. It was to be a year before they saw Ayutthaya again. Apparently someone told the old general that the Siamese boats following after with his cannon had run aground. This may have seemed to him an Oriental trick. His son had rejoined him, having been allowed to come aboard to have lunch (together with Monsieur Véret) and perhaps the ships were nearly in sight of the open sea. Whatever the reason Desfarges decided, dishonourably, to cut and run for it.

And so, in November 1688, after nearly 14 months trapped up the Chao Phraya river, the French expedition was on the open sea once more. Prudently, they decided to make for Pondicherry, the nearest French base in Asia. There they would learn, if they had not already, that the ruler of Holland had now become King of England (as William III) and both countries were now at war with France, with warships looking for French vessels to attack. Desfarges and de l'Estrille would need to make careful preparations. Two of their ships were not their own; they were on loan, sight unseen, and they would certainly need to be modified for the long voyage to Europe. They needed to replace their lost guns and they would probably need to recruit more sailors, since they only had the crew of the 'Oriflamme'. When they reached Pondicherry three months later, they found there another remnant of French soldiers. It may be recalled that Phaulkon had allowed about a quarter of the French contingent at Bangkok to go off to garrison Mergui. They remained there under their commander, de Bruant, and the French governor, M. de Beauregard, until the local people came to their senses and expelled these unwanted visitors. The French managed to seize and board two ships in harbour, losing 20 soldiers in the retreat. They

put to sea but, perhaps because they had no seamen on board, were driven back on to the coast of Burma, where they were refused succour by the inhabitants. Then they were captured by the English, their Siamese vessel was confiscated and by the time they struggled into Pondicherry, they could only muster 30 men out of a force of 120. It was this demoralised little group that Desfarges took charge of when he arrived two weeks after them. Indecisive as ever, he put their future course of action to the vote of his officers. Five chose to return to France, but the ships they were in were captured by the Dutch and they remained prisoners till the war in Europe ended 12 years later.

Desfarges himself and over 300 of his men returned to Siam, for reasons that are unclear. Arriving off Phuket, Desfarges sent one thankful Siamese hostage ashore and offered to treat. The Siamese apparently declined and Desfarges weakly released his two remaining hostages and left.

He returned to the safety of Pondicherry, put his men aboard the 'Oriflamme', and set off again, this time for the West Indies! Perhaps he was trying to avoid Dutch and English ships coasting up and down the western shores of Africa. We shall never know. 11 months later, within sight of Brittany, the 'Oriflamme' was driven onto the rocks by a rough Atlantic storm. The ship was smashed to pieces. Five days later two officers and a few of the men staggered into Brest. Some 800 French soldiers had been shipped to Siam; this handful of shipwrecked mariners was all that were left.

It was years before all this became known in Siam. There were about 70 Europeans then living in Ayutthaya, many of them French missionaries. Some were imprisoned when Desfarges made off with his Siamese hostages, but they were apparently released when the Siamese returned from Phuket where they had been freed by Desfarges. On the whole, foreigners do not seem to have suffered for the violent behaviour of their fellows. Life went on very much as it had before. The missionaries continued to teach in Lopburi and Ayutthaya, paddling up and down by boat. The Jesuits went about in their strange, half-Buddhist garb, consisting of Buddhist robes and the distinctive Jesuit hat. The priests served their little flock from their church on the south bank of the Chao Phraya just outside the city wall. French and English freebooters came up river to trade, freed from the restrictions of their companies.

The only visible reminder of the French expedition was the fort they had built for the Siamese, and then occupied by themselves, just below the present Wat Arun. Two years later the German doctor, Engelbert Kaempfer, coming to Ayutthaya for the first time wrote: "At Bangkok we saw the new Fort, which was raised by the French on the right bank, quite demolished". The Siamese usually destroyed buildings which had been used by the enemy for shelter. After Forbin's fortress had been slighted, it may be that the people of Thonburi came out, picked over the ruins and lugged away the best bits for themselves. The Siamese fortress on the east bank (the Bangkok side) was allowed to stand.

Holland was the only western country with an official presence. The Dutch East India Company continued to trade from its 'factory' outside

Ayutthaya. It was still there, like the missionaries, when Ayutthaya fell to the Burmese 80 years later. For the rest, the unrecorded masses, the Chinese merchants arriving every spring in their junks, the Muslims from Mergui bringing goods from India and Persia, the ordinary traders in Ayutthaya, the country people who came paddling into town with their produce, life continued as it always had done, mostly unaffected by these ructions of the *farang*. What shattered their lives and laid the city flat was the coming of the Burmese in 1767.

Petraja, having murdered all the male claimants to the throne, proclaimed himself King of Siam and ruled for 15 years. His son (King 'Tiger') and his grandson followed him. It is said that he forced King Narai's sister and daughter to marry him though it seems doubtful if they would have had issue. It is also said that Phaulkon's widow was given a position of authority in the royal kitchens and worked for the man who had murdered her husband. Phaulkon's son became a captain in the Siamese navy and one of his grandsons was living in Ayutthaya when it was sacked by the Burmese in 1767. He was carried away to Burma but, with his grandfather's resource, made his way back to Siam and was seen there in 1771.[15] It has even been claimed that one of Phaulkon's descendants married, in 1825, the first English merchant to settle in Bangkok.[16]

1. A. Kerr, Notes on a Journey from Prachuap to Mergui. *The Journal of the Siam Society*, vol. XXVI.

2. De Bourges, *Rélation du Voyage de Mgr. l'Evêque de Béryte*. Paris,1666.

3. Some Italians who went to Madagascar during the war in Abyssinia were told of this local belief by the inhabitants. From the Thai side the legend is supported by at least one family who believe that one of their ancestors was on the ship and ended his days living among the 'natives' of Madagascar. (Verbal communication from Thanpuying Arun Kitiyakara).

4. Luang Sitsayamkan, *op. cit.* (see page 32).

5. Mémoires et documents, *Asie*. Quai d'Orsay, Tome II, p. 37.

6. Bénigne Vachet, *Mémoires* (extracts). Paris, Groupy 1865.

7. Dirk van der Cruysse, *op. cit.* p. 290.

8. Michael Smithies, The Travels in France of the Siamese Ambassadors, 1686-7, *The Journal of the Siam Society*, vol. 77, part 2.

9. Petithuguensin, L'Imprimerie au Siam, *The Journal of the Siam Society*, Vol. 8.

10. Nicolas Gervaise, *The Natural and Political History of Siam 1688*. Translated by O'Neill, Bangkok 1928. Also translated by John Villiers, White Lotus. Bangkok 1989.

11. R. W. Giblin. Early Astronomical and Magnetic Observations in Siam. *The Journal of the Siam Society*, vol. 6 part 2.

12. Professor van der Cruysse, A lecture at The Siam Society on 4th. February 1992.

13. Luang Sitsayamkan. *op. cit.* p. 169. Also '*Three Military Accounts of the 1688 Revolution in Siam*, Translated and edited by Michael Smithies, Bangkok, Orchid Press, 2002. This contains two other, slightly different accounts. But as the explosion occurred out of sight of Bangkok and all the French were blown sky-high, it seems that one version must be as good as another.

14. *Three Military Accounts of the 1688 Revolution in Siam, op. cit.* Two of these accounts mention the 'Oriflamme' (p. 49 and 148) and both claim that she did not pass in front of the French fort but went up by a side canal. But a European warship of 750 tons, carrying 200 soldiers could not possibly have sailed up Klong Bangkok Noi and must have been seen by the astonished French garrison.

15. Father Manuel Teixeira, St. Joseph's Seminary, Macau, in a letter to the *Bangkok Post*, 12th. November, 1983. For further details see his book *Portugal na Tailandia*, Macau 1983.

16. R. Adey Moore, Hunter, his wife and descendants, *The Journal of the Siam Society*, vol. XI, part 2, p.34.

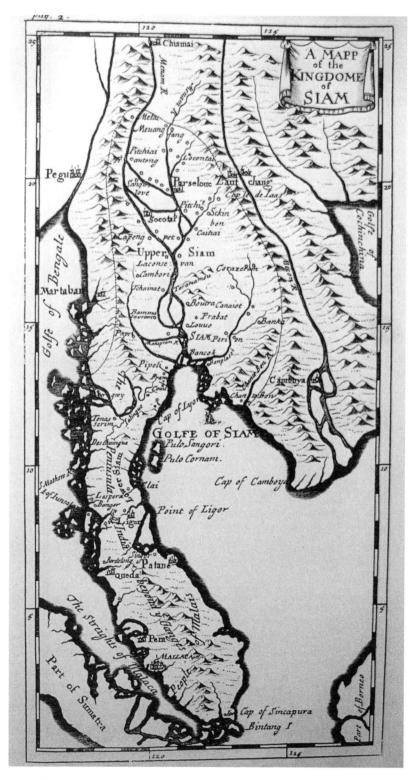

La Loubère was the first cartographer to attempt to delineate the complexities of the river system north of Ayutthaya (for details, see page 123). For this, he may have relied on reports of a journey made by La Mare and two French Jesuit mathematicians. (River Books Collection)

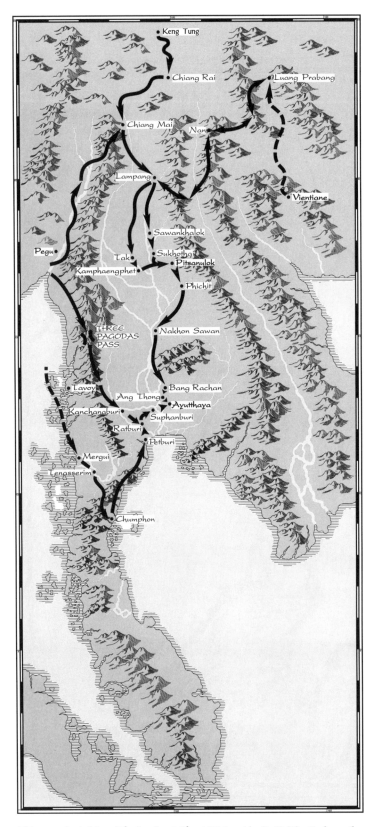

This map adapted from 'Thailand – A Short History' by D. K. Wyatt, shows the routes followed by the three Burmese armies as they slowly advanced on Ayutthaya.

The Fall of Ayutthaya

The Chao Phraya had brought to Siam the ships and trade which made Ayutthaya the wonder of the Orient. Now it brought the Burmese, intent on sack and pillage. They had not attacked Ayutthaya for nearly 200 years, nor had the kings of Ayutthaya attacked them. It is difficult to explain the motive for this sudden and ferocious onslaught. The pretext was that Siam had given shelter to a large number of Mon refugees fleeing the fighting in Burma. The Mon kingdom of Pegu had recently been very successful. They had captured the Burmese capital of Ava, toppled the Burmese king, and ended that dynasty. The new Burmese leader, Alaunghphaya, was perhaps somewhat uncouth, but an inspiring and energetic leader. He rallied the people, retook the Burmese capital and threw the Mon out of Burma. Then he followed them into Pegu and destroyed their own kingdom. After this, it seems he simply continued his conquests. Perhaps fighting was what he was best at; perhaps he wanted to emulate the sixteenth century warrior-kings of Burma, who conquered Ayutthaya, Chiang Mai and Laos. Whatever his motive, in 1760, he attacked Martaban, Tavoy and Tenasserim, crossed the hills to Pranburi, and, sweeping through Petburi and Ratburi, by April, was outside the walls of Ayutthaya.

He might well have taken the city then, if one of his siege-guns had not exploded and injured him so badly that he had to be carried back to Burma, dying on the journey. Three years later, the Burmese came again. They attacked Chiang Mai and the northern towns, which they regarded as their vassal. After reducing Chiang Rai, Chiang Mai and Lampang in two years, they crossed the hills to the east to subjugate Nan and the king of Luang Prabang. Now only Ayutthaya and the towns to its north on the Chao Phraya and its tributaries, remained.

The army spent the wet season at Lampang, then in July 1765 they continued their relentless march southward. Tak, Kamphaeng Phet, Sawankhaloke, Sukhothai, Pitsanuloke, Phichit and, finally, Nakhon Sawan fell before them. Nakhon Sawan was regarded as the last bastion against attacks from the north using the Chao Phraya. Traditionally, the king's eldest son would organise its defences, while his younger sons would be sent to more northerly outposts such as Kamphaeng Phet. On this occasion Ayutthaya seemed unable to co-ordinate these city states into an effective defence and most made only a show of resistance as the Burmese were terrifying opponents.

Many races testified to their ferocity. Crawfurd took depositions from those who had been their prisoners of war. One man told how 6,000 of them

had been chained together in pairs, forced to carry heavy loads and given very little to eat. A woman who refused, saying she must carry her child, had the baby snatched away. Its head was cut off and the body thrown into the river.[1] In Assam it was said the people who opposed the Burmese were skinned alive, burnt in oil or driven into the village prayer-houses which were then set on fire. Sometimes the soldiers would slice slivers of flesh off their prisoners and eat it in front of them. The Burmese were in Assam for seven years; in that time the population was halved. Years later, the people still shuddered at the mention of *Manar Upadrab*, the oppressions of the Burmese.[2] Whether these tales are true or not, they reveal the fear the Burmese soldiers inspired. When reproached with cruelty, the Burmese would reply that at home they were a mild people,[3] but when they invaded foreign countries they would give rein to their passions, plundering and murdering without control so that foreigners should learn not to provoke them.

At Chiang Mai, they had taken a stretch of the city wall. Then they had hauled their guns up on to the parapet and fired point-blank into the houses below. The next morning the monks went out to implore them to stop and accept the surrender of the town. Elsewhere, it is said they cut off the heads of their enemies and stacked them in rotting piles under the eyes of the defendants. Only one small settlement held out, Bang Rachan, near Suphanburi. The inhabitants threw up earthworks and, using the river as a barrier, held off the Burmese army for five months, before being slaughtered to a man. The remains of their ramparts can still be seen, and there is a simple memorial to their heroism. Meanwhile, the Burmese army moved on once more, down the Chao Phraya, to their destination.

At the same time, a second Burmese army was approaching inexorably from the south. Some of the troops had come over the Three Pagodas Pass and down the valley of the Kwae Noi as far as Ratburi. There they had met those who had come over the Tenasserim Hills and up the coast, past modern-day Hua Hin, to Petburi and Ratburi. From here the army spread out over the Central Plains towards Ayutthaya. By boat, by barge, on foot they came, dragging their huge siege guns behind them on sleds or carts.

Finally, when every outlying town had been taken and the enemy were a day's march away, the Siamese seemed to shake themselves out of their lethargy. They assembled an army of 60,000 men and sent it off to the front. Without any experience of battle, and with no good leaders, they were soon routed, and came streaming back into the city. This engagement reveals the main cause for the Siamese defeat: poor leadership. The villagers of Bang Rachan had shown what could be done. But there were no men of this metal in Ayutthaya. The descendants of King Boromakot seem to have degenerated into weaklings. Many of the family had died in the feuds which broke out on the death of each king. Those who remained inspired little loyalty.[4] It is said that King Suriyat Amarin ordered the gunners on the walls to cease their night bombardment of the enemy out in the rice fields, since it disturbed the ladies of his court. His only plan seems to have been to wait for the Burmese to go away.

This was not perhaps so stupid as it sounds. The Burmese had arrived after the rains of 1765, intending to take the city during the next six months or so of dry weather. But Ayutthaya could hold out for longer than that. The siege was not so intense as to prevent food arriving and families could come and go. When the rains came, the rivers would rise and the rice fields would turn into an inland sea. Nothing could live on the ground. Cattle were stalled in cowsheds on stilts; the deer retreated to the mounds (or *nern*) which now appeared as islands in that sheet of water which stretched to the horizon, and men would come after them with lances and spear them from their boats. Even corpses had to be wrapped and lodged high up in the branches of trees until the waters fell. The people retired to their houses built high off the ground, or paddled about in boats enjoying themselves. No army could sit out the floods.

The Burmese did retreat, but only to higher ground, where they lived off the villagers and waited for the waters to go down.[5] Perhaps they had stern or inspiring commanders; perhaps they looked at the spires of the city, glistening in the sunlight and thought of the booty that lay there; perhaps they enjoyed the months of respite from fighting and marching, and gave themselves over to fraternizing with the local girls. Whatever the reason, their morale did not crumble. When the waters fell, they returned to the siege and in at least three places were able to build brick forts – at Pho Sam Ton, at Si Kuk and at Bang Sai.

While the Burmese were sitting it out in the foothills, the river had little of the appearance of war. Foreign merchant ships might well have been unaware of the situation. However, as well as controlling the river, the Burmese also held onto their headquarters at Wat Thien, south of Nontaburi, so Ayutthaya remained cut off. There is a tale of two English merchant ships, under the command of the interloper Captain Powney, who had just unknowingly passed Nontaburi, when they were ferociously set-upon by the Burmese. But English merchantmen in those days came armed and, having driven off their attackers, they turned their guns on the earth ramparts of the Burmese and blew great breaches in them. Prudently, Captain Powney then sailed away down the Chao Phraya to look for calmer waters in which to do his trade. The missionaries, bottled up in Ayutthaya, tell a different tale about Captain 'Pawni'. They say the Dutch had already fled, so he was asked by the Siamese to take over the defence of Ayutthaya, but was ordered to deposit his 38 bales of cargo in the arsenal. After his devastating attack on the Burmese, he asked for more ammunition; but the Siamese were so alarmed by his ferocity and (remembering White) so doubtful of his intentions, that they refused to rearm him or return his merchandise. He left in a huff, and hunted up and down the Gulf for merchantmen whom he could despoil, telling them that the king would compensate them.[6]

The same fate nearly overtook a Chinese junk, although one might have expected Chinese sailors to be more aware of what was happening in a port where so many of them traded every year. Their ship had got nearly to

Ayutthaya when suddenly she was set upon by Burmese who almost boarded her. The crew hacked away with their cutlasses, shook themselves free and escaped down the river. The fact that both these ships got so far up the Chao Phraya suggests that there were no Burmese ships on the river. Indeed, apart from one naval engagement at Chumporn, there is no mention of the Burmese navy appearing in the Gulf of Siam.

On land the Burmese ranged far and wide; they were seen in Chonburi and made their way down the coast towards Pattaya and Sattaheep. They were even rumoured to have built a small town, called 'Mae Klong at the junction of two rivers'. Was this perhaps the origin of the present 'Mae Klong', the common-or-garden name for Samut Songkram? It would have been an excellent base from which to send troops and guns by water up towards Ayutthaya.

In Bangkok and Thonburi the Burmese were everywhere, sacking the latter. In Bangkok they nearly captured Chao Phraya Surasih, the younger brother of the future king, Rama I. He had been an equerry to King Suriyat Amarin, but like many others had left the court in disgust and had gone to Pitsanuloke, where his father was the 'Chakri', or military governor. Now he and some companions were coming down the Chao Phraya by boat, hoping to turn into Klong Bang Luang and somehow make his way across to Ratburi where his elder brother was deputy-governor. As they were nearing Thonburi, they noticed that both banks of the Chao Phraya were infested with Burmese troops. The sun had not yet risen, so they pulled into the shore, turned their boat over, plucked some long-stemmed water hyacinths from the river and draped them over the hull. Then they pushed off again, hoping their cockleshell craft would merge with the floating weeds of the river. Just as they were reaching Klong Bang Luang, they peeped out and saw the outline of old Wat Jaeng, pink in the dawn light. Moved by the sight, the future Second King vowed that he would return and restore that *wat* if the country was freed of the Burmese. (The promise, was kept and King Rama II preserved the story by renaming the *wat*, Wat Arun, or the Temple of the Dawn).[9]

At Ayutthaya, as the flood waters receded, the Burmese were preparing their second siege. In a final attempt to halt the inevitable, the governors of Petburi and Tak led a force in boats to attack the assembling troops, but the governor of Petburi was killed and the attack fell back. Phraya Tak felt unfairly blamed for this failure, and, hindered from making a second sortie, he slipped out of Ayutthaya with some of his followers. They made their way by water and by land south-east to Chonburi. This, of course, was the future King Taksin, saviour of the country.

The Burmese troops came closer, placing their guns on the 'Golden Mount' and firing into the city, at what seems an extreme range for eighteenth century field guns. They built up earthworks from which to fire down into the city and they sent out sappers to undermine the walls. The inhabitants of the town knew their fate. Families buried their treasure, but in their haste often forgot where they had put it. Women, fearing rape, cropped their hair,

dressed in *pha nung* like their husbands and brothers, and 'manned' the parapets with them.[7] To save the city from sack, King Suriyat Amarin offered to open the gates. He was rebuffed. The Burmese king died of dropsy but his troops did not falter. A huge fire broke out amongst the wooden buildings of the town – perhaps temporary shelters put up by the villagers who had come in to escape the Burmese – and about 10,000 houses were destroyed, leaving these families to camp out in the open. Disease was rife and people starved. Eventually, on 7 April 1767, a portion of the wall collapsed, mined from beneath. As the sun was setting the Burmese poured into the town.

They had been outside for 14 months – now their feelings were unleashed. As darkness fell, they looted, burned and raped. The sky was red with flames. In the confusion, the king fled in a small boat. 10 days later he was found, starved to death. Perhaps he was luckier than his brother, with whom he had contested the throne. Ex-King Uthumporn was found hiding with members of his family and his entourage. They were shackled and led away over the hills to Burma. He ended his days pathetically, recalling the past glories of the kings of Ayutthaya.

Meanwhile the palaces and temples were looted. It is said that soldiers piled up brushwood against the statue of Phra Sri Sanphet, lit the wood and kept the fires burning for seven days to melt off the gold, which allegedly now adorns the Shwedagon pagoda in Burma. The Siamese had prided themselves on their huge guns; one was said to fire a cannonball weighing 100 lbs. The bigger guns the Burmese burst, or threw into the river. The smaller ones were taken back to Burma. Four of these are now in the Madras museum, inscribed in Burmese with the date of their capture, 18 March 1766.[8] In Mandalay there stand some bronze statues which the credulous touch to relieve their pain. These were also brought from Ayutthaya, but had begun their journey in Angkor, from whence they were looted by the Siamese.

Some things were not destroyed. In particular, the Burmese were looking for skilled artisans. Ayutthaya had been a rich and tranquil society (beneath the surface turmoil of those who murdered each other for the throne). Craftsmanship had flourished and the arts were patronised. Burma was in comparison much less settled with neither the wealth nor the time for the refinements of life. We think of lacquerware as being typically Burmese. In fact it seems that the art was brought by Siamese prisoners. In captivity, they taught their expertise to the Burmese who improved upon it.[10]

But the Burmese were looking also for people with more ordinary skills and above all, for women. Thousands were rounded up and marched away to Burma. '*Khwat Ruen*' the Thais called it, or 'sweeping a village' (of its talented people). Old Thai families still recall how their ancestors were taken away and never returned. The hot season had just begun and walking for three or four weeks was unpleasant even for hardened soldiers. The people of Ayutthaya would have been unaccustomed to such hardship; worse, many were hobbled and had to shuffle along in lines, roped together. It is said the Burmese guards made thongs out of twisted strands of rattan and

threaded it through the flesh behind the Achilles' tendons of their prisoners. Such brutality cowed the Siamese, as perhaps was intended; 20 or 30 could be led away by one or two Burmans. Their fear and hatred lasted for years; it is said that mothers would hush their children's cries by saying *"Pama ma leo"* (Quiet! The Burmese are coming). They were reluctant to marry a Burmese spouse because of the curse their forefathers had put upon the Burmese race, but this may also have been the underlying antipathy of one race for another.

Suffering on this scale is usually faceless. The victims seldom leave records, even if they do survive. We are lucky to have one account of prisoners thus led away, handed down by a family whose ancestors were daring enough to escape.[11] Khun Phaeng, aged 24 or 25, and his brother Duang, a year or two older, were caught and put into a *rua krone* or sampan with a number of other Siamese and two Burmese guards. They had to pole the boat down the Chao Phraya. They were given no food or salt, but were allowed to pull into the bank when they saw a guava or tamarind tree which has prickly but edible leaves. During the day they watched Burmese soldiers walking down the banks of the Chao Phraya, beginning their own march home. At night, the two Burmese guards simply told their prisoners to guard each other; themselves closed their eyes and went to sleep. They had, apparently, been travelling by night; perhaps to avoid the heat of an April day. At any rate, as the sun was rising, the guards told them to pull into the east bank of the river at the village of Bangkaen, near Nontaburi. They stopped under a tree and the guards went to sleep. So did all the Siamese except Phaeng who wondered how they could escape. Eventually, when it was almost midday, he woke his brother. One went to the Burmese in the bows, the other to the stern. At a signal, they snatched the Burmese' swords and cut off their heads. The other prisoners woke up and were terrified; but they helped to wedge the bodies into the boat and sink it. Then they cut themselves staves with sharpened tips and made their separate ways into the village.[12]

Eventually, the last of the Burmese and their captives left Ayutthaya. The great city stood there, silent and empty. The temple roofs had fallen in, blackened beams hung down. The royal palace was a ruin where only dogs prowled and lizards flickered in the sunlight. Slowly people began to wander back, to gaze at what had been. And to wonder at such splendour and such power brought so low. No ships came up the Chao Phraya to seek for trade. No foreign merchants walked the streets. The wooden buildings of the French mission were reduced to ashes. The stout Dutch factory was slighted and forlorn. It would be 50 years before foreigners came once more to Siam. Meanwhile, for ordinary people, there was the business of finding food and shelter. The Burmese still roamed the countryside; the Siamese, like refugees in their own country, scratched a living as they could, and kept their heads down.

But in the East, a Star was rising. One man had lived to fight another day.[13]

1 John Crawfurd, *Journal of an Embassy from the Governor-General of India to the Courts of Siam and Cochin-China.* London, 1828; vol. I, p. 423.

2 G. E. Harvey, *History of Burma*, London, 1969, p. 298.

3 François-Henri Turpin, *Histoire civile et naturelle du royaume de Siam*, Paris, Costard, 1771. Translated by B. O. Cartwright. Bangkok, American Presbyterian Missionary Press, 1908, p. 158-159.

4 Turpin, *op. cit.* p. 156.

5. The village of Ban Song Phi Nong was built, perversely, in the middle of the flood plain. The houses were constructed three storeys high with the two lower floors for shops. When the floods came, the inhabitants used to shift their goods up to the second floor while the ground floor filled with water to a depth of ten feet.

6. This story, like the preceding one, is taken from 'The History of Siam' by Turpin, published in Paris in 1771. Turpin, who had never been to Siam himself, took them from manuscript accounts of the siege by the Bishop of Tabraca and by other missionaries in Ayutthaya at the time of the siege. It is the only European account of the siege which we possess. It is therefore of great interest even though many of the stories seem garbled & somewhat improbable.

7. This, of course, is the origin of the 'masculine' style for women which became de rigueur in the time of King Chulalongkorn and we see in so many old photographs.

8. From a paper on 'Old Siamese Guns', by Seymour Sewell, read to the Siam Society on 14th Sept. 1921.

9. Oral communication from Thanpuying Arun Kitiyakara. Some historians dispute this and say the story concerns (King) Taksin and not Chao Phraya Surasih.

10. Over the centuries it has been a two-way exchange. Khanom Cheen is said to have come from Burma, and the word the Thai use for 'shrimp paste' (*kapi*) is a corruption of a Burmese word, so perhaps the paste itself originated with the Burmese.

11. It comes in the funeral book of Mom Khao, whose father, Khun Sura, served King Rama VI, from whom he received the family name of Surasongkram. His ancestor had been given the title of Phraya Siharaj Dejochai by Rama I. As a young man, he had been captured at the fall of Ayutthaya.

12. It is not surprising to find a young man of such spirit reappearing later in Thai history. He is mentioned in the Chronicles as leading as attack on Thonburi to overthrow King Taksin, having first attacked and killed the King's governor at Ayutthaya.

13. This, of course, was the future King Taksin, who retired to Chanthaburi, raised an army, built a war fleet, drove the Burmese out of Thailand and founded a new capital at Thonburi. He was the forerunner of the present Chakri dynasty.

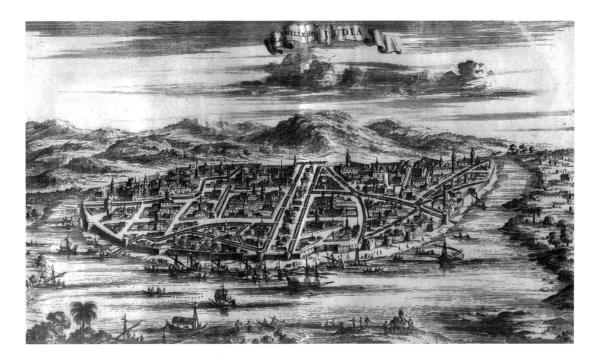

A Family Tree of the Kings of Ayutthaya (1350-1767)

Phraya U Thong

3 **King Boromrajadhiraj I**
1370-1388
Usurper and founder of
Suwannaphum Dynasty
Seized the throne from **2**

Phra Indraraja
Ruled Cambodia from
1373

4 **KingThonglan**
1388
Ruled 7 days and killed by **2**

Princess Indramitra

Prince Ai Phraya

Killed each other in a
duel on elephant back

9 **King Boromrajadhiraj III**
1488-1491
Took Tavoy from Burmese

Son

15 **Khun Vorawongsa**
1548
Ruled 42 days

14 **King Yodfa**
1547-1548
Poisoned by **15**
at the age of 11

Prince Ramesuan
Taken to Burma and died on the way

Princess Kaewfa

Prince Srisaowaraj
Killed by **17**

Son

6 King Indradhiraj
1409-1424

1 King U Thong
(King Rama Thibodi I) 1350-1369
Founder of Ayutthaya (U Thong Dynasty)

Prince Ei Phraya

7 King Boromrajadhiraj II
1424-1448 (Chao Sam Phraya)

Daughter

2 King Ramesuan
Reigned twice 1369-1370 and 1388-1395

5 King Rama Rajadhiraj
1395-1409
Seized the throne from **6**

Prince Indraraja
Ruled Cambodia from 1431

8 King Boromtrailokanat
1448-1488
(Governed Pitsanulok for 25 years
before ascending the throne)

Prince Indraraja
Died from a gun shot wound

10 King Rama Thibodi II
1491-1529

Son

13 King Chairajadhiraj
1534-1547
Poisoned by his consort,
Sri Sudachandra

11 King Boromrajadhiraj IV
1529-1533
Died from smallpox

16 King Maha Chakrapat
1548-1569

Prince Srisin
Executed by **13** at the age of 7

12 King Rasadadhiraj
1533-1534
Reigned for 5 months
killed by **13** at the age of 5

Princess Visutthi Kasat
Became queen of **18**

Princess Thep Kasattri
Went into battle with Queen
Sri Suriyothai

17 King Mahintradhiraj
1569-1569
Burmese sacked Ayutthaya in 1569
and he died in the same year

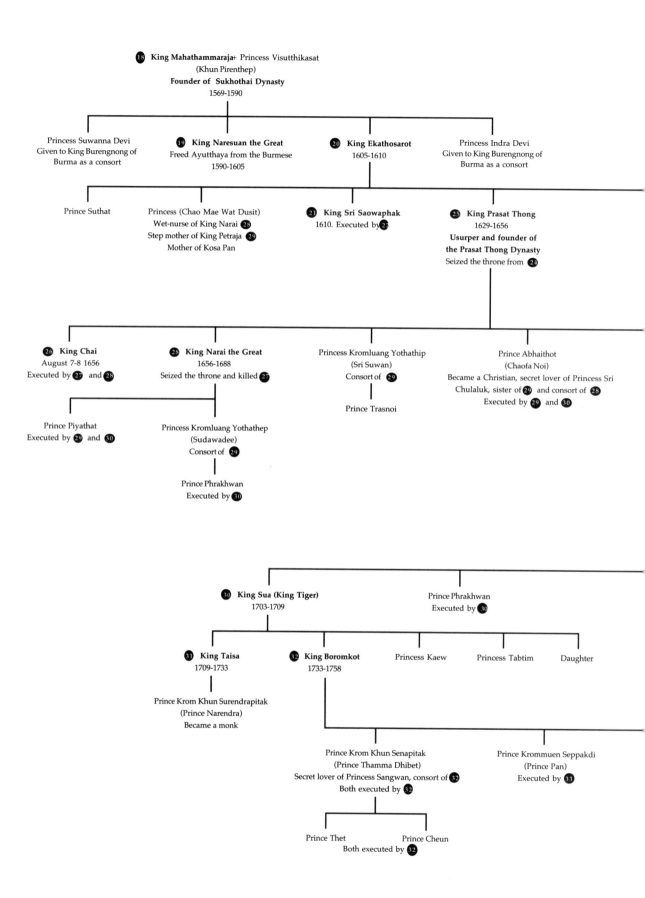

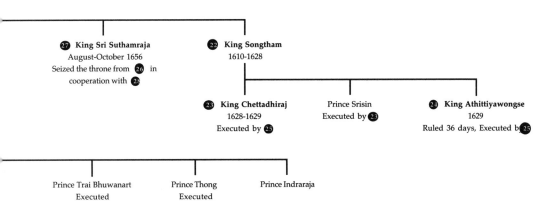

27 **King Sri Suthamraja**
August-October 1656
Seized the throne from **26** in
cooperation with **28**

22 **King Songtham**
1610-1628

23 **King Chettadhiraj**
1628-1629
Executed by **25**

Prince Srisin
Executed by **23**

24 **King Athittiyawongse**
1629
Ruled 36 days, Executed by **25**

Prince Trai Bhuwanart
Executed

Prince Thong
Executed

Prince Indraraja

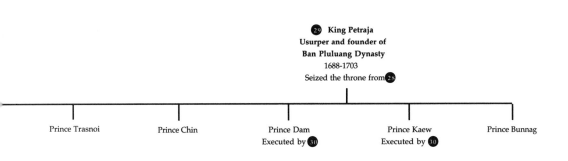

29 **King Petraja**
Usurper and founder of
Ban Pluluang Dynasty
1688-1703
Seized the throne from **28**

Prince Trasnoi

Prince Chin

Prince Dam
Executed by **30**

Prince Kaew
Executed by **30**

Prince Bunnag

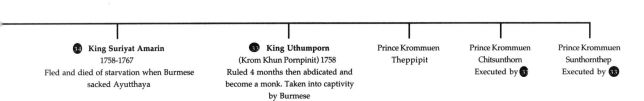

34 **King Suriyat Amarin**
1758-1767
Fled and died of starvation when Burmese
sacked Ayutthaya

33 **King Uthumporn**
(Krom Khun Pornpinit) 1758
Ruled 4 months then abdicated and
become a monk. Taken into captivity
by Burmese

Prince Krommuen
Theppipit

Prince Krommuen
Chitsunthorn
Executed by **33**

Prince Krommuen
Sunthornthep
Executed by **33**

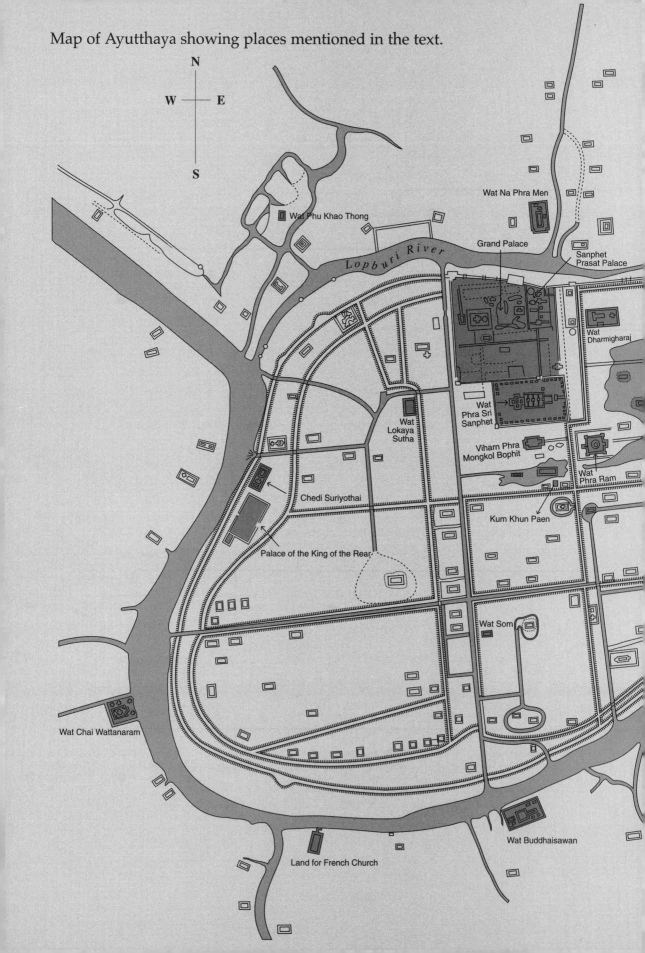

Map of Ayutthaya showing places mentioned in the text.

N
W E
S

Wat Phu Khao Thong

Lopburi River

Wat Na Phra Men

Grand Palace

Sanphet
Prasat Palace

Wat Dharmigharaj

Wat Lokaya Sutha

Wat Phra Sri Sanphet

Viharn Phra Mongkol Bophit

Wat Phra Ram

Chedi Suriyothai

Kum Khun Paen

Palace of the King of the Rear

Wat Som

Wat Chai Wattanaram

Wat Buddhaisawan

Land for French Church

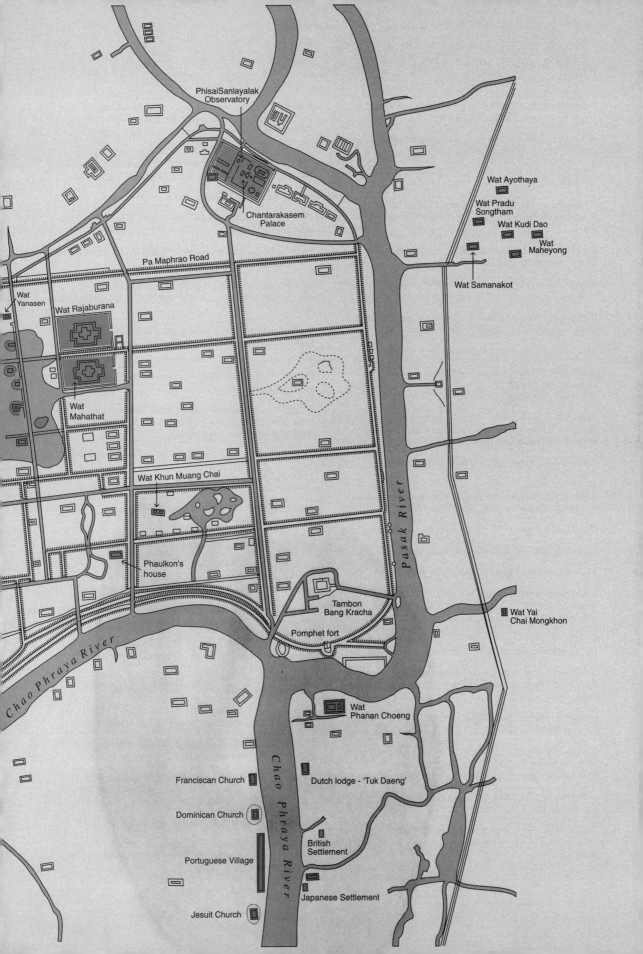

List of Sources

Adey Moore, R., 'Hunter, his wife and descendants'. *The Journal of the Siam Society*, vol. 11, part 2.

Amatayakul, Tri. *The Official Guide to Ayutthaya and Bang Pa-In*. Fine Arts Department, 1972.

Anon, *The Origin and Evolution of Thailand Boats*. Siam Society Library.

Archambault, Michèle, 'Block printed fabrics of Gujarat for export to Siam'. *The Journal of the Siam Society*, vol. 77, part 2.

Bangchang, The history of the Bangchang family, from whom Queen Amarindra was descended.

Bleyerveld-van't Hooft, Mrs. Elisabeth, 'The Dutch Presence in Siam'. *The Siam Society Newsletter*. Vol. 3, No. 2, June 1987.

Bourges, Jacques de., *Rélation du voyage de Monseigneur l'Evêque de Béryte......*, Paris. D. Bechet. 1666.

Bradley, Rev. D. B., *Bangkok Calendar*, 1859-60.

Braga, J. M. (Conselheiro da Uniao das Comunidades de Cultura Portuguesa); *Portugal and Asia*, published in honour of the Bangkok Bicentennial 1982.

Breazeale, Kennon, editor. 'From Japan to Arabia – Ayutthaya's Maritime Relations with Asia'. Foundation for the Promotion of Social Scienes and Humanities Textbook Projects, Bangkok 1999.

Caddy, Mrs. Florence, *To Siam and Malaya*. Hurst and Blackett, London, 1889.

Campos, Dr. Joaquim de., 'Early Portuguese Accounts of Thailand'. *The Journal of the Siam Society*, vol. 32.

Chamaraman, Ajarn Chusiri, many verbal communications.

Chao Krok Wat Pho, *Diary of Chao Krok Wat Pho*.

Choisy, *Journal du Voyage de Siam*, Paris, 1687.

Chutintaranond, Dr. Sunait, 'The Origins of Siamese-Burmese Warfare'. Published in the 'Proceedings for the International Workshop, 'Ayudhya and Asia', December, 1995.

Collis, Maurice, *Siamese White*. London. Faber & Faber, 1965.

Crawfurd, *Journal of an Embassy of the Governor-General of India to the Courts of Siam and Cochin-China*. London, 1828, Vol. I.

Edwardes, Michael, *Ralph Fitch, an Elizabethan in the Indies*. London. Faber & Faber, 1972.

Gervaise, Nicholas, *The Natural and Political History of Siam 1688*. Translated by O'Neill, Bangkok 1928. Also translated by John Villiers, White Lotus Press. Bangkok, 1989.

Giblin, R. W., 'The Abbé de Choisy'. *The Journal of the Siam Society*, vol. 8.

Giblin, R. W., 'Early Astronomical and Magnetic Observations in Siam'. *The Journal of the Siam Society*, vol. 6, part 2.

Grimm, T., 'Thailand in the Light of Official Chinese Historiography – A Chapter in the History of the Ming Dynasty', reprinted in *The Journal of the Siam Society*, vol. 49, 1961.

Giles, F. H., (Phraya Indramontri), 'Adversaria on Elephant Hunting', *The Journal of the Siam Society*, vol. 23, part 2.

Harvey, G. E., *The History of Burma*.

Howitz, Dr. Pensak C. 'Was the "Sattahip" a Siamese cargo ship?'. *Bangkok Post*.

Hudson, Major Roy, an article on Ralph Fitch in the *Bangkok Post*, Jan. 23rd, 1977.

Ishii, Professor, A talk given at the Siam Society on 1st March, 1988 & reprinted in *The Siam Society Newsletter*, vol. 4, no. 2.

Kaempfer, Engelbert, *A Description of the Kingdom of Siam (1690)*. (English translation, 1906). White Orchid, Bangkok, 1987.

Kerr, A., 'Notes on a Journey from Prachuap to Mergui'. *The Journal of the Siam Society*, vol. 26.

Khao, Mom, the funeral book of Mom Khao's father, Khun Sura, served King Rama VI, from whom he received the family name of Surasongkhram.

Kitiyakara, Thanpuying Arun, many verbal communications.

Krairiksh, Piriya. 'A Revised Dating of Ayudhya Architecture'. *The Journal of the Siam Society*. Vol. 80, parts 1 & 2.

Kritakara, M. L. Toh and the late M. R. Pimsai Amaranand, *Modern Thai Cooking*.

Lach, D. F., editor. *Asia on the Eve of European Expansion*. 1965.

La Loubère, *A New Historical Relation of the Kingdom of Siam*, London 1693. Reprinted by Oxford University Press, Singapore, 1986.

Launay, Adrien. (editor), *'Histoire de la Mission de Siam'*. Documents historiques. 2 vols. Paris. Société des Missions Etrangères, 1920.

Luce, G. H., 'The Early Syam in Burma's History'. *The Journal of the Siam Society*, vol. 46, part 2.

Malcolm, Howard, *Travels in Southeast Asia*, vol 2. 1839.

Morson, Ian, 'Four hundred Years – Britain and Thailand'. An informal presentation. Bangkok, Nai Suk, 1999.

Mouhot, Henri. Diary, Abridged and edited by Christopher Pym. Oxford University Press, Kuala Lumpur.

Neale F. A., *Narrative of a Residence at the Capital of the Kingdom of Siam*. Office of the National Illustrated Library, London. 1852. Reprinted, White Lotus, Bangkok.

O' Kane, *The Ship of Sulaiman*. Routledge & Kegan Paul, 1972.

Panyacheewin, Saowarop, An interview with the Portuguese ambassador, Dr. José Eduardo de Mello-Gouveia. *Bangkok Post*, September 18th, 1983.

Petithugensin, 'L'Imprimerie au Siam'. *The Journal of the Siam Society,* vol. 8.

Pinto's Travels. Translated by H. Cogan, 1663.

Princess Krom Luang Narindra Devi, her diary, written anonymously.

Royal Historical Annals, vol. 2.

Sewell, Seymour, A paper on 'Old Siamese Guns', read to the Siam Society on 14th September l921.

Sirisena, W. M. 'Relations between Ayudhya and Sri Lanka', in the Proceedings of the International Workshop on Ayudhya and Asia. December, 1995.

Sitsayamkan, Luang, *The Greek Favourite of the King of Siam.* Singapore. Donald Moore Press, 1967.

Smith, G. V., *The Dutch in Seventeenth-Century Thailand.* Centre for S.E.A. Studies, 1974 and 1977.

Smith G. V., *The Dutch in Seventeenth Century Thailand.* Centre for Southeast Asian Studies, Northern Illinois University, 1977.

Smith, Sammy, 'Siam Repository' for 1869 quoting from *The Bangkok Calendar* for 1850.

Smith, Sammy, *The Siam Repository,* 1871.

Smythe, H. Warrington, *Five Years in Siam 1891 to 1896.* 2 vols. London 1898. Reprinted, White Lotus, Bangkok, 1984.

Smithies, Michael, *A Resounding Failure.* Chiang Mai. Silkworm Press. 1998.

Smithies, Michael, (translated and edited by) *Three Military Accounts of the 1688 Revolution in Siam.* Bangkok. Orchid Press, 2002.

Smithies, Michael, 'The Travels in France of the Siamese Ambassadors, 1686-7'. *The Journal of the Siam Society,* vol. 77, part 2.

Smithies, Michael and Euayporn Kerdchouay, 'Report on a tour to Ayutthaya'. *The Siam Society Newsletter,* vol. 4, number 1.

Spruit, Ruud, 'Thailand and the Dutch'. A talk given at the Siam Society on 30th, October 2002.

Tachard, Guy, *Voyage de Siam.* Paris, 1686.

Teixeira, Father Manuel, St. Joseph's Seminary, Macau. *Portugal na Tailandia.* Macau, 1983.

The Bangkok Post, Sunday July 21st, 1985, 'Divers Hunt for Lost Treasure of Siamese King'.

The Bangkok Post personal column, annually on 9th, July. A memorial to the Captain and Master's Mate of the East India Company ship. 'The Globe', who died at Pattani on that day in 1612.

The Oriental of Tomé Pires. 2 vols. The Hakluyt Society. London, 1944.

Turpin, *The History of Siam,* Paris, 1771.

Vachet, Bénigne, 'Mémoires'. (extracts) Paris. Groupy, 1865.

Van der Cruysse, Dirk, *Siam and the West.* Silkworm Press, Chiang Mai, 2002.

Van Vliet, 'Beschrijving van het koningrijk Siam'. (*A Description of the Kingdom of Siam*). Translated by L. F. van Ravenswaay. *The Journal of the Siam Society.* Vol. 7, part 1.

Van Vliet, Jeremias, 'The Short History of the Kings of Siam'. *The Siam Society,* 1975. Editor, David Wyatt.

Vickery, Michael, *The Journal of the Siam Society,* vol. 67, part 2, page 145.

Wolters, O. W., 'Chen-Li-Fu, A state on the Gulf of Siam at the beginning of the 13th century'. *The Journal of the Siam Society,* vol. 48, no. 2.

Wright, Michael, 'Ayudhaya and its Place in Pre-Modern Southeast Asia', *The Journal of the Siam Society,* vol. 80, part 1. 1992.

Wright, Michael, 'Where was Sri Vijaya?;. *The Siam Society Newsletter,* vol. 1, No. 1.

Wyatt, David K., *Thailand – A Short History.* Yale University Press & Thai Wattana Panich, 1984.

Young, Patricia, 'The Lacquer Pavilion – First Reign Masterpiece'; a lecture given at the National Museum on Dec. 15th, 1992.

Index

Note: References in italics refer to illustrations.

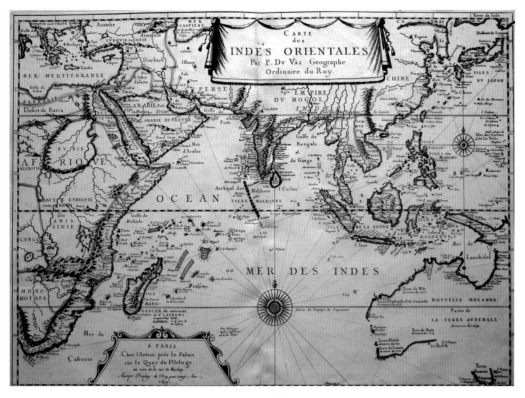

'Carte des Indes Orientales' drawn by Pierre Du Val, 1677. *(Courtesy the Dawn Rooney Collection)*

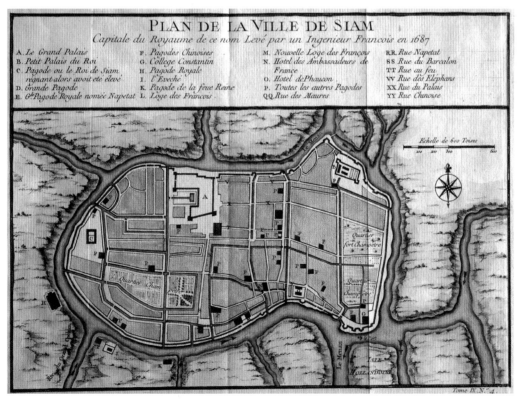

'Plan de la Ville de Siam' drawn by a French engineer, Jacques Nicolas Bellin, shows Ayutthaya in 1750.
(Courtesy the Dawn Rooney Collection)

A coastal chart from the Traiphum manuscript.
The captain of a junk, provided with this map, could find his way along the coasts of Asia from China to Arabia.
(To understand it, one needs to hold this book by the left hand edge and let the book hang down.

Now the coast of China becomes apparent with the islands of Japan and Korea, amongst others, away to the east.

As one moves into the second picture, the book should be rotated slightly in a clockwise direction to show southern Vietnam and the mouth of the Mekong river.

When we reach the third picture, the book should be upside down, whereupon we see the Gulf of Siam with Ayutthaya, quite out of scale, at the head of the Gulf. Like so many Chinese inventions, in its simple way this map is remarkably effective.
(see page 10)

All images on this page are from the Triphum Scriptures, Thonburi period.
(Courtesy of the National Library, Bangkok)

156

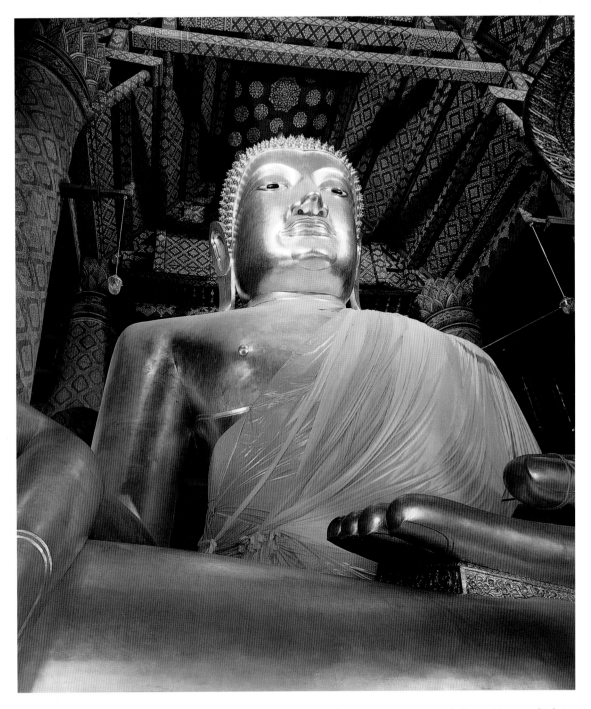

Phra Phanan Choeng. This image was made some years before Ayutthya was founded; nevertheless at 19 metres high, it is one of the largest Buddha images in the city. It was created as a thank-offering for the very prosperous trade which existed between that place and China and indicates that tuere was a thriving commercial centre here many years before King U Thong founded Ayutthaya. (see page 14)

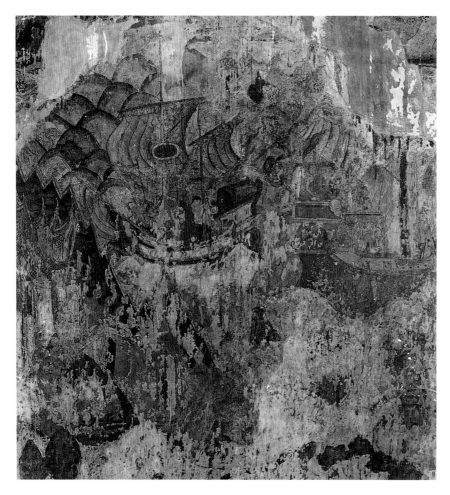

Thai junks were famous both for the quality of the wood from which they were made and for the skill of Siamese boat-builders. The Chinese placed many orders for junks to be made here. Of the 16 junks wrecked off the coast near Pattaya, three were made of wood unknown in China. (Wat Buddhaisawan, Ayutthaya) (see page 18)

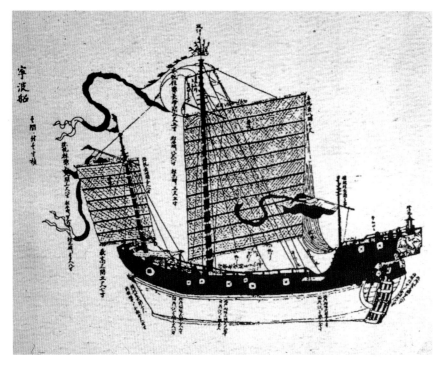

A Siamese junk from a Japanese 'Tosenzukan' document. Siamese merchants were seen in Japan as early as the fourteenth century. By the seventeenth century, Siamese junks were well-known along the quays of Nagasaki. (see page 16)

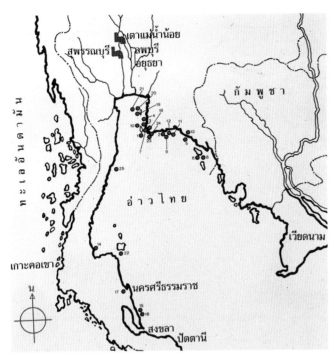

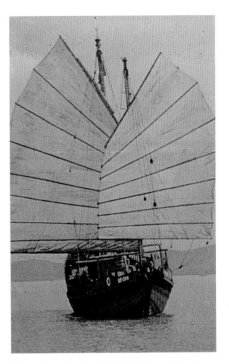

A map of the Gulf of Thailand showing the sites of wrecked vessels. Despite their seaworthiness, many junks were blown on to the rocky shore and sank. Perhaps their captains were too anxious to keep in sight of the landmarks by which they navigated.
(Courtesy of the Underwater Archaeology Project, Chantaburi)

A modern day junk 'The Elf Chine'. Note how the sails of a junk can be extended on either side to catch every breath of wind. *(Asia Magazine)*

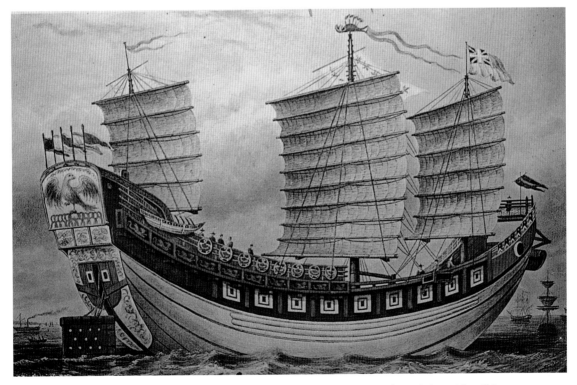

'The Keying' junk was commissioned by a group of Westerners in China in 1846, who sailed it, with a Chinese crew, to Europe, where it was berthed in the river Thames and aroused much interest. *(Asia Magazine)*

Bambou

Aruore de Raiz

Two plants common in Siam, the bamboo, which has so many uses in everyday life; and the banyan tree, a kind of Indian fig, with its curious aerial root system.

To. 1. pag. 69.

l'Aré Kier

Betel Nut, which comes from the Areca palm, is a mild stimulant and was chewed by the Siamese of all classes, though it made their teeth black. When King Mongkut got a western dentist to make him a set of false teeth, they had to be made out of a special kind of black wood.

160

The Ginseng plant has a forked root which the Chinese esteem for its supposed medicinal properties. The name 'Ginseng' is a corruption of two Chinese words ('Ren' – a man, and 'Shen' – a kind of herb). The Chinese gave it this name because the forked root was supposed to resemble a person. And thus the artists portrayed it.

Rhinoceros horn was one of exotic products of the forest of Siam much prized by foreign traders. The killing of a rhinoceros was a slow and cruel business. (see page 59)

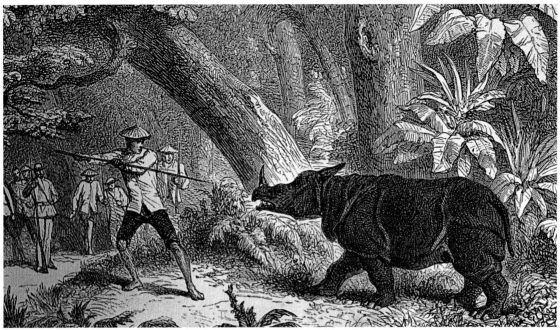

A Dutch navigation chart from about 1650. This very accurate map would make it easy to reach Ayutthaya without veering off into any of the numerous meanders. But the owners of such useful maps tended to keep them very much to themselves. *(Courtesy of the Netherlands National Archives)* (see page 91)

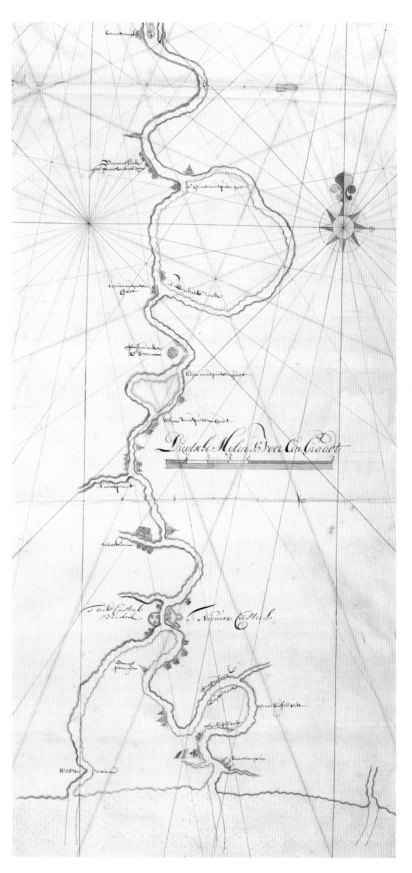

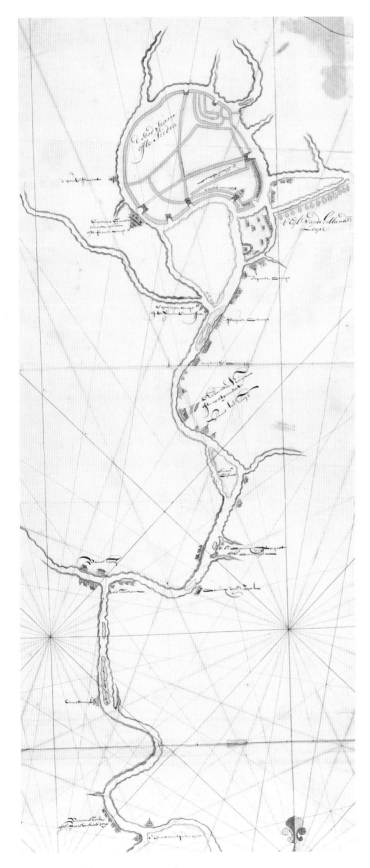

Compare this chart with the two maps of the Chao Phraya on pages 22 and 37. Picturesque to armchair travellers, they would be quite useless to a foreign sea-captain, who would have to employ a Siamese pilot instead.
(Courtesy of the Netherlands National Archives) (see page 91)

Similarly this 19th century chart would enable a ship to avoid the dangerous mud flats and bars and follow the channel which lead to the mouth of the Chao Phraya.
(Richards, 1865)
(Courtesy of the Dawn Rooney Collection)

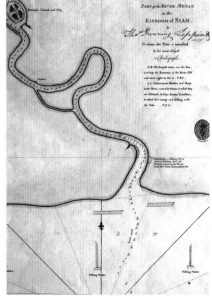

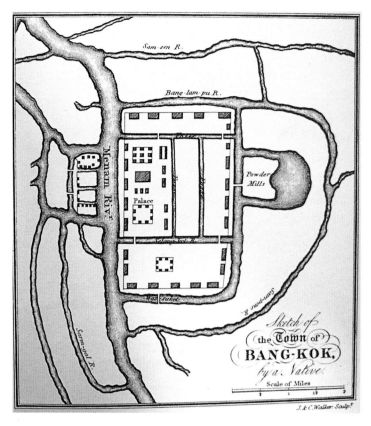

Crawfurd's map of Bangkok, c. 1822. Although somewhat crudely drawn, this 'local' map shows the old rivers of Bangkok: the Samsen River, the Banglampu River and the Sam Pheng River. (see page 33)

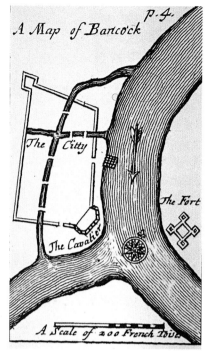

A simple plan of Bangkok by La Loubère, 1687, showing the citadel and the two forts, one on either bank. Note that the name 'Bangkok' then applied to the western side of the river which is now known as 'Thonburi.
(For an explanation see page 32)

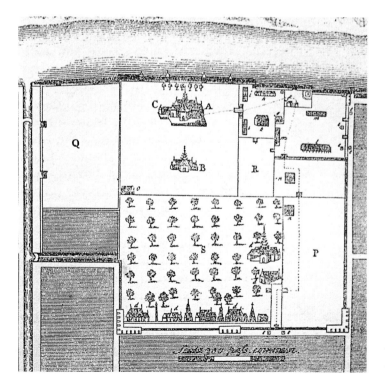

Kaempfer's map of the Grand Palace in Ayutthaya. King Rama I followed the same plan when he laid out his palace in Bangkok. (see page 43)

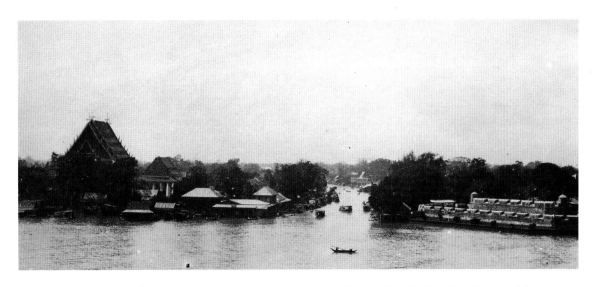

A photograph of the mouth of Klong Bangkok Yai taken in the 1930s. This canal marks the original course of the river which became silted up when a new short 'cut' was dug in the sixteenth century. To the right is Vichai Prasit fort, shown in La Loubère's plan, and the king's toll-house would have been on the left where there is now a large *wat*. (see pages 31-32)

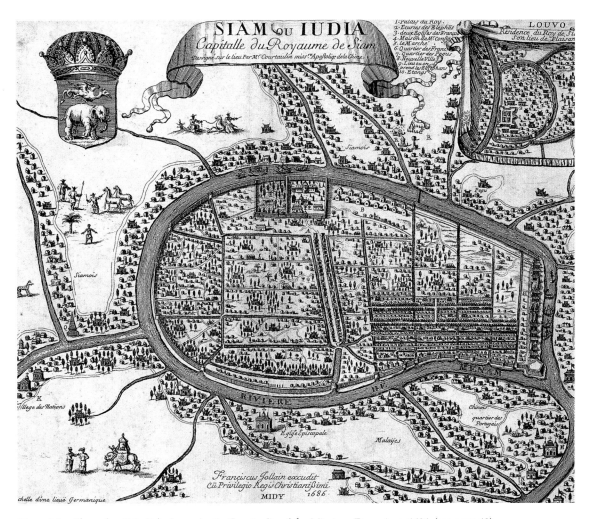

Map of Ayutthaya (spelt Iudia), drawn by Fr. Courtaulin of the Missions Etrangères, 1686. (see page 48)

The fortress of Pomphet. The walls of Ayutthaya were so strong that they withstood an 8-month siege. In fact they were never breached. The Burmese entered the capital by other means. (see page 72)

A colossal head in bronze, U Thong style, from Wat Dharmigharaj, Ayutthaya. Many such remains have been found in and around Ayutthaya. They indicate that a wealthy community lived there decades before Ayutthaya itself was founded. (*Courtesy of the Bangkok National Museum*) (see page 40)

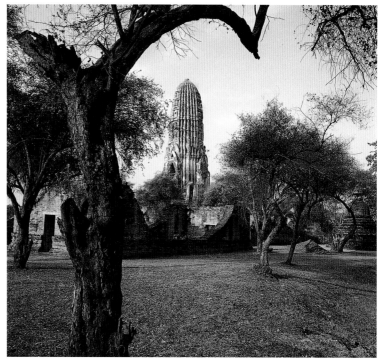

Wat Phra Ram is possibly one of the earliest temples to be founded in Ayutthaya. The main tower is in the Cambodian style which was common at that time, but much of what we see dates from the 18th century. (see page 41)

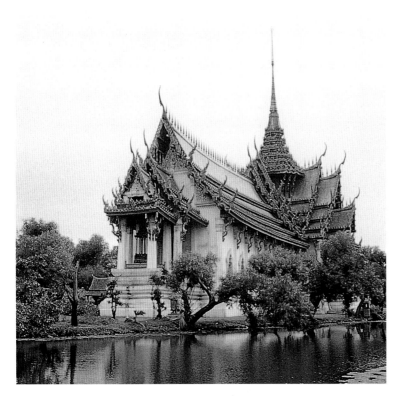

The Sanphet Prasat Throne Hall. The original throne hall in Ayutthaya was regarded as one of the most beautiful buildings in the capital. Even this model, in three-quarter scale, reveals something of that elegance. *(Courtesy of Muang Boran)* (see page 42)

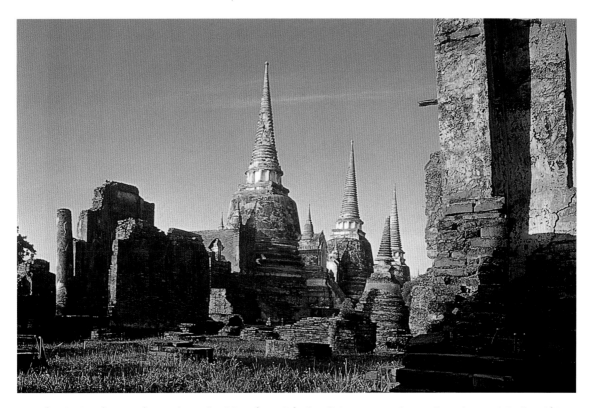

Wat Phra Sri Sanphet was the royal temple of Ayutthaya; it had no living quarters for monks and was originally within the walls of the Grand Palace, like the temple of the Emerald Buddha in Bangkok. The principal image was a standing Buddha cast in bronze and covered in gold. At 16 metres high, it was the tallest standing image ever made in Thailand. (see pages 41, 44, 45)

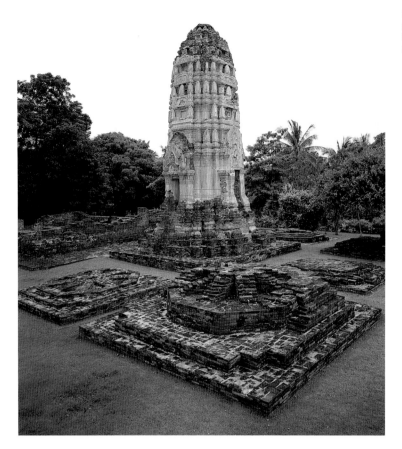

Wat Som, although very small, retains much of its original stucco-work and is much closer to the true Cambodian style than many other buildings.

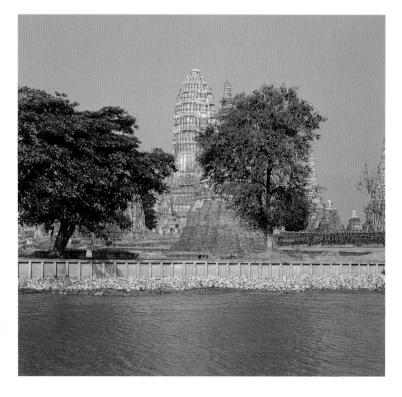

Wat Chai Wattanaram is unusual in being perfectly symmetrical and built all at one time. Again, it reflects the Cambodian style of Angkor because that country was then a vassal state of Ayutthaya.

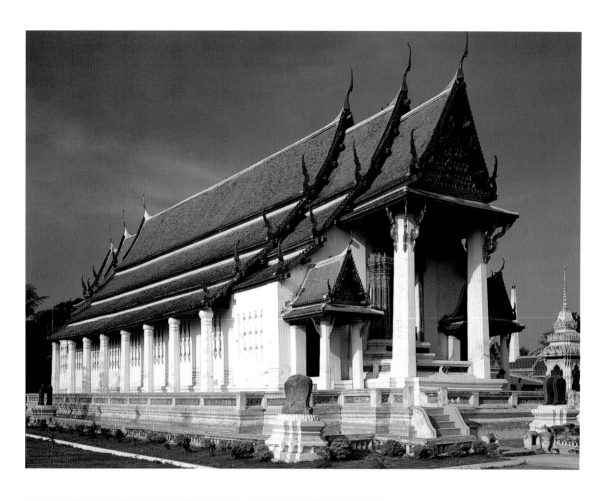

Wat Na Phra Men is the only major temple in Ayutthaya to have survived the Burmese onslaught in 1767. Even so, much of what we see is a 19th century restoration.

A portion of a circular scripture cabinet of the Ayutthaya period, showing a strange octagonal building. It is also shown in western paintings of Ayutthaya (see page 186). It must have been one of the sights of the capital; but no one seems to know what it was for. (National Museum, Bangkok)

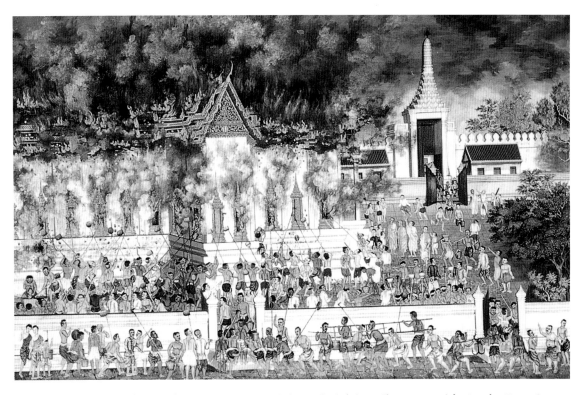

The Phra Thinang Indraphisek in the Grand Palace, Bangkok, was built (of wood) as a copy of the Sanphet Prasat by King Rama I. But it was struck by lightning in 1789 and the palace officials were unable to save it. The king himself is said to have braved the flames and dragged the throne to safety. *(Courtesy of the National Gallery)* (see page 42)

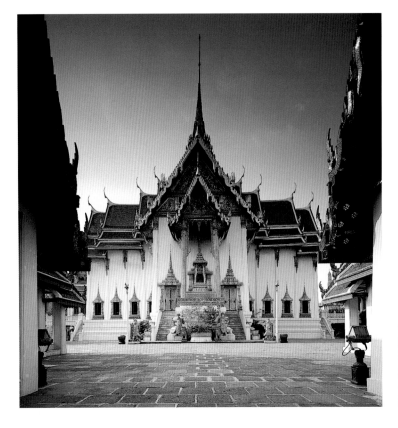

The Phra Thinang Dusit Maha Prasat in the Grand Palace was put up by King Rama I as a copy of the Suriyat Amarin Throne Hall at Ayutthaya. There is another version of that building at Muang Boran.
(see page 42)

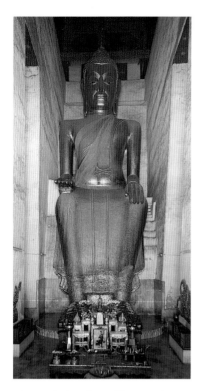

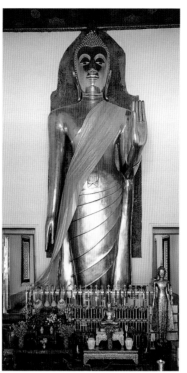

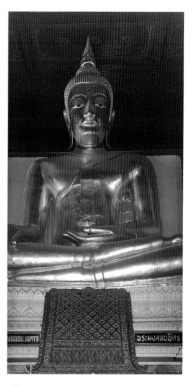

Phra Pa-le-lai. This U Thong style image once stood out in the open amidst the rice fields of Suphanburi. (see page 45)

Phra Lokanart. This is one of only two Buddha images which were saved from the Chapel Royal in Ayutthaya. It was restored by King Rama I and can still be seen in the Temple of the Reclining Buddha in Bangkok. (see page 44)

Phra Mongkol Bophit. This statue was once covered in plates of gold and stood out in the open. It is still in its original location and was restored during the Pibul Songkhram period. (see also page 44)

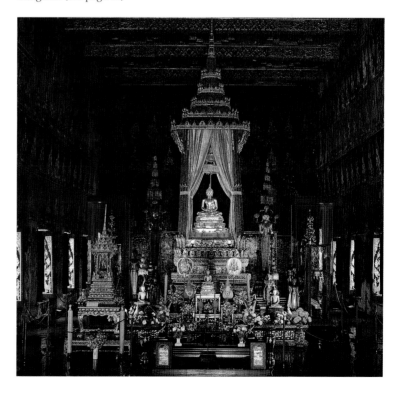

The Phra Thinang Buddhaisawan. The Chapel Royal of the 'Second King'. It houses the Phra Buddha Sihing, second only to the Emerald Buddha in public esteem. Legend has it that the image came from Sri Lanka, but it is cast in bronze and is clearly in the Sukhothai style. This image is a copy. The original is in Chiang Mai. (see page 42)

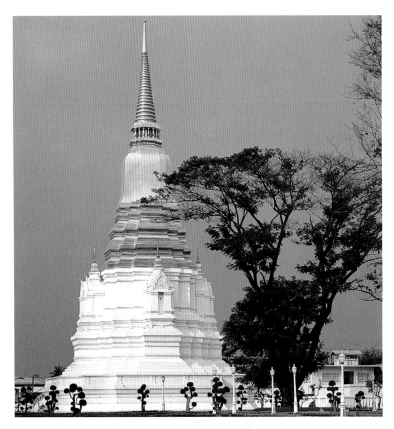

The *chedi* of Queen Sri Suriyothai. Here lie buried the ashes of the brave queen, who rode into battle beside her royal husband and saved his life by giving up her own. The *chedi* was restored in the 1990s by Her Majesty the Queen. Queen Sri Suriyothai has recently been the subject of a major Thai film. (see page 45)

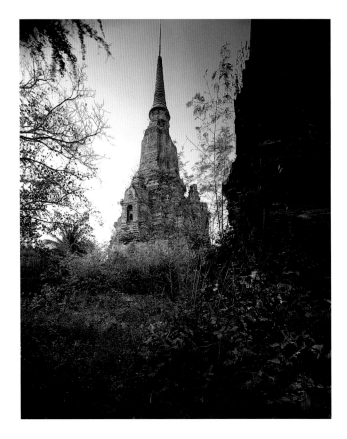

An unrestored brick *chedi* at Wat Yanasen. It remains one of the most beautiful *chedi*'s in the whole of Ayutthaya. (see page 45)

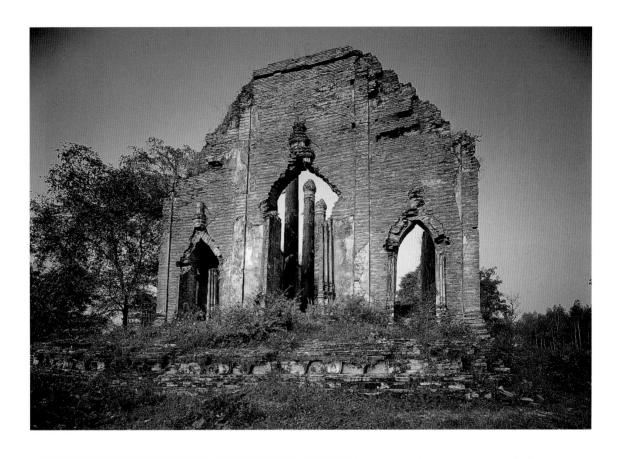

Above: The ruins of a *viharn* which was constructed in the early Ayutthaya period at Wat Kudi Dao. (see page 51)

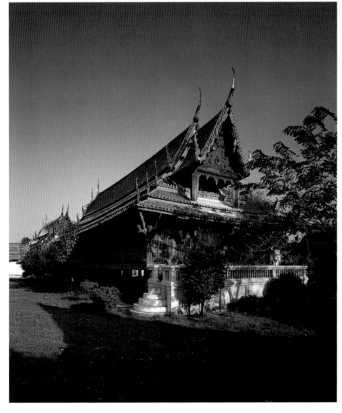

The Sala Kan Parian of Wat Yai Suwannaram, Petburi is unique. It is the only royal building from Ayutthaya that has survived. The king (King Tiger) sent it as a present to his old monastery in Petburi. (see page 42)

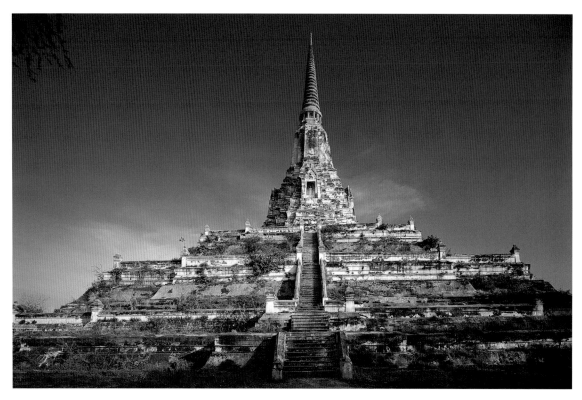

Wat Phu Khao Thong. This huge, Mon-style base of the *chedi* was built by King Naresuan, to commemorate his victory over the Crown Prince of Burma on this spot, but was then abandoned. About 60 years later, the *chedi* itself was built by King Prasat Thong, but on a smaller scale than its base.

Chantarakasem Palace, the residence of the King of the Front Palace. This was rebuilt by King Mongkut but reduced in size. (see page 47)

Phisaisanlayalak Observatory. Originally constructed by King Narai, it was rebuilt on the original site by King Mongkut, who was himself a keen astronomer. It was restored in 1967. (see page 47)

A photograph of Phraya Boran Rajathanindra. The governor of Ayutthaya. He took a great interest in the ancient site, and carried out many excavations himself. (see page 47)

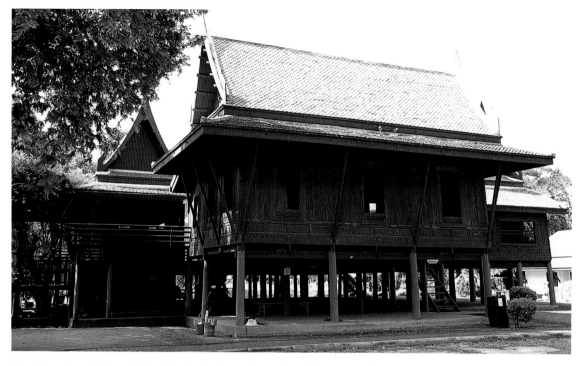

Kum Khun Paen. This traditional Thai-style cluster house shows how a wealthy person's house would have looked in the Ayutthaya period. It was built in the reign of King Rama V.

A 'white' elephant. Although to the untrained eye this looks like a very black elephant, these rare animals possess many distinctive features of their own. They were highly esteemed and brought lustre to any king who owned them. *(Courtesy of the National Gallery)*

Adam's Peak in Sri Lanka. The monks of Sri Lanka invited Thai monks from Ayutthaya to go there and help re-establish the Buddhist faith. It was a gruelling assignment. On the first expedition, two-thirds died. On the second, they were perhaps invited to ascend Adam's Peak. Certainly, the mountain seems to have impressed those who returned. (It is a seven-hour climb). (From a mural painting of Wat Buddhaisawan, Ayutthaya) (see page 63)

Royal Barges of Ayutthaya: Rua Nakha and Rua Khamodya of the late Ayutthaya peroid.
(Courtesy of the National Library, Bangkok)

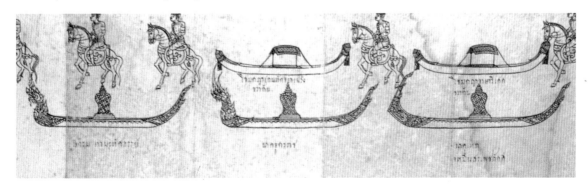

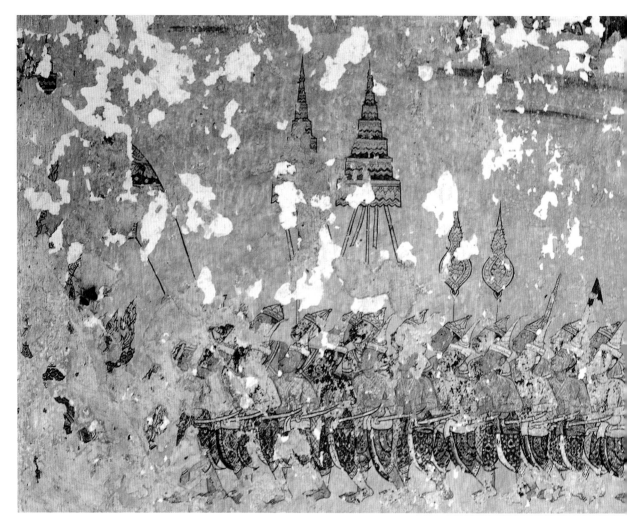

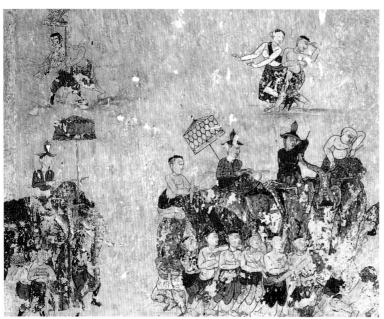

Three royal processions on elephant back in Ayutthaya which had good, wide streets where the king might pass before his subjects. In a *kathin* procession there might be two hundred elephants and six or seven thousand men. We have seen nothing like it since. In the early days of the present dynasty, the kings did not have the means, and the new city did not have the streets to lay on such a display. (Above and left: Wat Pradu Songtham, painted in 1863; right: Wat Yom, Ayutthaya) (see page 47)

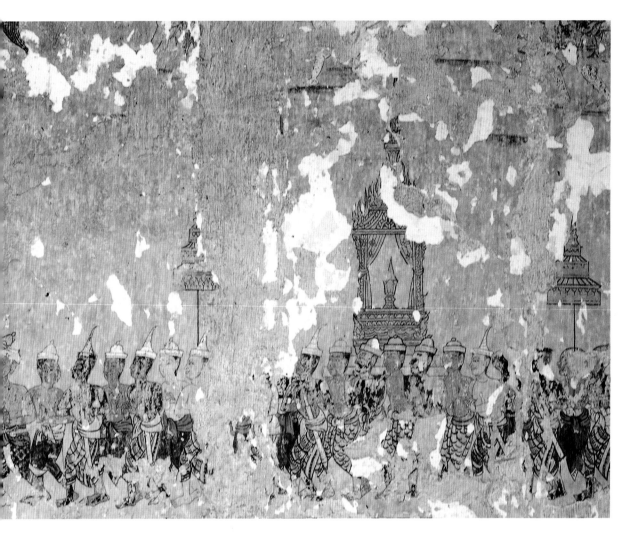

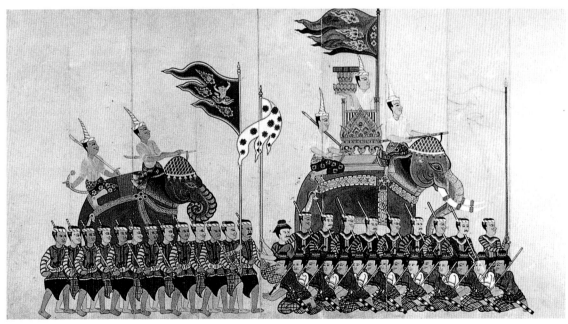

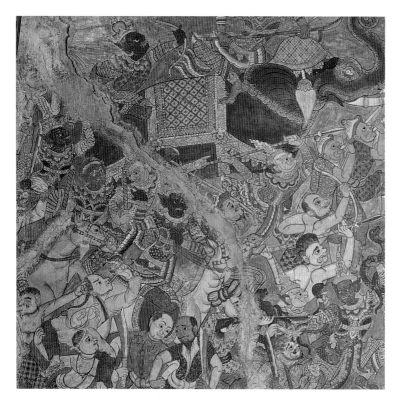

Demons in Mara's Army. The large mural on the wall facing the principal Buddha image often depicts the defeat of Mara's army. They are washed away by the flood of water released when Mother Earth wrings out her hair. Originally Mara's followers were depicted as devils, wild animals and monsters. A mural from Wat Bot, Samsen. (see page 33)

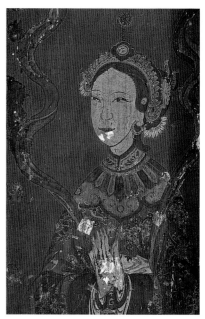

Mural painting of a woman from Wat Bang Khun Tien, Bangkok.

Mural painting at Wat Bang Khun Tien showing a man and woman in typical Siamese attire.

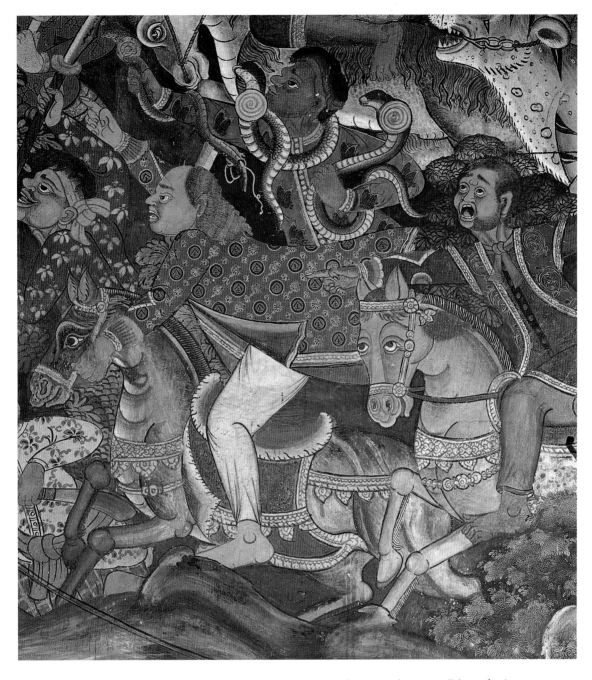

The Siamese welcomed mercenaries of all nationalities. Its native population was far too small for such a large country. Wars in those days were often fought to gain more people rather than more land. (Wat Suwannaram, Bangkok)
(see page 70)

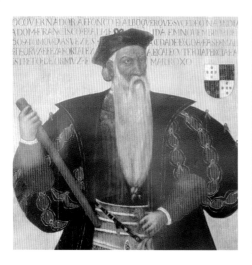

Afonso de Albuquerque, the governor-general of Portuguese colonies in Asia. A portrait from the National Museum, Lisbon. (see page 69)

This French canon named Prommas Phab Mara is now situated in front of the Ministry of Defence, Bangkok.

The remains of a Portuguese Dominican church in Ayutthaya. At one time there were said to be two thousand families in the Portuguese settlement, served by three churches. (see pages 73-74)

Part of a Portuguese graveyard at Ayutthaya. Touchingly, local people put flowers on some of these graves. Are there still people in Ayutthaya who regard themselves as of Portuguese descent? (see page 74)

Strange figures using a cannon mounted on a trolley with wheels. *(Courtesy of Suan Pakkard Palace, Bangkok)*

A lucky shot by King Naresuan kills the Burmese general on the other side of the river. The musket he used was preserved as one of the emblems of royalty. (see page 72)

A pepper plant. It was this spice, above all others, which drove men to seek trade with the East Indies. Some made a profit of up to 1,000%. *(Courtesy of the Underwater Archaeology Project, Chantaburi)*

Ginseng, whose roots were used as medicine. (see also page 161) *(Courtesy of the Underwater Archaeology Project, Chantaburi)*

Nutmeg also grew in Siam. It came originally from the Moluccas where the trade in nutmeg was so profitable that it caused bloodshed between the English and the Dutch. *(Courtesy of the Underwater Archaeology Project, Chantaburi)*

Opposite: *Kaew kalapa*, or coconut oil lamps. 'Kalapa' is the Indonesian word for coconut; perhaps the lamps were introduced to the Siamese by the Dutch who had already taken them to Batavia (see page 89). Beneath this homely scene, we see the French on horseback looking very grand in their huge and fashionable hats. They thought the Dutch very provincial in their sober dress; see also inside front cover.
(Courtesy Suan Pakkard Palace, Bangkok) (see page 92)

Mural painting from Wat Suwannaram. While the Dutchman looks through his telescope, the Thai gentleman with a viewing glass inspects a lady's bosom! (see page 92)

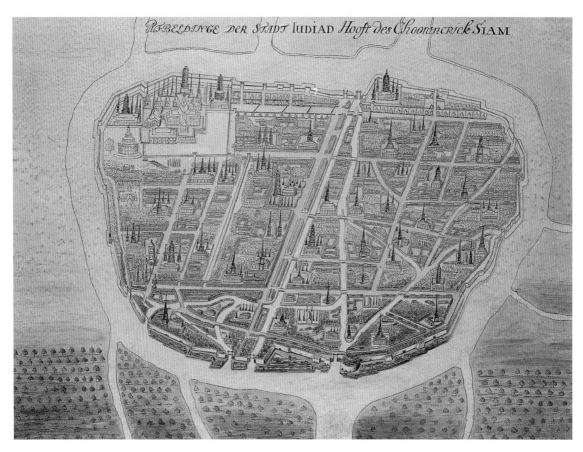

A view of Ayutthaya by Johannes Vingboons, c. 1665. Notice the octagonal building at the northwest corner of the city. *(Courtesy of the Algemeen Rijksarchief at the Hague)* (see page 91)

A Dutch drawbridge on Asdang Road in Bangkok. The low, make-shift bridges over the minor canals in Ayutthaya were a great nuisance to cargo boats. So the Dutch introduced this elegant form of drawbridge. (see page 92)

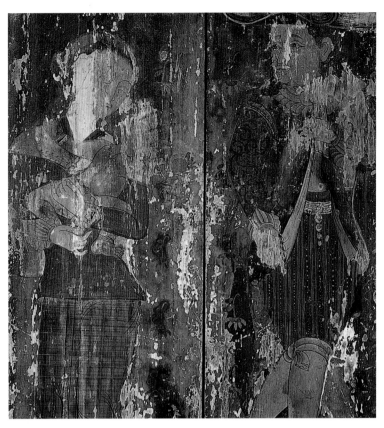

Dutch gables on Asdang Road. The Dutch lodge outside Ayutthaya was furnished with gables in this style. It was known as 'Tuk Daeng' because it was built of brick; a material used by the Thais only for wats.
(see page 85)

A Dutch husband and wife with their baby. It was most unusual for married couples to come and work in Asia. The lady's Javanese sarong suggests they had come from Head Office in Batavia. (Wat Bang Khun Tien) (see page 92)

A Jesuit monk in Buddhist robes. It is unclear what they hoped to gain by this curious form of 'cross-dressing'. Did they think it would allay the fears of their Buddhist audience? The Thais prudently obliged them to retain the distinctive Jesuit hat. (Wat Koh Kaew Suttharam, Petburi) (see page 131)

Three western musketeers with their Muslim loader. Muskets and the men to fire them were one of the most acceptable, and deadly, gifts that westerners brought to less sophisticated lands. (Wat Suwannaram, Bangkok) (see page 70)

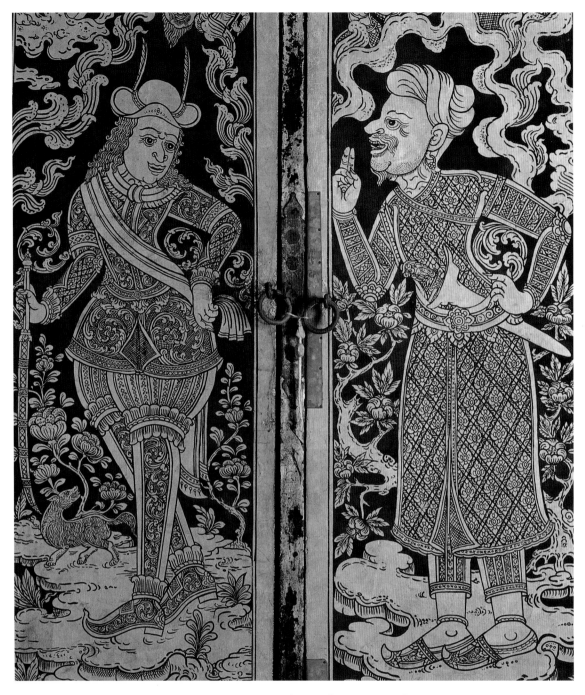

Western and Persian traders from a gold lacquer cabinet of the Ayutthaya period in the National Museum, Bangkok, a rare survival.

Opposite Left: Mgr. Pallu, Bishop of Heliopolis (or Baalbec). He loved Siam and the Siamese and twice went back to Europe to recruit architects and craftsmen whom he brought to Ayutthaya. (see page 112)

Opposite Right: Bishop Lambert de la Motte was the first Frenchman, so far as we know, to come to Ayutthaya. He had already walked the whole way across India and was on his way to China. (see page 111)

Kosa Pan. A man of powerful aspect and presence.
He led the first successful Siamese delegation to France.
(see pages 51-52)

Phaulkon. An imaginary portrait. In fact he was a
young Greek of enormous talent who became the
favourite of King Narai and negotiated for him with
the French delegation. (see pages 101-127)

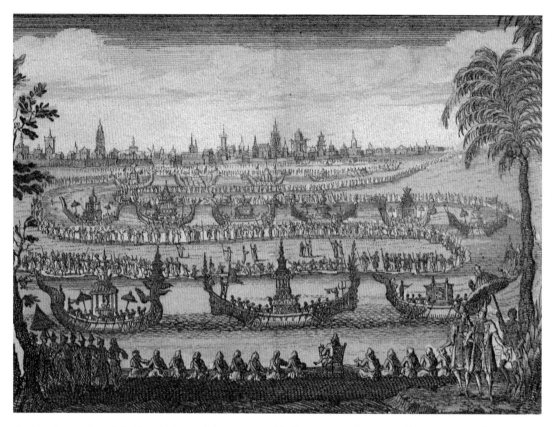

An imaginary view of the French envoys being conveyed in Siamese state barges up the river to Ayutthaya. *(Courtesy the Old Maps and Prints shop)* (see pages 116-117)

Route de Mr. le Chevalier

l'oiseau vaisseau de guerre de sa majesté

The French warship L'Oiseau which brought Chaumont's mission to Siam. (see page 116)

Guy Tachard, a Jesuit priest. An elusive
figure, distrusted by the other French
emissaries, he outlived them all.
(see pages 115, 124)

The three Siamese envoys to France in 1686-
1687. (see page 121)

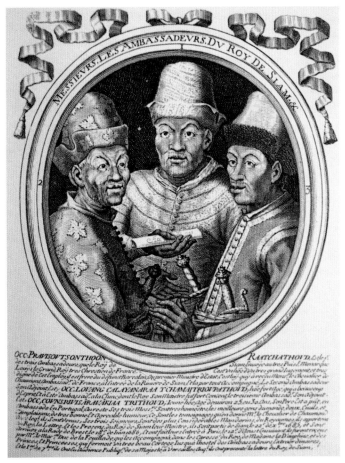

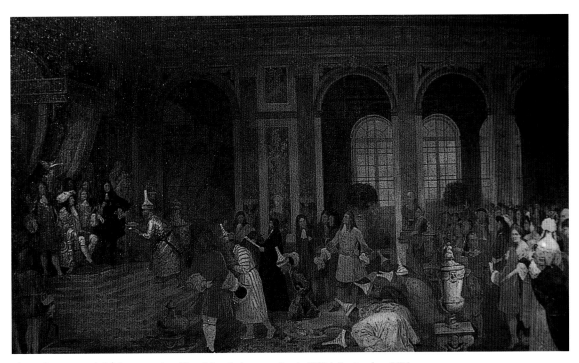

Chao Phaya Kosathibodi presenting King Narai's letter to Louis XIV, 1 September 1686.

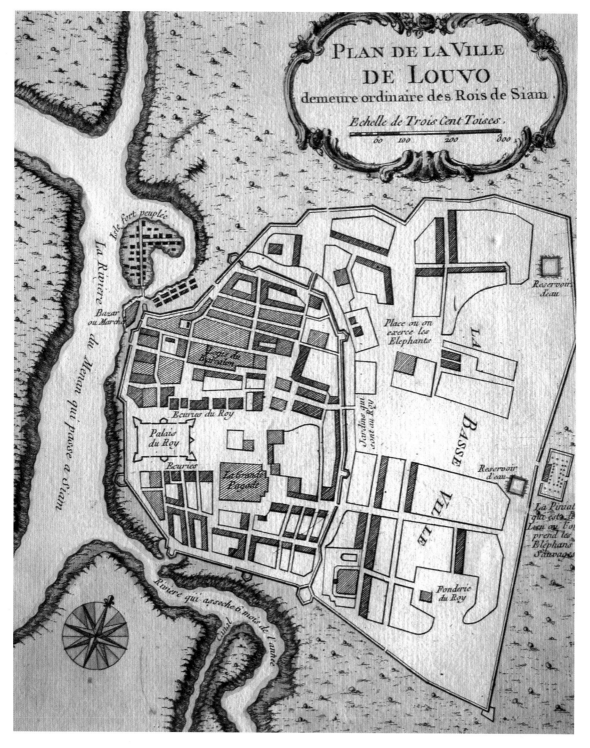

On the map, the following labels are visible:

PLAN DE LA VILLE
DE LOUVO
demeure ordinaire des Rois de Siam.

Echelle de Trois Cent Toises.

60 100 200 300

Isle fort peuplée

La Rivière du Menan qui passe a Siam

Bazar ou Marché

Reservoir d'eau

Place où on exerce les Elephants

Eg.e du Benoisten

Ecuries du Roy

Jardins qui sont au Roy

Palais du Roy

Ecuries

La grande Pagode

LA BASSE VILLE

Reservoir d'eau

La Pintate qui este le Lieu ou l'on prend les Elephans Sauvages

Fonderie du Roy

Rivière qui assèche 6 mois de l'année

Canal

A Plan of Lopburi drawn by Jacques Nicolas Bellin, 1750. It shows the king's palace, and Phaulkon's grand residence nearby. *(Courtesy the Dawn Rooney Collection)*

Opposite: Inside the grounds of King Narai's palace at Lopburi. From left to right: Dusit Sawan Thanya Maha Prasat. This is where King Narai received in state the emissaries of foreign countries. Piman Mongkut pavilion and the Chantra Pisal pavilion. The two latter were rebuilt by King Mongkut in the nineteenth century.

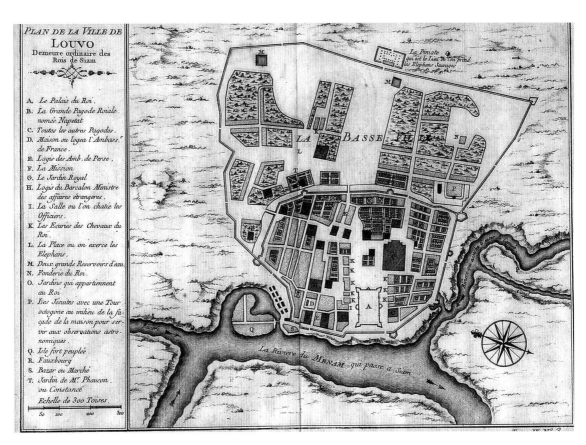

Lopburi, the second city after Ayutthaya was founded by King Narai. Drawing by Jacques Nicolas Bellin, 1764.
(Courtesy the Dawn Rooney Collection)

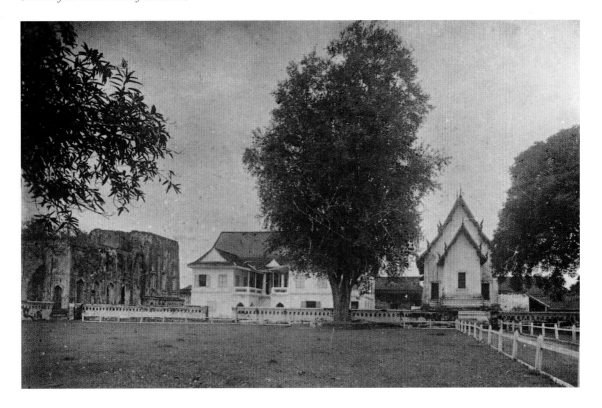

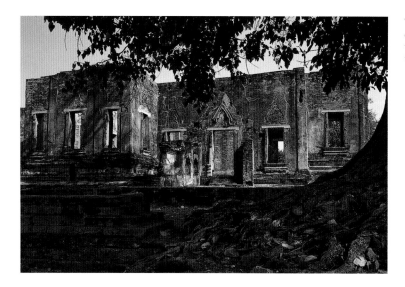

The Phra Thinang Yen was located outside Lopburi where King Narai went to observe the total eclipse of the sun. (see illustration on page 197)

Phaulkon's house at Lopburi. He already had a house in Ayutthaya. Such ostentation by a young foreigner did not sit well with the Siamese ruling class.

Tuk Phra Chao How in Lopburi. The chapel inside the palace grounds where King Narai venerated the Buddha image.

Opposite: Chaumont presenting a letter from King Louis XIV to King Narai on 18th October 1685. Chaumont commissioned this picture himself. It reveals how he held the letter teasingly out of reach of King Narai, forcing him to lean down to take it. Phaulkon may be seen on the floor gesturing to Chaumont to raise it higher.
(Drawn by Jean-Baptiste Nolin) (see page 119)

Above: Phaulkon weighing a cannon called Phra Phirun. To demonstrate the intelligence of his Greek favourite, King Narai asked him to weigh a heavy cannon. Phaulkon, who had been a sailor and understood displacement, put the cannon on a boat and marked the water-line. He then removed the cannon and replaced it with stones until the boat sank to the same level as before. It was then an easy matter to weigh the stones.
(Courtesy of the National Gallery)

The ruins of St. Paulo Church, Lopburi. It is said that King Narai paid for this church himself. The French saw it as a sign that the King was interested in becoming a Christian. This mistake caused their whole mission to founder.
(see page 114)

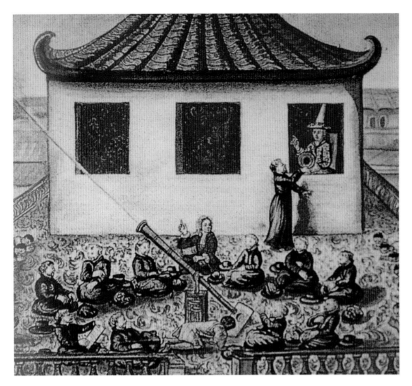

King Narai observing a total eclipse of the sun with Jesuit priests. The King was suffering from dropsy and asthma and died three months later. It is a sad but curious fact that Thailand's two astronomer-kings, King Mongkut and King Narai, both died shortly after they had observed a total eclipse of the sun. (see page 124)

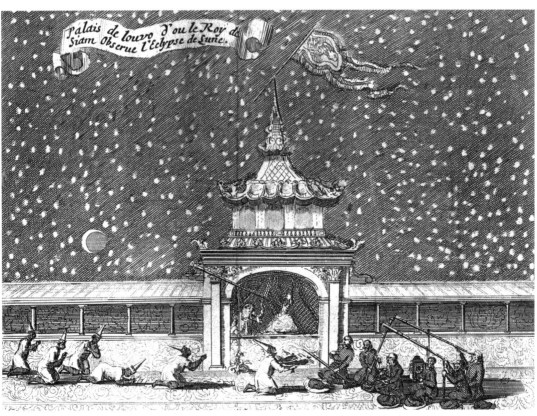

King Narai observing a total eclipse of the moon with Jesuit priests. A Brahmin priest at King Narai's court had already predicted this eclipse, even though the Thais did not have such accurate instruments as this 5-foot telescope which the French brought with them. (see pages 123-124)

The bronze statues which the Burmese took from Ayutthaya are today situated in Mandalay. (see page 139)

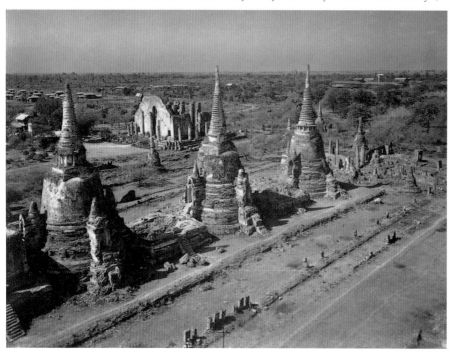

The three *chedi*s of Wat Phra Sri Sanphet after the temple had been burnt by the Burmese in 1767. This is all that remained of the Chapel Royal.
(Courtesy of the Williams-Hunt Collection, SOAS) (see pages 139-140)

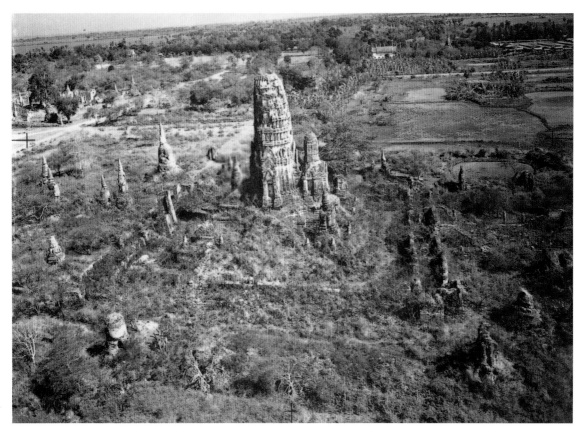

The main *prang* of Wat Phra Ram photographed in 1946. *(Courtesy of the Williams-Hunt Collection, SOAS)*
(see pages 139-140)

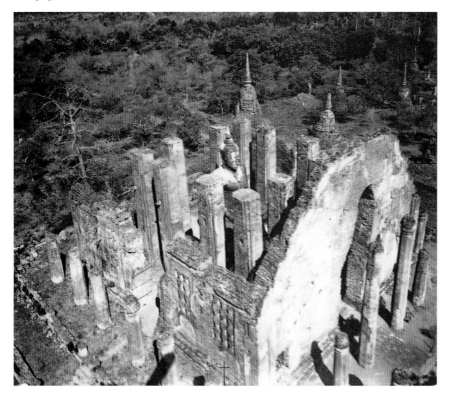

The Viharn of Phra
Mongkol Bophit
as photographed in 1946.
(Courtesy of the Williams-Hunt Collection, SOAS)
(see pages 139-140)

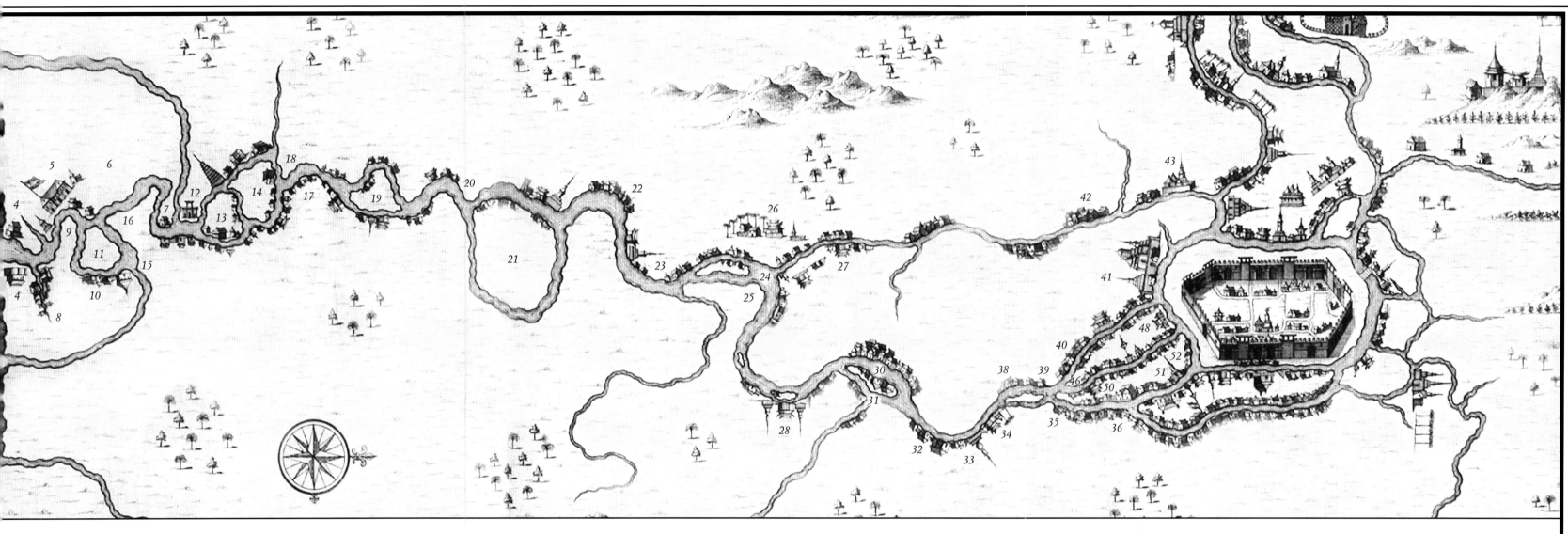

the River from its Mouth to Bangkok.

appeared to have three mouths and as the coastline here is quite featureless it was difficult to find the only navigable

n river, by which smaller vessels could get up to Bangkok. (p. 23-24)

the Chao Phraya River.

Bar across the mouth of the river is not shown here.

houses which would watch out for ships and warn the authorities at Samut Prakan of their approach. (p. 25)

ya' in the village of Samut Prakan, where an official with the high rank of 'Chao Phraya' resided. From

name of the river, the Menam Chao Phraya. (p. 25-6)

rehouse know as 'Amsterdam', built in about 1634. (p. 26)

house, controlling both routes to the sea. (p. 31)

alo field' where the villagers put out their animals to graze. (p. 27)

, a small town and a good site for cannon to bombard enemy ships. (p. 28)

ened short cut canal. (p. 27)

an Hia river joined the Chao Phraya. Now it is know as 'Klong Samrong'. (p. 28)

rds and gardens along both banks. (p. 28)

12. The Fortress of Bangkok just below Wat Arun (the Temple of the Dawn). (p. 32)

13 & 14. If we now keep to our right we shall be following the main channel which was once merely a short-cut canal.
The original course of the river followed the line of Klong Bangkok Yai and Klong Bangkok Noiand rejoined the Chao Phraya near 18.

B. The Course of the River from Pakkred to Bang Pa In.

19. Now we come, abruptly, to Pakkred, having missed out Nonthaburi altogether with its huge meander starting at Klong
Bangkruai. The cut at Pakkred was cut as recently as 1721 and is still noticeably narrower than the old course of the river to the
west. It is know in Thai as 'Kred Noi' or little cut. The foreigners nicknamed it 'the small mosquito cut', because of the swarms
of mosquitoes which gathered there. (p. 34)

21. Shows us the 'cut' made in 1608 and the old course of the river. To foreigners it was 'the great mosquito cut'. (p. 34)

22. It is called 'the pottery village' on Valentyn's map. This must be the Mon town of Pathum Thani. The Mons were, and still are,
famous for their pottery. (p. 34)

23-24. Somewhere along this stretch the river widens out and the wind freshens, a danger to sailing ships. It is know as 'Lan Tay'.
Wat Gai Tia, the 'Bantam Wat' is not shown. (p. 35)

27. The Menam Noi or 'little river' joins the Chao Phraya at this point having run parallel with it for over 100 kilometres.
It was probably the old course of the river, which gradually transgressed eastwards. (p. 35)

28. 'The King's pagoda' and 'the King's audience hall'. References to Bang Pa In. King Prasat Thong built himself a palace
there 350 years ago. (p. 35)

C. The Course of the River from Bang Pa In to Ayutthaya.

32. Here is the royal customs house at Hua Laem, where all merchant ships had to call. (p. 35)

33. Marks the spot where the Dutch East Company had its orchards; a sign that the Company intended to maintain a
presence in this profitable city.

34. And now, as we pass Wat Prote Sat, Ayutthaya itself comes into view.
Between 34 and 35 we pass the island of Koh Rien, where many vessels foundered on its hidden shoals. (p. 36)

36. At that time when foreigners were so welcome, even the Japaneses had their own settlement. They were the descendants
of Christians who had fled persecution in their own country.

50. Our ship will take the main course of the river with the large Portuguese village on our left and the Dutch compound
(53) on our right with its brick buildings and gabled roofs. (p. 36)
Look on your map and now the battlements of Fort Pomphet would come into view. Our ship would swing to starboard
and make ready to anchor at one of the many wharves on the eastern side of the city.